W9-AWH-305

THE ART OF

WYLAND

INTRODUCTION by Robert Bateman
TEXT by Mark Doyle
WORDS by WYLAND

America's Leading Environmental Marine Life Artist

Copyright ©1992 Wyland Studios

4

Artwork ©1992 Wyland

All Rights Reserved

All rights reserved. No part of this book may be reproduced or transmitted in any form by any means, electronic or mechanical, including photocopying and recording, or by any information storage or retrieval system, without written permission from the copyright holders, except for brief passages quoted by a reviewer in a newspaper or magazine.

First published in U.S.A. by Wyland Studios
2171 Laguna Canyon Road, Laguna Beach, California U.S.A. 92651

Library of Congress Catalog Card Number 91-91490

Second Edition 1993

U.S.A. Cataloging in Publication Data

Wyland, 1956-
The Art of Wyland

ISBN 0-9631793-0-6 (CASE)

ISBN 0-9631793-1-4 (LIMP)

Produced by:
Wyland Studios
2171 Laguna Canyon Road, Laguna Beach, California U.S.A. 92651

Printed in Hong Kong

The publisher would like to thank the following people whose support and encouragement made this book a dream come true. Robert Bateman, Mark Doyle, Dan Fogelberg, Jimmy Buffett, Ted Danson, Darlene M. Wyland, Robert Wyland, Steve Wyland, Bill Wyland, Tom Wyland, Tom Klingenmeier, Peter M. Paul, Dick Lyday, Micky Zondervan, Angela Eaton, Jennifer Mueller.

I would also like to thank all the people around the world who have worked to protect our ocean friends, this book is dedicated to you.

It is my hope that this book in some small way may make a difference.

NOTICE

This book may not be reproduced in any manner or the pages or artwork applied to any materials listed but not limited to the following:

— Cut, trimmed or sized to alter the existing trim size of the pages.
— Laminated, transferred or applied to any substance, form or surface.
— Carved, molded or formed in any manner in any material.
— Lifted or removed chemically or by any other means, or transferred to produce slides or transparencies.
— Used as promotional aids, premiums, or advertising or for non-profit or educational purposes.
— Engraved, embossed, etched or copied by any means onto any surfaces whether metallic, foil, transparent or translucent.
— Matted or framed with the intent to create other products for sale or re-sale or profit in any manner whatsoever, without express written consent from:

Wyland Studios
c/o Wyland Galleries
2171 Laguna Canyon Road, Laguna Beach, California 92651 U.S.A.

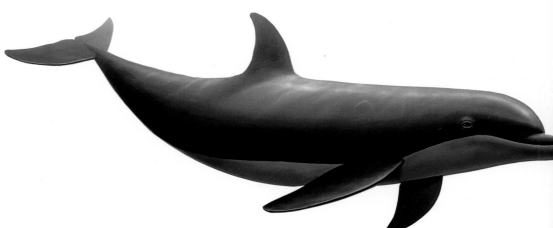

▶ **Hawaii,** Born in Paradise — Oil 36" x 48"

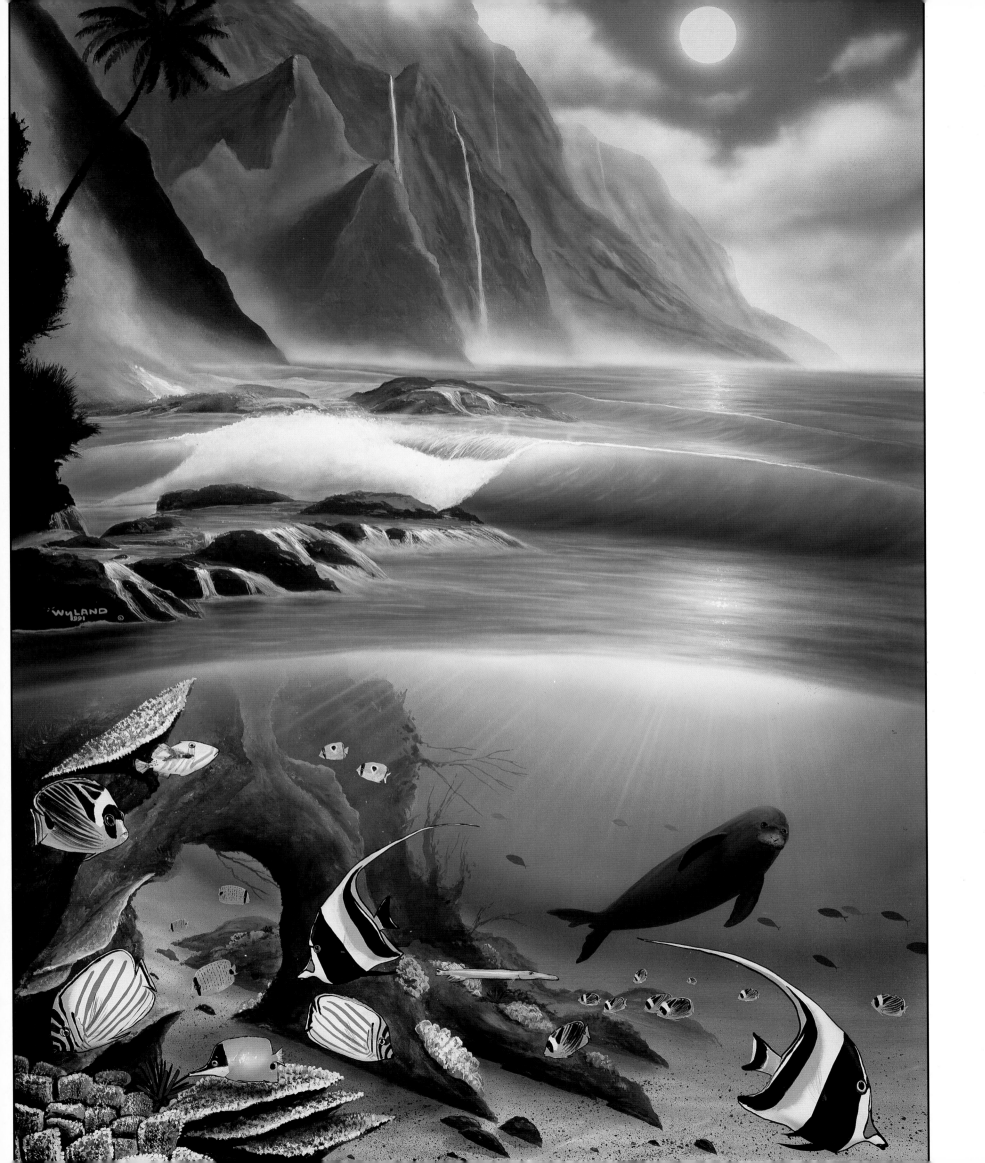

Dedicated to my mother, Darlene Wyland,
who has been the inspiration in my life as an
artist and a proud son. Thank you, Mom.

"To open the covers of Wyland's new book is to journey into a
special world, a world where art and nature exist in a dazzling
synthesis of color, form, and inspiration. Like no one else, Wyland
captures that unique blend of undersea fantasy and natural fact
with a beauty and grace that sets him apart. Like the whales he
paints, Wyland is a huge presence in the world of marine life art."

Chris Newbert
Marine Life Photographer

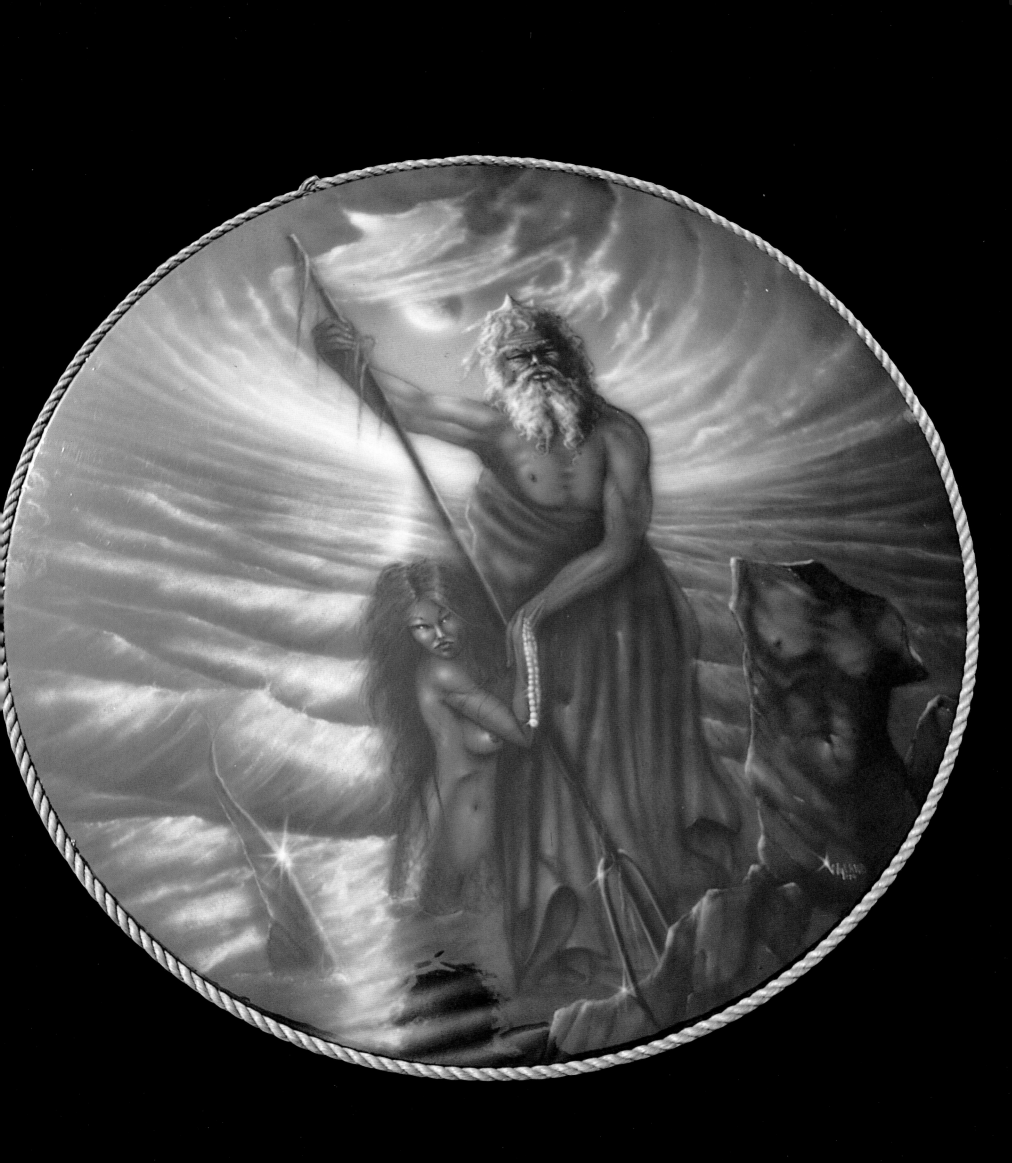

. . . they have traveled through the misty waters in native tribes for 50 million years . . .

▶ ORCA MIST — Oil 36" x 48" ©1990

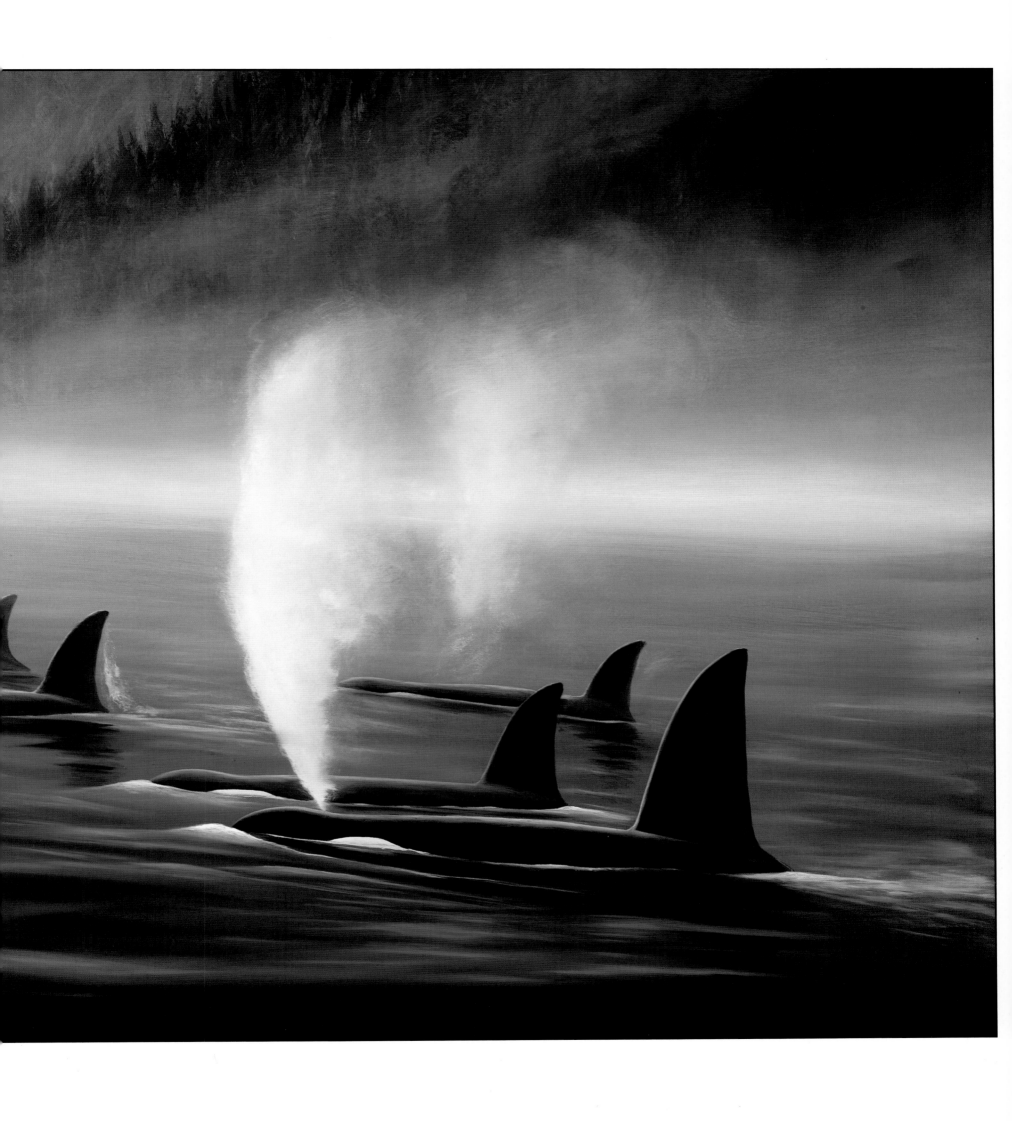

BOB TORRES

C O N T E N T S

INTRODUCTION by Robert Bateman

WORDS by WYLAND

LIMITED EDITIONS

SCULPTURE COLLECTION

12

Photo by Greg O'Loughlin

WYLAND

INTRODUCTION

Robert Bateman

Whales and Wyland, Wyland and Whales. They fit together in a wonderful relationship. Wyland has dedicated his life and his art to the whales, and the whales in turn have received great benefit from Wyland's life and talent.

Wyland has come along in the "nick of time" to bring his message to the world and his help to the whales. This decade and perhaps the next will be the most important for the entire life of the planet, in fact, for life <u>on</u> the planet. Countless thousands of organisms have become extinct in the last half of the 20th century. Luckily there are sustainable populations of some of the most spectacular creatures on earth. However, most of these populations are dangerously low or their habitats are at risk. I include creatures such as the great predators – the bears, wolves and cats, the great primates and, of course, the mammals of the sea.

Everyone knows the saga of the massive whaling industry of the nineteenth century … slaughter on an industrial scale will destroy it and jeopardize our own future. I include industrial logging, industrial fishing and industrial agriculture. New technology seems to only encourage a more frantic scraping of the bottom of the barrel of life.

This was true of the so-called great age of whaling, which lasted for only a few short years. I have visited and painted a vast boneyard at a whaling base in the Antarctic, the last fertile "fishing" grounds of this creature. Sonar, faster ships and more deadly guns threatened to wipe out every species of whales. This was an even greater tragedy because of the high intelligence and social structure of these magnificent beings.

In the last quarter of the 20th century an outcry went up against this murderous slaughter. Books, films, articles and speeches were heard on behalf of the whales. Organizations sprang up and legislation was passed for their protection.

Of all of these efforts none has been more monumental than the work of Wyland. His skill and energy and vision combined to bring whales to our attention on a grand scale. Most of us are not lucky enough to have mingled with whales in their own world. I have seen whales of many species in many oceans, from ships, zodiacs and from land. I have even been lucky enough to see an Orca from our own windows. I have swum with dolphins and sea lions, but never a great whale.

Wyland takes us into their world. He captures the feeling of the many moods of that world, not only the characteristics of the species, but in some cases, particular individuals. We can see them in movies, or in a book, but nothing compares with his life-size murals. They take us there and put us in our place.

As a painter, I am overwhelmed by the scope and ambition of Wyland's work. To me, the physical difficulty increases logarithmically as the size of the painting increases. I find four small paintings easier than one four times as large. My larger ones, which are a tiny fraction of the size of Wyland's work, require constant standing back to look, every few strokes. I cannot comprehend just starting in on a huge wall and being confined to a scaffold. In oils, watercolours or airbrush, Wyland displays deep knowledge and confidence in both his medium and subject matter.

Beyond this is the force of his personality and enthusiasm. His winning ways bring countless people together to literally transform a city landscape. In doing so he transforms the consciousness of all who see his work. We are lucky he exists … so are the whales. One of the onlookers at one of his murals says it all … "Awesome!"

Robert Bateman

. . .Whales are not essential today as a product . . . only a product of beauty worthy of protection . . .

W Y L A N D
The Beginning
A Profile by Mark Doyle

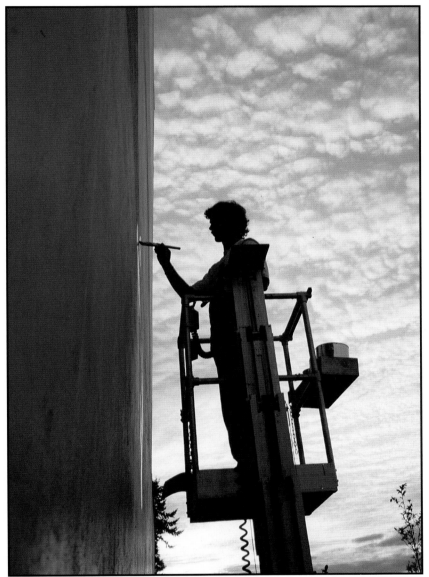

PAINTING AT DUSK

4 YEARS OLD

I
THE BEGINNING

Wyland was born in 1956 in Detroit by mistake. Even at a very early age, he was drawn to the ocean. And he maintains to this day that he should have been born instead on the West Coast, closer to the whales and other marine life he has come to know so well.

"I was born under a water sign, a Cancer," he explains, almost as if that says it all. "The ocean is a very important part of my life, and I actually feel more comfortable in the water than out. I've always enjoyed the experience of water, whether it's a stream, a lake or an ocean."

As a small child, however, Wyland had to wait years before he could even step into a body of water. Born with a severe clubfoot, he underwent 11 major surgeries before the age of seven, and he was continuously hobbled by a corrective cast that prevented his swimming. He remembers frequent trips with his family to Michigan's Cass Lake, where he would watch his brothers and cousins run into the water and play while he had to stand on the shore and watch.

"I used to sit by the shore and paint paintings of what I felt lived beneath the ocean," he says. "To me the lake was an ocean, and I had an ocean of ideas. When the final operation was completed, and the cast finally came off, I ran out into the water as if I'd been reborn. It felt like I belonged there."

The young artist's lively imagination regarding sea creatures, however, had actually begun years earlier — in the form of dinosaurs. Wyland remembers looking in closets and under the kitchen sink for old cans of house paint his mother used for painting the kitchen and bathroom. He only found a few cans of dull greens and beiges, but he managed nonetheless to begin painting on almost anything he could find.

"I started painting my first murals on the back of the headboard on my parents' bed," he says with a smile. "I would slide underneath the bed with the paint and brushes, and I would paint these fantastic land and seascapes of the world of dinosaurs. I was only three years old."

An early start? Indeed. And his passion for drawing and painting never waned. Throughout grade school and junior high, he constantly held either a pencil or a brush in his hand. His grade school teacher immediately recognized his talent and encouraged him to concentrate more heavily on his artwork. The same thing occurred in junior high, where a supportive art teacher named Kay Schwartzberg not only encouraged, but inspired, the intense boy artist to work even harder. Schwartzberg would later transfer to Lamphere High School in Detroit where she continued to work with Wyland. Today, he credits her as being one of the greatest influences on his early development as an artist.

Another early influence was his older brother, Steve. When Wyland was nine, he entered a citywide poster contest to promote a campaign to "Paint up, Fix up and Clean up Detroit." For weeks he ran around the house telling his mother he was going to win the contest. And sure enough, a month later, his mother received a call from the mayor's office asking for her son to appear the next Sunday at city hall to accept his award as the winner.

Wyland's mother was ecstatic, but a little confused. The voice on the telephone had asked her to bring Steve Wyland to accept the award, not her artistic young son, Robert. (Wyland was born Robert Wyland, but has since dropped the first name. At his request, everyone now refers to him only as Wyland.) Evidently, without anyone else knowing, the 11-year-old Steve Wyland also had entered the contest and, to everyone's complete surprise, won. His younger brother, Robert, was flabbergasted.

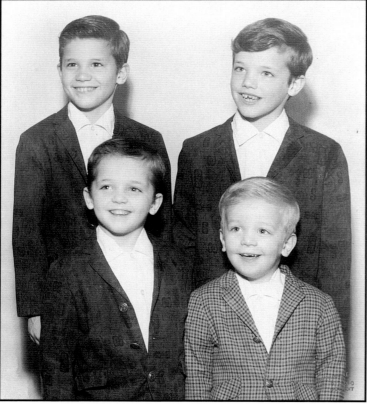

STEVE, WYLAND, BILL, TOM

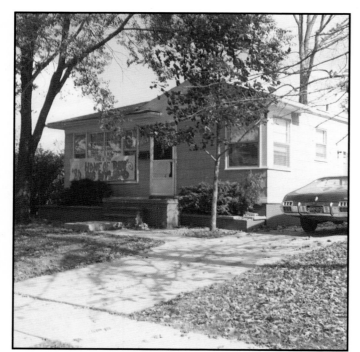

HOME — MADISON HEIGHTS, MICHIGAN

"It was an incredible thing I had to go through," Wyland points out ruefully, still stung by the episode. Today, in his studio, he has an old photograph of him knocking the mayor's crown off his brother's head. "But it really strengthened me," he hastens to add. "I decided right then and there that I was going to have to work very hard to be a good artist."

And work hard he did. Every day, 14 hours at a stretch, and often through the night, he locked himself in his room — a makeshift studio — and slaved over his art projects. Wyland's parents, both auto workers in Detroit, divorced when he was four years old, and his mother was saddled with raising four spirited boys by herself.

Besides older brother Steve, Wyland and his two younger brothers, Bill and Tom, presented their mom with hungry mouths to feed.

Wyland remembers that before settling into a home in Madison Heights, Michigan, the family relocated often in Detroit — 13 times in one year alone. He had seen poverty creep close to his family's door, and he was determined to use his art to work himself away from it.

"By the time I was in the 10th grade, I was a hardcore artist," he admits. "Every day my art teacher, Mrs. Payne, would tell me to leave when school was over because she had to lock up the room. I would tell her 'OK,' and then the janitors, who really liked the work I was doing, would let me back in the room.

"One time I worked all night long, and when Mrs. Payne came in the next morning, she startled me by asking why I had come to school so early. I decided that the janitors may have known more about art than my teacher."

One summer, Wyland did take a break from his brushes. When he was 14, his mother drove him and his brothers to California to visit an aunt. It was the first time he had seen the Pacific Ocean, and the experience left him absolutely awestruck. Not only was he suddenly able to gaze out onto the vast expanse of ocean he had dreamed of for so many years, he also was fortunate enough to be in the right place at the right time to see his first whale. In actuality, he witnessed the annual migration of the California grey whales on their way down to the warm lagoons of Mexico.

"This early sighting of whales had an enormous impact on my life, and on my future," Wyland points out. "When I went back to Michigan, I began painting and studying whales and dolphins and fish and the sea. I just started painting canvas after canvas."

The television programs of Jacques Cousteau, which began receiving major network air time in the '70s, also were major influences on the young artist. As he began watching the Cousteau broadcasts, he became more and more fascinated with the ocean and started digging into libraries to learn all he could about whales and dolphins. Then, when he learned of the whales' alarming plight against whalers and the fishing threat to dolphins, he decided he wanted to help. He wanted to get involved somehow in the movement to save the whales.

Wyland's powerful new inspiration injected him with renewed vigor and energy. In addition to the countless hours he spent with his art, he spent months researching whales and other marine life. He also found time to excel in sports, despite the handicap he had overcome as a small boy. He was a starting corner-back and kicker for his high school football team, and a captain on the basketball team as well. He also served as captain of the school's track team, setting school records in the high jump and the 440-yard relay.

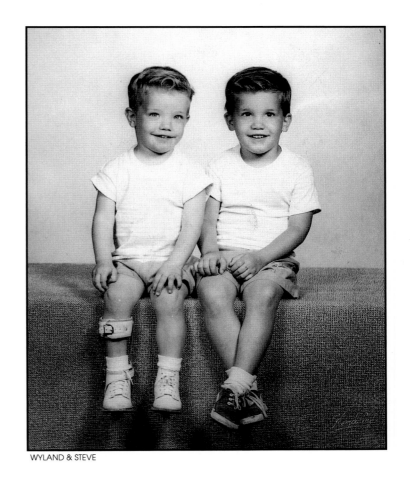
WYLAND & STEVE

WYLAND BEFORE KNOCKING CROWN OFF STEVE'S HEAD

6TH GRADE

PENCIL DRAWING — JIMMY HENDRIX — 15 YEARS OLD

But the young painter was not destined for sports. Although his mother strongly supported his dedication to art, she decided one summer to send her 16-year-old son out to learn about the working world by way of a minimum-wage job. After several weeks, the boy finally landed a $2-an-hour job from the unemployment bureau, whereupon he ended up getting fired within hours for failing to keep his mind on his work. Several similar situations quickly ensued, and the youth decided it was impossible for his artistic soul to concentrate 10 hours a day on the menial tasks demanded of him by a step-on-the-pedal, push-the-button assembly line.

The unlikely wage earner learned a lesson that summer, however. He says the series of ill-fated jobs, brief as they were, "really put it on the line" that he needed to work even harder as an artist if he was to avoid a dull, vapid future in the auto industry. "I literally locked myself in my basement studio and painted from dawn to dusk after that," he recalls. "By the end of the summer, I had developed a very good portfolio."

Wyland's mother, much to her son's relief, finally relented on the subject of traditional employment. Instead, she knocked on his bedroom door one evening and showed him an article about one of the top airbrush muralists in the country, a fellow named Dennis Poosch, better known as "Shrunken Head."

ART CLASS — 9TH GRADE

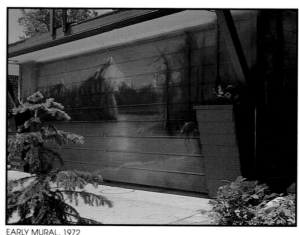

EARLY MURAL, 1972

KAY SCHWARTZBERG, ART TEACHER

Well, this might be something I can do, thought Wyland. So he dropped in on the airbrush master at his custom van shop in Detroit. Shrunken Head evidently saw something he liked in Wyland because he took the teenager on as an apprentice and taught him the finer points of using an airbrush. Wyland says the 40-year-old muralist appreciated his passion and willingness to work hard. The two also hit it off artistically — they both loved the work of Salvadore Dali.

It was during this same period that Wyland began painting his first murals. Already recognized as the best artist in high school, he had completed paintings of the school's mascot, a ram, on several school landmarks — the main lobby, the side of the football stadium, the center of the basketball court. But his first mural, for which he was paid $300, was commissioned by a teacher who owned a local Dairy Queen restaurant.

"I created an Alps scene in three days," he remembers, adding that the Dairy Queen's owner expected the project to take two months. "It made everyone hungry for ice cream, so I have to admit it had some commercial appeal. It also made everyone feel differently about the building."

Wyland's second mural created even more of a local sensation. Now that he was an official "mural painter," he accepted an offer to paint a cow on the side of a meat market. The novelty of a giant heifer staring down the establishment's beef-eating customers drew the attention of the local media, and Wyland began to make a name for himself in his community.

His work suddenly began to appear on his friends' vans and on numerous garages in his neighborhood. But he knew this was just practice. His next stop would be art school. "I finally got a grant to go the Center for Creative Studies in Detroit," he recalls. "I got half a grant for being poor, and half a grant on scholarship."

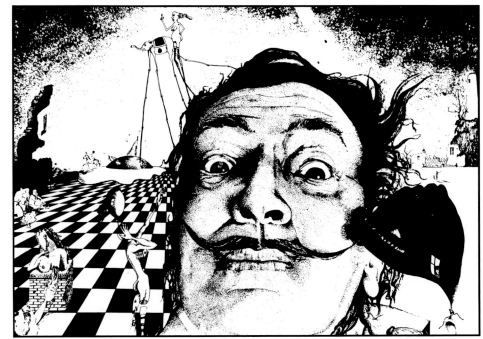

DALI'S WORLD, PEN AND INK DRAWING—14 YEARS OLD

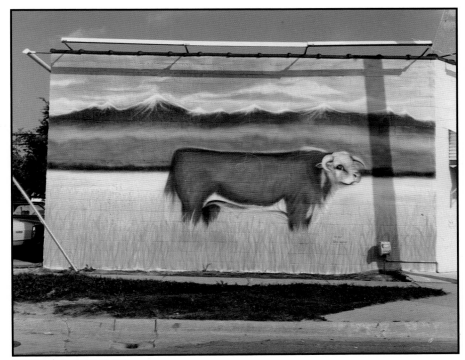

HEIFER MURAL—17 YEARS OLD

DALI, CHARCOAL—16 YEARS OLD

24

WYLAND, #80 FRONT ROW

VARSITY BASKETBALL, 1ST ROW #44

EARLY MURAL, "RAM" HIGH SCHOOL LOBBY

Continuing to paint murals to help fund his studies, Wyland attended the renowned center for two years, packing in as many courses as he could. "I think I crammed six years of art school into one," he quips. Majoring in sculpture, he attended classes well into the evening and formed close relationships with several of his professors. "Bill Girrard, my painting teacher, was a tremendous influence in my development," Wyland notes. "And so was Russell Keeter, the best contemporary artist at the school, and Jay Holland, who taught me sculpture."

After two years, Wyland sat down with the three artists and told them he was going to move to California and "either make it or break it." They each told him his style was definitely "West Coast," and that he belonged in California.

Wyland wanted to be in the forefront of that vibrant, innovative "California style," a desire that may have been influenced by his astrological sign. But it was more likely the result of his keen interest in the ocean and the Los Angeles art movement. "My favorite artists — those who have influenced me most — are God, Salvadore Dali, Andrew Wyeth, Robert Bateman, Michelangelo, Rodin, Diego Rivera, Jon Pitre, Frank Frazetta and Kent Twichel," he says. "I'm not extreme about religion, but all one has to do is look at a sunset to see who the ultimate artist is. He is the major force in my work."

In 1977, Wyland made his pilgrimage to the West Coast, taking a small apartment in Laguna Beach, where he had once beheld a group of grey whales making their way south. He paid $100 a month to sleep, paint and share a bathroom in the tiny flat, and he was completely exhilarated by the experience. He was an artist, embarking on a professional career in which he would commit himself to making a powerful statement with his work.

Today, at 35, Wyland has come full circle from where he began. Internationally acclaimed for his famous Whaling Walls, some of his paintings now command over $150,000 each. His string of art galleries in Hawaii, California and Oregon have provided lucrative retail outlets for his work. And, with his mother managing the Laguna Beach galleries, and two of his brothers running the other eight, the little boy who used to lock himself in his room to paint is taking very good care of his family.

SCHOOL RECORD — HIGH JUMP

DENNIS POOSCH, AIRBRUSH MASTER

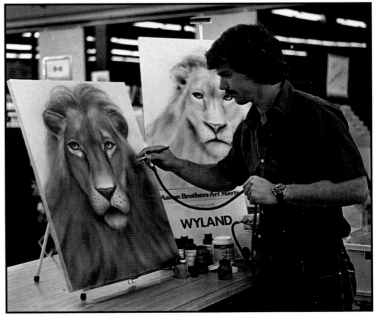
AIRBRUSH DEMO

CENTER FOR CREATIVE STUDIES, TEACHER BILL GIRRARD

CENTER FOR CREATIVE STUDIES, COLLEGE OF ART AND DESIGN — DETROIT

DAD

A confirmed bachelor, he makes his home and studio on the beautiful North Shore of Oahu, where he lives most of the year in a spacious house on the beach. He no longer has to imagine what is beneath the ocean because he can now look off his lanai and see many of his marine subjects playing in the surf.

Perhaps one of the most telling examples of how Wyland has closed the circle in his life occurred in 1986 in New York City. A limited edition print of his Aloha Liberty painting had raised over $200,000 to help the restoration of the Statue of Liberty. The festivities placed Wyland on stage with automobile mogul Lee Iaccoca, chairman of the restoration effort. The artist remembers talking with Iaccoca and taking great pride in telling the famous executive that his mother had once worked on the assembly line for Chrysler. Wyland suddenly realized during the conversation that he, the son of blue-collar auto workers, was receiving the adulation of a man who had been, and still is, a virtual legend in Detroit.

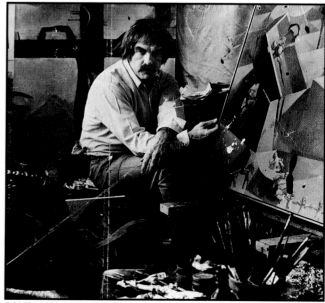

CCS TEACHER, RUSSELL KEETER

It has been said repeatedly, both by casual acquaintances and by those who really know him, that Wyland's most unique quality — aside from his gift as an artist — is his ability to remain himself. Most would agree he is a down-to-earth, proverbial "nice guy," unspoiled by phenomenal success. But to him, it's simply a matter of keeping his life in perspective.

"For an artist, the idea of success is having a roof over your head, some brushes and paint, and being left alone to do your art," he explains. "I have a very high appreciation of the ocean and what's in it. And to be able to experience that, and then go into your studio with those ideas and share that imagery with so many people... it's just incredible."

MOM

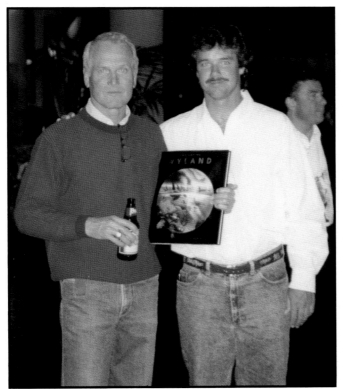

WITH PAUL NEWMAN

LIBERTY WEEKEND WITH LEE IACCOCA, NEW YORK 1986

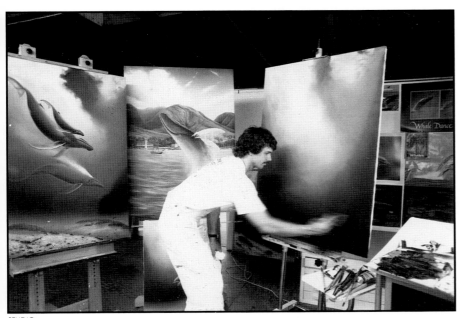

STUDIO

TOM, BILL, MOM, WYLAND, STEVE

. . . The 20th Century has seen the depletion of many species, some may never recover . . .

II
ENVIRONMENTAL ARTIST

GREY WHALES

. . . It is my hope that this book in some small way may
make a difference . . .

ARTIST RICHARD ELLIS AT WYLAND MURAL

TWO WORLDS, 36" x 48" ACRYLIC ©1977

When Wyland started painting whales and dolphins in the early '70s, the term "environmental artist" didn't exist. The whale, by virtue of its being hunted to near extinction, had become an international symbol for wildlife preservation. But to Wyland, these magnificent leviathans represented even more than that — they were the icons for an entire environmental consciousness, symbols for saving the earth's oceans and everything that lived beneath them.

"I first started painting whales and dolphins because I wanted to show their grace and beauty and maybe do something to help save them," the artist says. "But I've personally grown to see a much larger picture — to save the whales is great… but if we can't save the oceans, we're not going to be able to save the whales, and we're not going to be able to save ourselves."

Wyland reflects on his early years as an artist, watching the exploits of Jacques Cousteau on television and studying everything he could get his hands on that dealt with whales and dolphins. He also remembers reading about a grassroots group of volunteers called Greenpeace, which would eventually grow into an international organization and bring widespread attention to a host of critical environmental problems.

SAILING WITH DENNIS CONNER ON STARS AND STRIPES

"Greenpeace's efforts were to go out in small Zodiacs and put themselves between the harpoons and the whales," Wyland says of the organization. "My method was, and still is, to draw attention to the delicate beauty of these creatures by painting them and sharing my art with others.

"In fact, I learned about the environment by painting it. When I painted the oceans and the creatures, I became closer to them and understood not only their anatomy, but their spirit."

Wyland admits, however, that in those days his favorite subjects were not very popular when framed on canvas. He says people found them to be even more peculiar than dinosaurs, his first love. "I remember thinking about dinosaurs being extinct, and I was afraid the same thing was going to happen to the whales," he says. "I wondered what I could do to change that, and all I could think of was to learn more."

Wyland painted on and did, in fact, learn more about his subjects. His intense research taught him a great deal about the ocean in general, which immediately began to show in his work. In addition to painting whales, he also began to capture the way they related to their environment. His work soon evolved from beautiful pictures to paintings that told stories about whales and dolphins and the different ways they behaved in their underwater habitat.

PAINTING STONE LITHOGRAPH

WITH TED DANSON — AMERICAN OCEANS CAMPAIGN

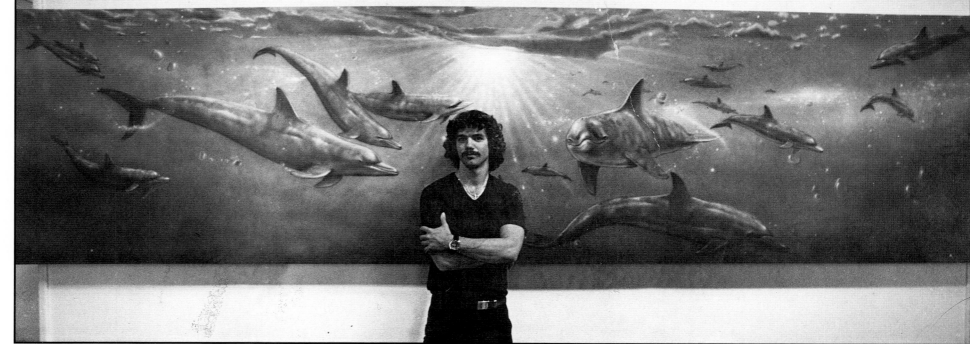

DOLPHIN HEAVEN — 3½' x 17' LONG

WITH FRIEND DAN FOGELBERG

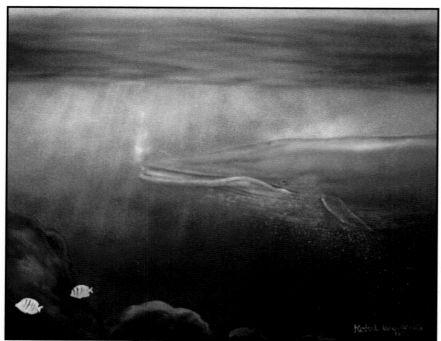

EARLY PAINTING, BLUE WHALE ©1973 — ABOVE AND BELOW

At first, he says, he couldn't even give the paintings away. They were so unique there wasn't a market for them. At that time, there were only a few artists who were painting whales. One was Richard Ellis, whom Wyland would eventually meet while painting a mural at the Orange County Marine Institute. Another was Larry Foster, an illustrator for National Geographic magazine who Wyland says was the "best in the world" at illustrating whales and dolphins.

But Wyland was undaunted. He found that the more he could tell stories in his paintings, the more impact they seemed to have. Eventually his work began to sell. Also, society had begun to be more aware of the environment and was becoming more interested in subjects like endangered marine animals.

"As people's appreciation of the environment grew, so did my art, and so did my own appreciation of the environment," Wyland points out. "Each month, and each year, I tried to do different things with my art, and we all sort of grew together. It was nice, really nice. Hopefully, I was adding to the appreciation of these marine animals."

One thing for certain was that Wyland was adding to the size of his canvasses. As an artist, he had experimented with all mediums — oil, watercolor, acrylic, pen and ink, stone lithography — and he had drawn and painted in several styles, including abstract and surrealistic. But his whales demanded realism. And the more realistic he created his subjects, the more he realized that he needed to paint them in their true size.

Having already completed a number of "non-whale" murals along the California Coast, such as the Sea Captain in Dana Point, Wyland understood the impact a dramatic mural could have on the public. Why not, he thought, combine his talent and knowledge of whales with the dynamic power of a mural? It was the perfect solution to his problem of painting life-size whales and dolphins.

"This was where the idea for the Whaling Walls came from," he says. "I was an experienced artist, and I was an experienced muralist. I felt that if I could paint these huge walls, they would have a tremendous impact, and maybe I could do something that could help the whales."

Wyland's first task was to find an appropriate wall. He needed a surface that was the right shape, of course, but also one that would be seen by a lot of people. After driving up and down the Pacific Coast Highway searching for the perfect wall, he finally found it in 1978 in Laguna Beach. Three years later, the young artist would be allowed to complete his first Whaling Wall — an enormous life-size mural of a California grey whale and her calf making their trek from the Bering Sea to Baja Mexico.

WYLAND AND FRIEND TOM KLINGENMEIER

WITH FRIEND LINDA BLAIR

ARTIST WITH AUTO SPRAY GUN

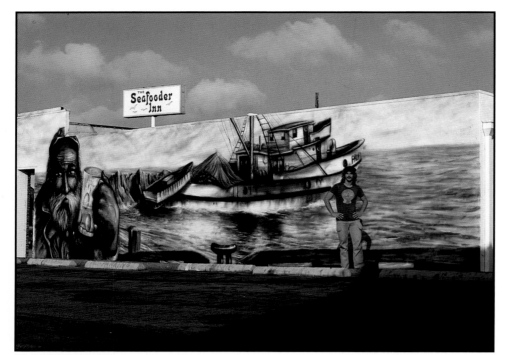

SEA CAPTAIN MURAL 1977

The project took three years because of what Wyland calls "red tape and politics." He remembers going to a meeting with the North Laguna Community Association that was supposed to be in favor of the wall. Instead, he says, the meeting turned out to a be forum for a group of people who were against the wall being painted. This opposition ended up delaying the mural for years and costing Wyland over $10,000 of his own money. If it weren't for the loyal support of a local newspaper reporter, he might have abandoned the wall and perhaps the idea itself.

"I met a writer named Tom Klingenmeier who was covering that first meeting for the local paper," Wyland recalls. "He came up to me after the meeting and said, 'This is fantastic...I can't believe anybody would be against this.'"

February 23, '85

Kahala Hilton

HONOLULU, HAWAII

Coming into Honolulu from the airport the other day I bolted up in my seat at the sight of this huge blue wall. I commanded my driver to circle over so this unexpected mirage could be viewed in its entirety.

Imagine the excitement when I discovered immense life size whales swirling and zipping about.

What a tremendous imaginative undertaking, so in keeping with the environment, what great subject matter and how capably and beautifully this talented daring young artist has so boldly tied into this awesome task.

Bravo! It will be a tourist attraction, residents will love it, lovers of sea life will identify with it and children for generations to come will experience it with wide eyes.

Congratulations Wyland.

LeRoy Neiman

LETTER FROM LEROY NEIMAN

"I was impressed with you and your work before but I am even more impressed now. Even though you show how it's done, I still can't imagine working that large and doing it so fast AND doing it very well."
Bob Bateman, Wild Life Artist

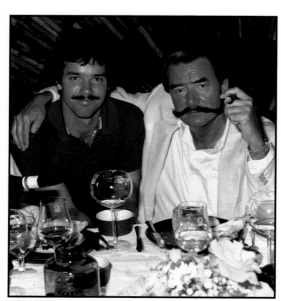

WITH ARTIST LEROY NEIMAN 1985

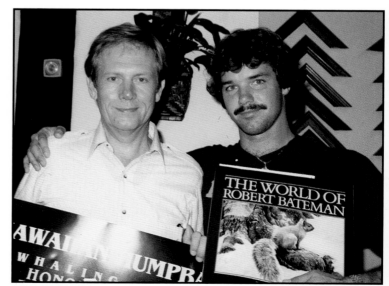

WITH ROBERT BATEMAN

For three years, Klingenmeier stood by Wyland and defended his idea to paint the mural, and today he's one of the artist's best friends and strongest supporters. "When I was down and frustrated with the situation, Tom was the one person who believed in me and encouraged me to continue," Wyland says. "He's like a brother."

The city of Laguna Beach finally embraced the mural, and it was completed in 1981 on Wyland's 25th birthday. The public's response was phenomenal throughout the actual painting of the wall, as was the media coverage. Wyland himself was so elated that he decided the mural would be the first of 100 Whaling Walls he would endeavor to paint throughout the world. In fact, he returned in 1987 to paint another wall for the city called Laguna Coast, the 12th installment in his ambitious project.

Today, Wyland claims that Laguna Beach, where he still keeps a house and his summer studio, will always remain one of his homes. He credits the environmental nature of the city and its people as a significant influence in his development as an artist. And, after 12 years, he still has a booth each year in the community's well-known Sawdust Art Festival.

"The Sawdust Art Festival allowed me to grow as an artist and display my work," he says. "It also allowed me the opportunity to publish prints of my paintings and start developing a list of collectors. I'll always be indebted to this festival and what it meant to me."

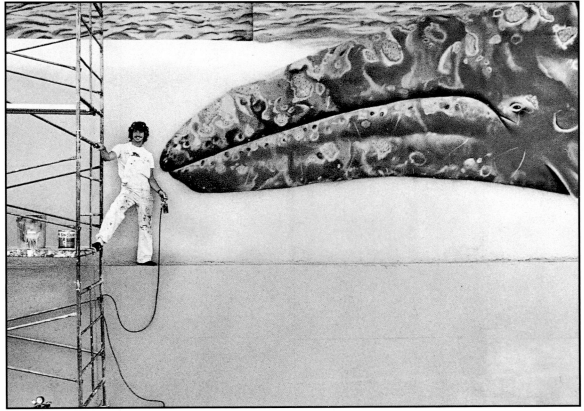

DETAIL — FIRST WHALING WALL MURAL, LAGUNA BEACH 1981

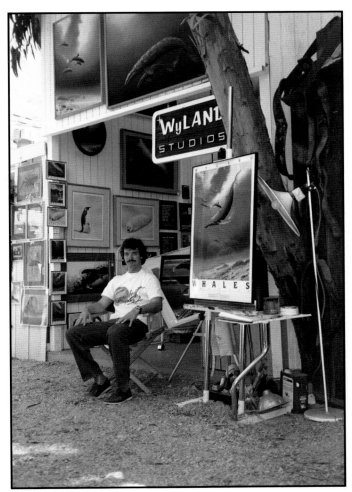

SAWDUST FESTIVAL BOOTH

FELLOW MICHIGAN ARTIST, GLENN FREY/THE EAGLES

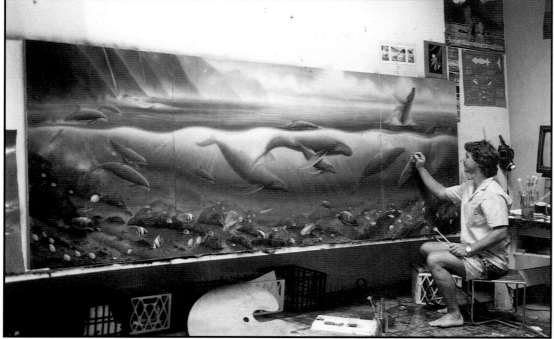

PAINTING IN LAGUNA BEACH STUDIO

DIVING THE CARIBBEAN

WYLAND TOUCHING HIS FIRST FRIENDLY GREY WHALE, SAN IGNACIO LAGOON,

Today, Wyland has approximately 25,000 collectors in over 30 countries and all 50 states who own his original work and limited edition prints. His Whaling Walls have drawn international attention to both himself and to his goal of saving the oceans, and his work has been collected by the likes of Robert Redford, Dan Fogelberg, Jimmy Buffet, Prince Charles, Ronald Reagan and Lee Iaccoca.

He has other celebrity supporters as well, including American Oceans Campaign founder Ted Danson. Other friends who share the artist's concern for the environment include singers Jimmy Buffet and Glenn Frey, each of whom has performed dedication ceremonies for his Whaling Walls.

Wyland also has been a long-time friend of actress Linda Blair. The two have dived together for years, and Wyland considers her to be an effective environmental spokesperson. Perhaps one of the most inspirational people in Wyland's career, however, has been singer Dan Fogelberg. Wyland often paints to Fogelberg's music, and each of the two men considers himself to be the other's greatest fan.

Wyland's fan club also includes other painters. Renowned wildlife artist Robert Bateman, whom Wyland reveres and calls the "Godfather of the wildlife art movement," has become a good personal friend and admirer. And the famous Leroy Neiman, who, upon viewing Wyland's gigantic Whaling Wall in Waikiki, wrote: "Bravo! It will be a tourist attraction, residents will love it, lovers of the sea will identify with it and children for generations to come will experience it with wide eyes."

As Wyland's art gained notoriety in the '80s, so did its quality. His financial success afforded him the opportunity to dive all over the world and get closer to his subjects. As a result, his whales, dolphins and seals began to take on personalities and moods that engaged the viewers of his work more completely. Suddenly, people started looking a little closer at the animals in the paintings — especially at their eyes. For the first time in their lives, millions of people were exposed to the true nature of these beings.

"To be able to swim with whales and look into their eyes... is an honor," Wyland explains. "They're so incredibly intelligent and just as spiritual as we are, maybe even more so.

"For me, the eyes are the focal point of my work. We have to be able to look into an animal's eyes if we want to look into its soul, and that's what I try to achieve with my work. I try to capture the spirit of the creature. I feel that if people see the beauty in nature, they will work to preserve it — before it's too late."

ANOTHER DAY AT THE OFFICE

HOME AND STUDIO, NORTH SHORE OAHU, HAWAII

TOM SELLECK, HONOLULU.

. . . As a whale artist I must portray not only the great whales but also the great spirit they possess . . .

PAINTINGS
OILS • WATER COLORS

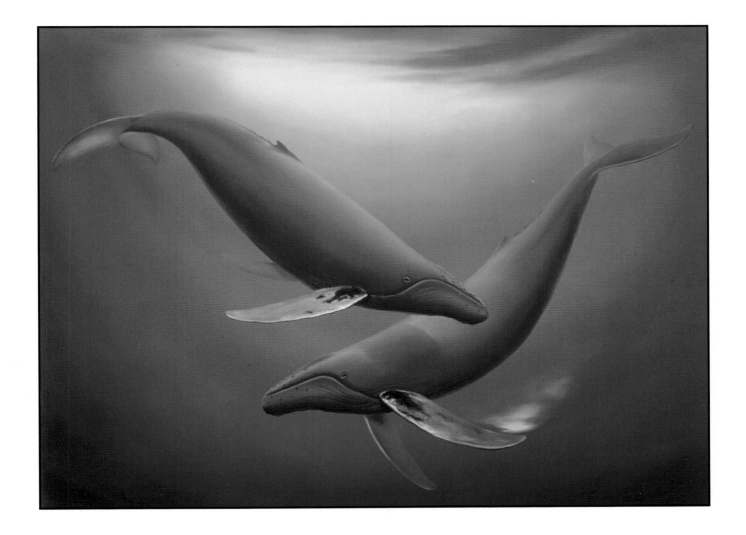

▲ Ocean Encounter — Oil 48" x 60" ©1986

Children Of The Sea

In this painting, I tried to capture the warm intimacy that exists between Pacific bottlenose dolphins, as well as the fantastic ocean environment in which they live.

This is one of my early works, and I'd have to say it's probably my favorite. I sold it in 1983 at the Sawdust Festival in Laguna, then bought it back in 1990 for my own collection. Children of the Sea to me is important in its meaning, and I feel it captures forever the spirit of our ocean friends.

Once I bought the painting back, I dropped everything I was doing and set aside time to sculpt it in bronze. I had always seen the painting three-dimensional, and when I actually began to translate it into sculpture, the impact was tremendous!

When people ask me how long it took to finish the sculpture, I say it took me seven years and five weeks — seven years to think about it and five weeks to physically create the piece. The result was very satisfying, though, and this painting inspired me to begin sculpting many of my earlier works.

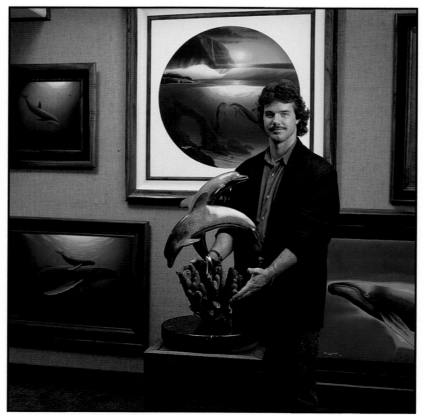

ARTIST WITH FIRST BRONZED SCULPTURE

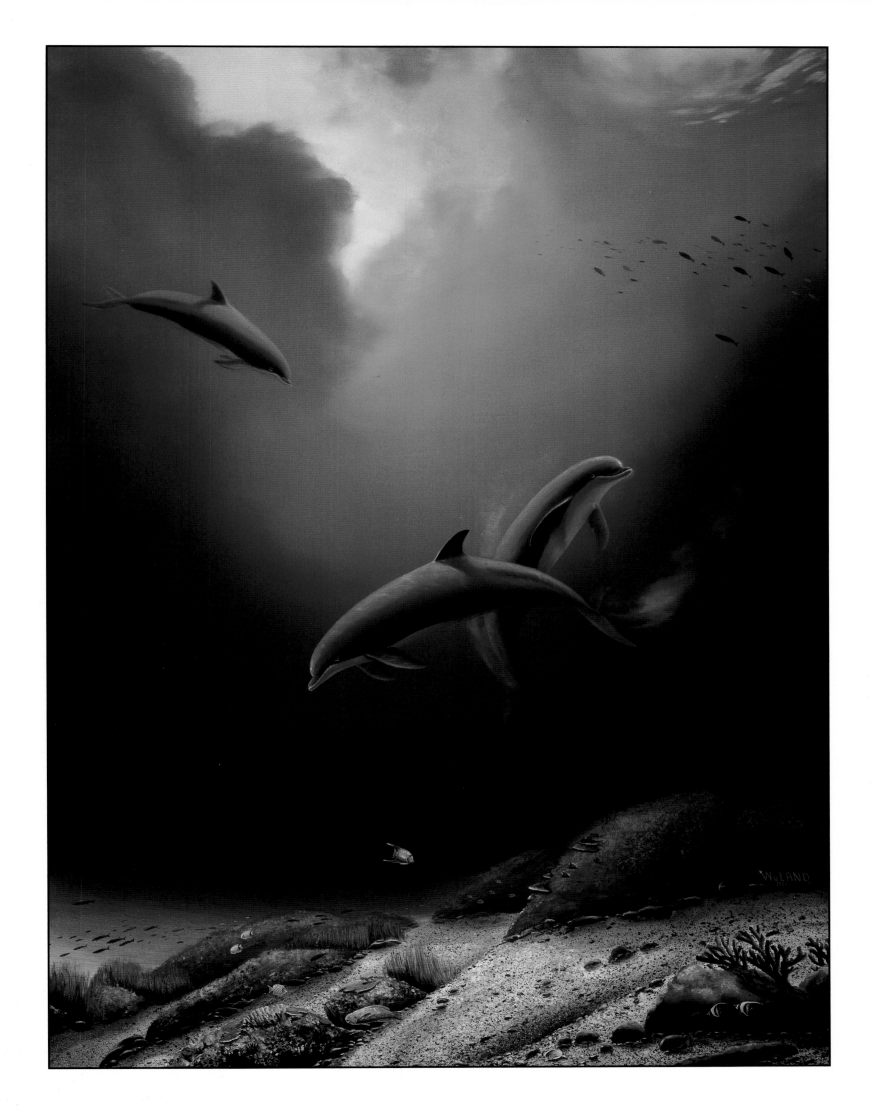

dren of the Sea — Oil 30" x 40" ©1983 — Collection of the Artist

Maui Moon

I first visited the island of Maui in 1980 to study the humpback whales in their own environment. The warm waters off Maui were, and still are, the winter home of the humpbacks. Each year they return to these waters to mate and give birth to their young.

Maui Moon depicts the historic whaling days of Lahaina, Maui, and its two worlds both above and below the ocean. I would come to spend many years on small boats studying the whales in their winter home. And I remember thinking continuously about the relationship between land and sea, man and whales.

I eventually made Lahaina my home for several years, painting and diving with the humpbacks.

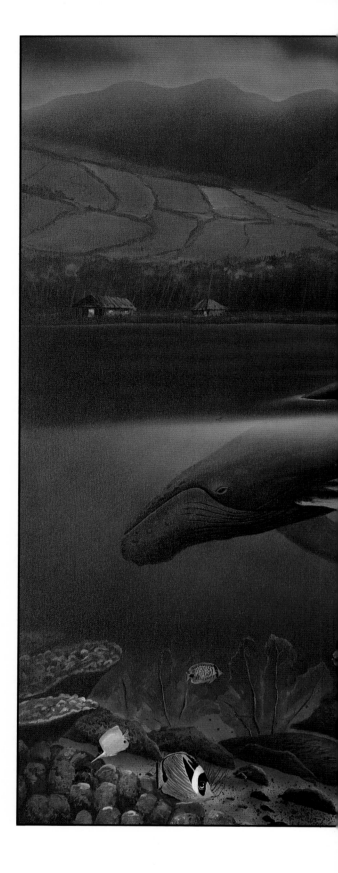

Dear Wyland,

In the early 1980's we met a young and talented artist who shared our concern for the great whales of our planet. Little did we know then, that this artist's zeal and compassion for our brothers the whales, would make such an impact on how we humans see the world in which we live. Through his work, and in particular, his incredible mastery of large, or rather "huge" murals, has he been able to strike our collective consciousness with the truth of knowledge. As we work on the ocean day in and day out, trying to better understand the humpback whale and their critical needs, it is gratifying to know that there is someone out there who has captured the spirit of the whales, portrayed them at "life size" so that all of us might share their magnificence, and work so diligently at educating "man-kind" to the wonder of life we share with all living things. We are pleased to say thank you ("mahalo") for your good will ("kokua") dear friend, Wyland. Thank you for your help, thank you for your talent, and thank you for the "whales"!

Mark J. Ferrari

Mark J. Ferrari

Debbie Glockner-Ferrari

Deborah Glockner-Ferrari

LAHAINA

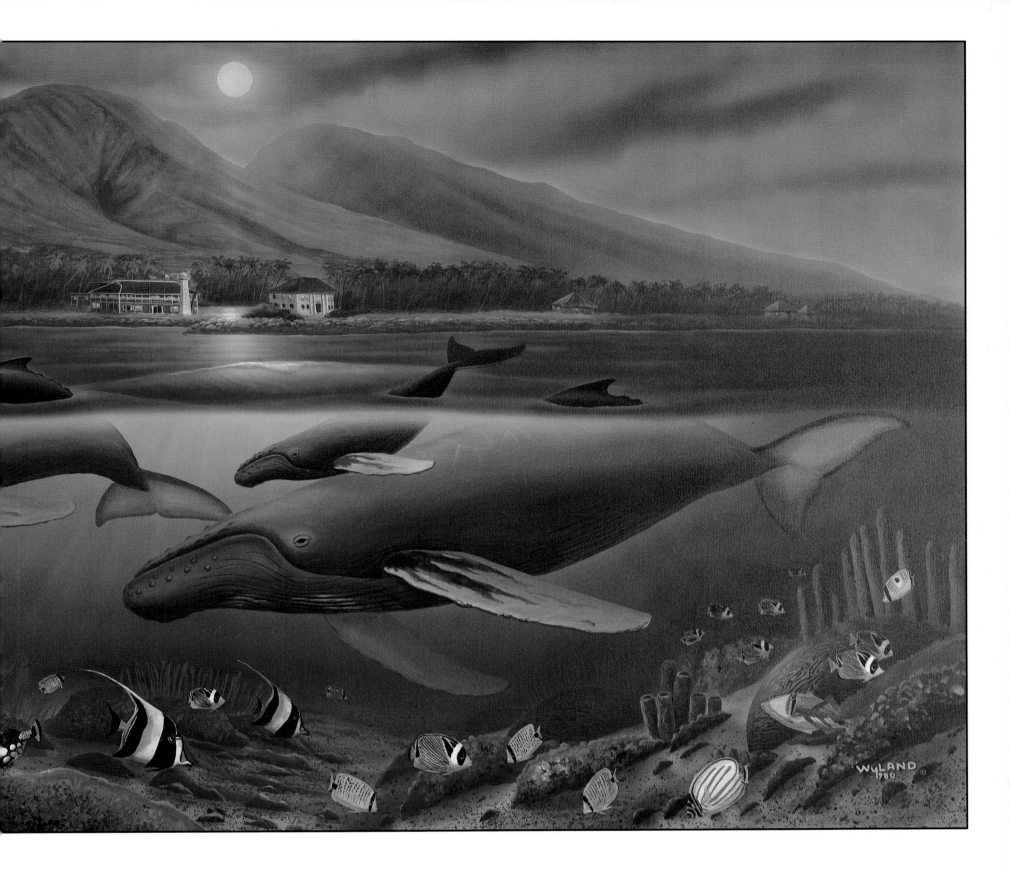

. . . Anyone who has had the pleasure of seeing a Whale is
much better because of it . . .

▲ "Maui Moon" — Oil 36" x 60" ©1980

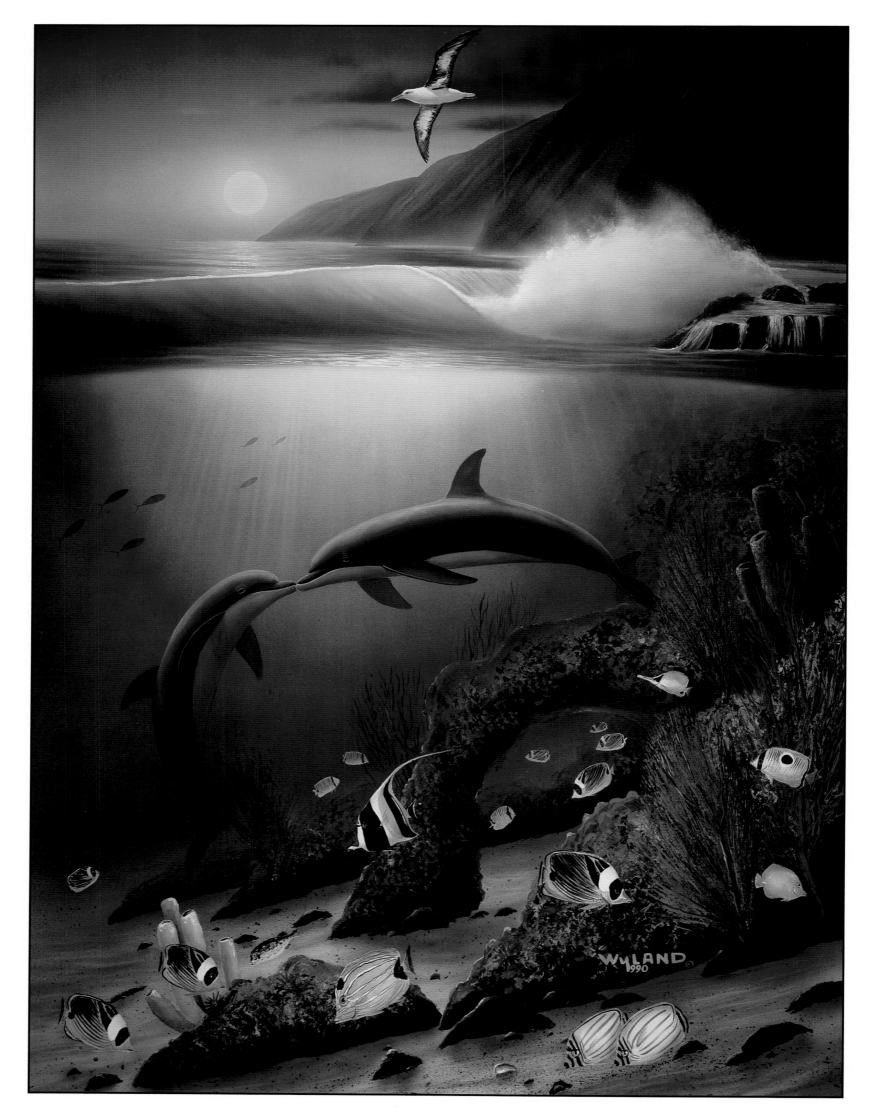

▲ **Kissing Dolphins** — Oil 36" x 48" ©1990

Idol Affair

Idol Affair reflects the grace, beauty and delicate balance between two Moorish idols swimming in unison through a montage of underwater colors. For me, watercolor is the perfect medium for portraying undersea life. When I paint, I work very "wet," and nothing could be more natural.

Kissing Dolphins

The obvious affection between dolphins is continuous — they appear to spend their entire lives playing, eating and just having fun. Kissing Dolphins, a tribute to that affection, reflects romantic encounters between partners. It's said that dolphins mate 365 days a year just for the pleasure. I've seen them kissing many times, and they seem to enjoy a lot of touching.

The bird in the painting is an albatross named Fred. Fred often visits my home on the North Shore of Oahu, flying by at sunset with his mate Ethel.

Underwater Color Dolphins

The watercolor technique I discovered while painting this mother dolphin and her calf developed quite naturally and by accident. Having applied too much water to the painting, I was forced to pick up the entire sheet of 1,160-pound arches paper and allow the excess paint to spill off the edge.

After my brother, Steve, spent several days mopping up the blue watercolor from my studio floor, he persuaded me to allow him to add rain gutters to the bottom of the tables to catch the excess paint. This early mishap turned into my trademark for original watercolor paintings.

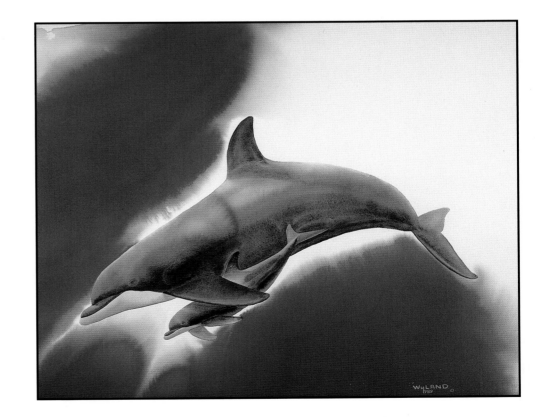

▲ Idol Affair — Watercolor 20" x 29-1/2" ©1990

▲ Underwatercolor Dolphins — Watercolor 29-1/2" x 40" ©1990

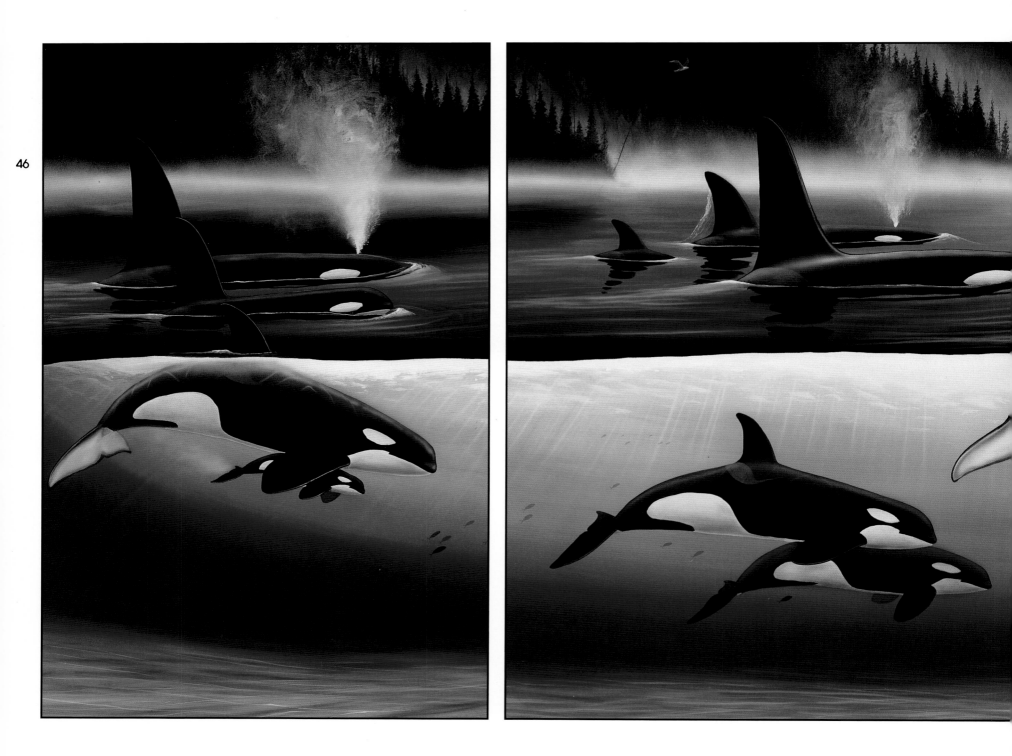

ORCA PORTRAIT

Northern Mist

I have had the great fortune and pleasure of spending many years studying the orca whales off Vancouver Island. The misty cool waters are home to many families, or pods, of killer whales. These pods consist of many generations of family members.

The dominant male is identified by his huge dorsal fin, which sometimes reaches six feet in height. Northern Mist depicts a pod of 16 orcas traveling in harmony under a hazy morning light, with only man to fear.

▲ **Northern Mist** — Oil 4 Feet x 12 Feet (Triptych) ©1991

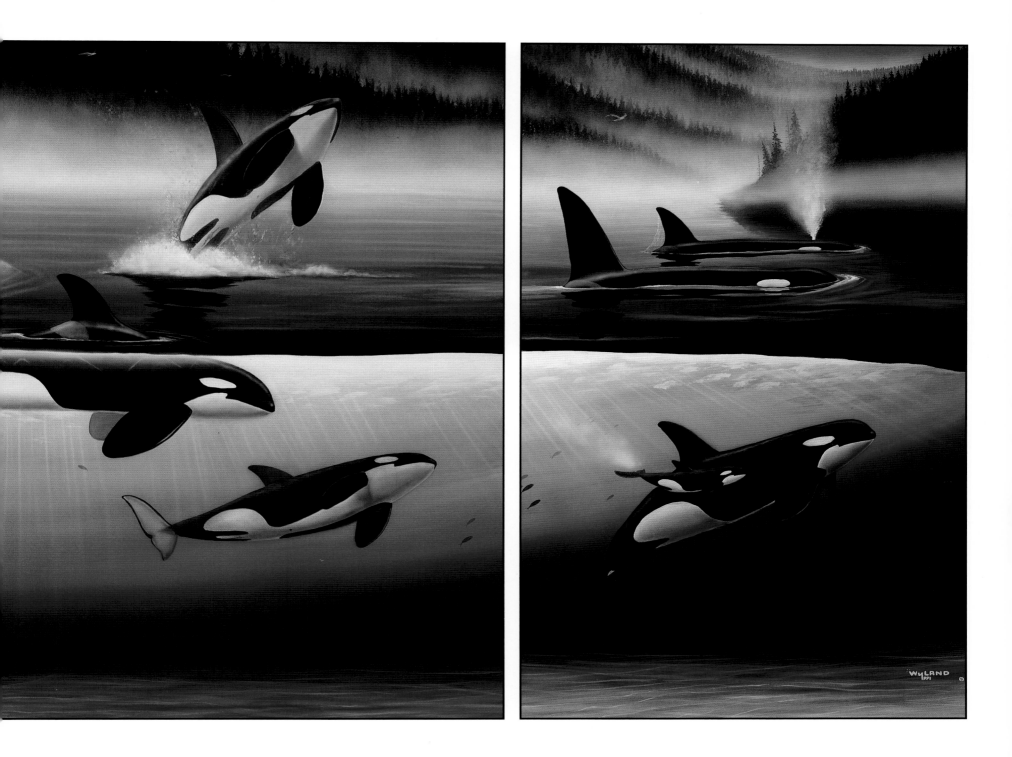

. . Whales speak to each other through hundreds of miles of vast oceans . . .

ORCA EXPEDITION, IN PREPARATION FOR PAINTING

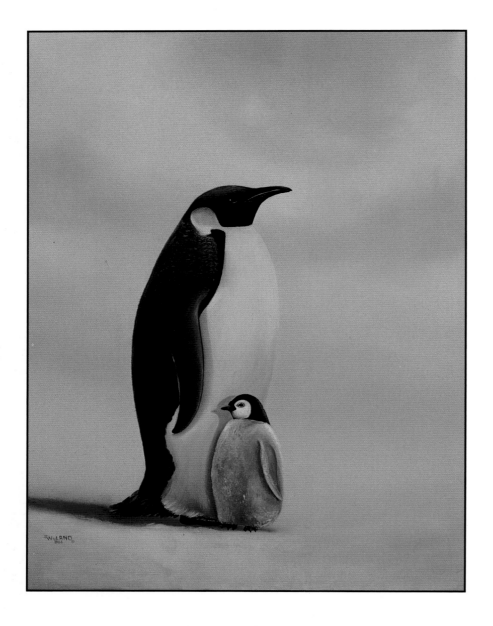

Snow Pups

The baby seal has become an international symbol for wildlife protection. For me, as an artist, it's the eyes that reveal the soul of the animal. And for this baby seal, the eyes may very well be what saved it from extinction.

Harp Seals

This painting portrays a mother harp seal checking on her pup. The bond between them, in my opinion, transcends all other life on this planet.

Emperor Penguins

Many of my paintings are very simple. I've always felt that in nature, less is more.

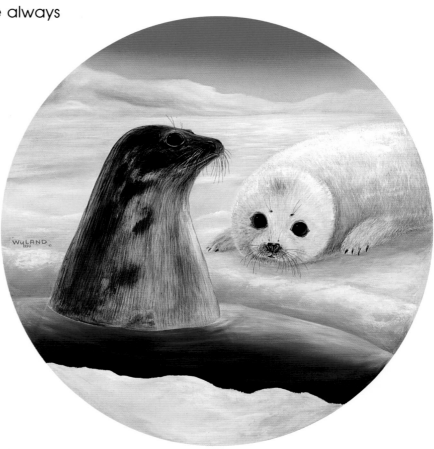

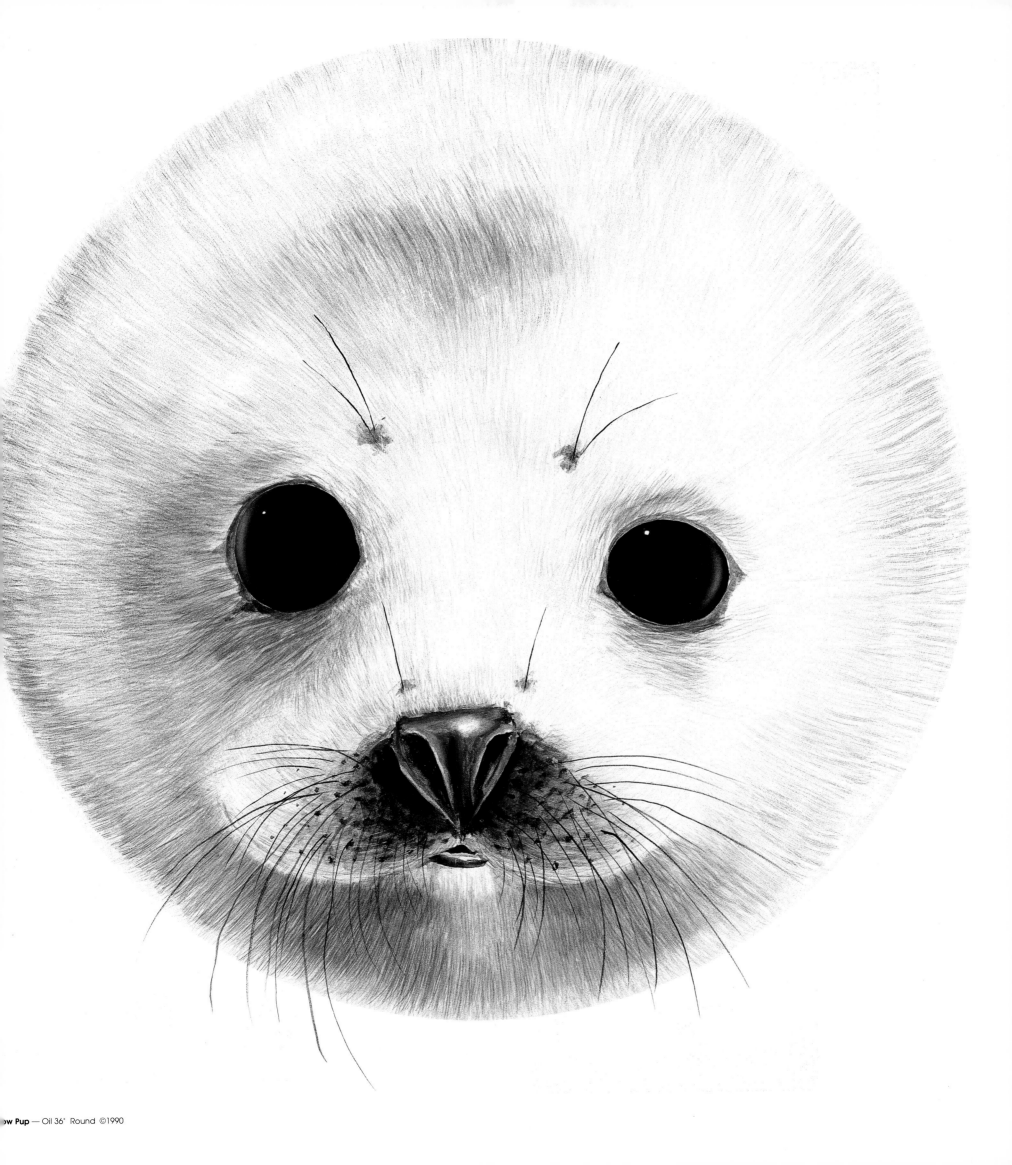

w Pup — Oil 36" Round ©1990

50

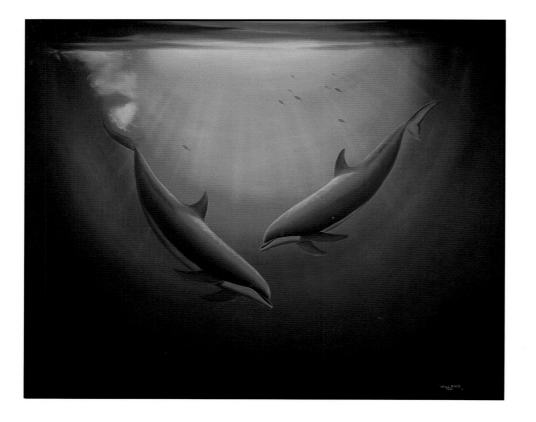

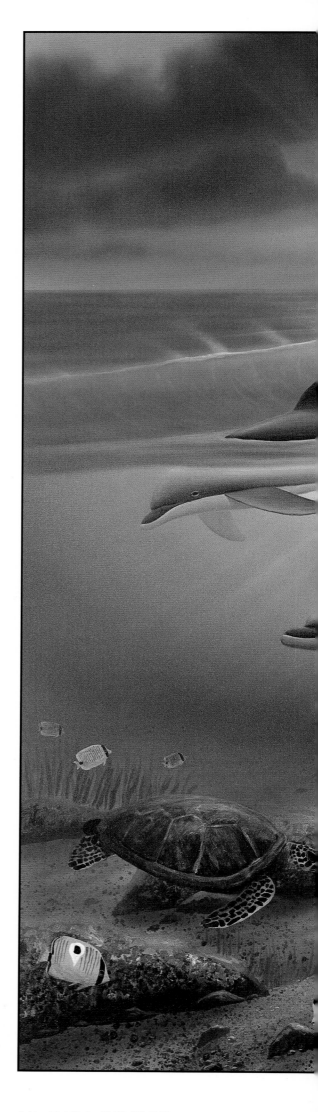

Minds In The Waters

I named this painting Minds in the Waters because it symbolizes the idea that dolphin intelligence is unequalled on earth. Dolphins have lived in harmony for 50 million years, taking only what they need and no more. We have so much to learn from our brothers in the sea.

Island Dolphins

The Hawaiian Islands have greatly influenced my art over the years and inspired many of my images of ocean life. In this work, a family of dolphins travel along the warm Hawaiian waters amid green sea turtles and an array of tropical fish. The sun sets on another perfect day.

DOLPHIN PORTRAIT

▲ Minds in the Waters — Oil 48"x 60" ©1986

▲ Island Dolphins — Oil 48"x 60" ©1988

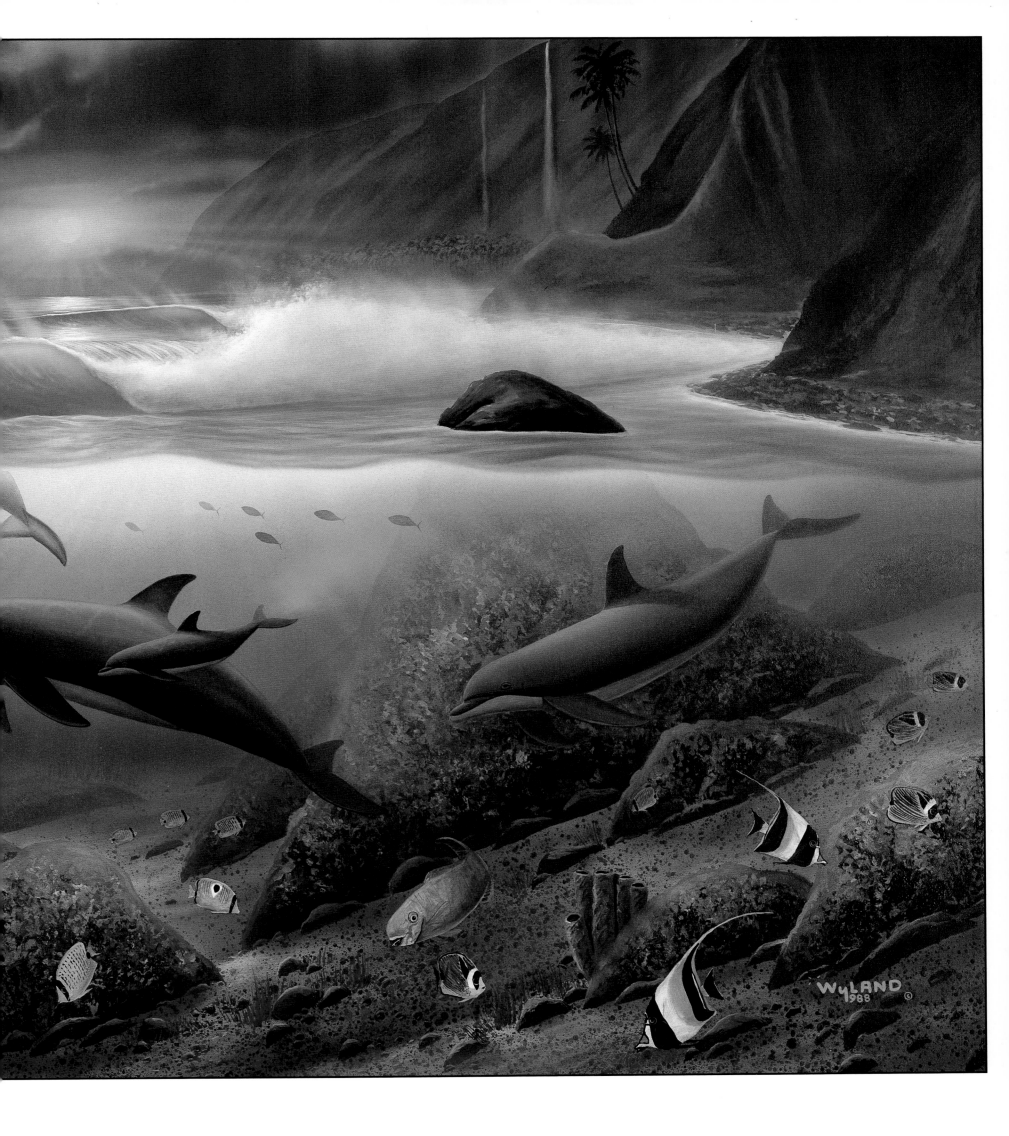

52

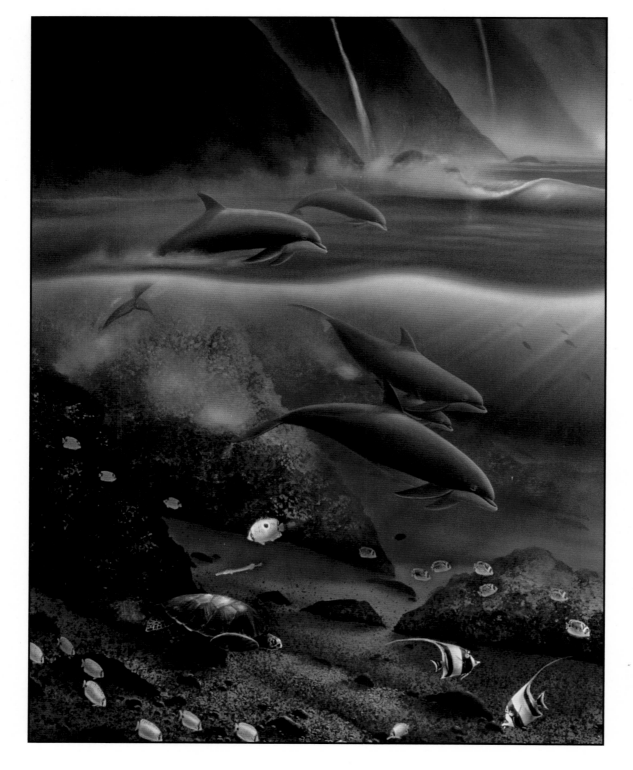

Hawaii Dolphins

Kauai's Na Pali Coast is home to several species of dolphins and many other forms of marine life. I wanted this painting to give the viewer a glimpse into that world.

The Art of Saving Whales

This painting, for me, represents my personal encounters with humpback whales. Now, the viewer of this work can also encounter a mother, her calf and their escort as these magnificent animals swim ever so gracefully through a glorious cathedral of light from the ocean's surface.

When I look at this painting, I remember hearing the songs of the humpbacks and sensing their gentle spirit.

...The permanent smile of dolphins reflects their friendly spirit...

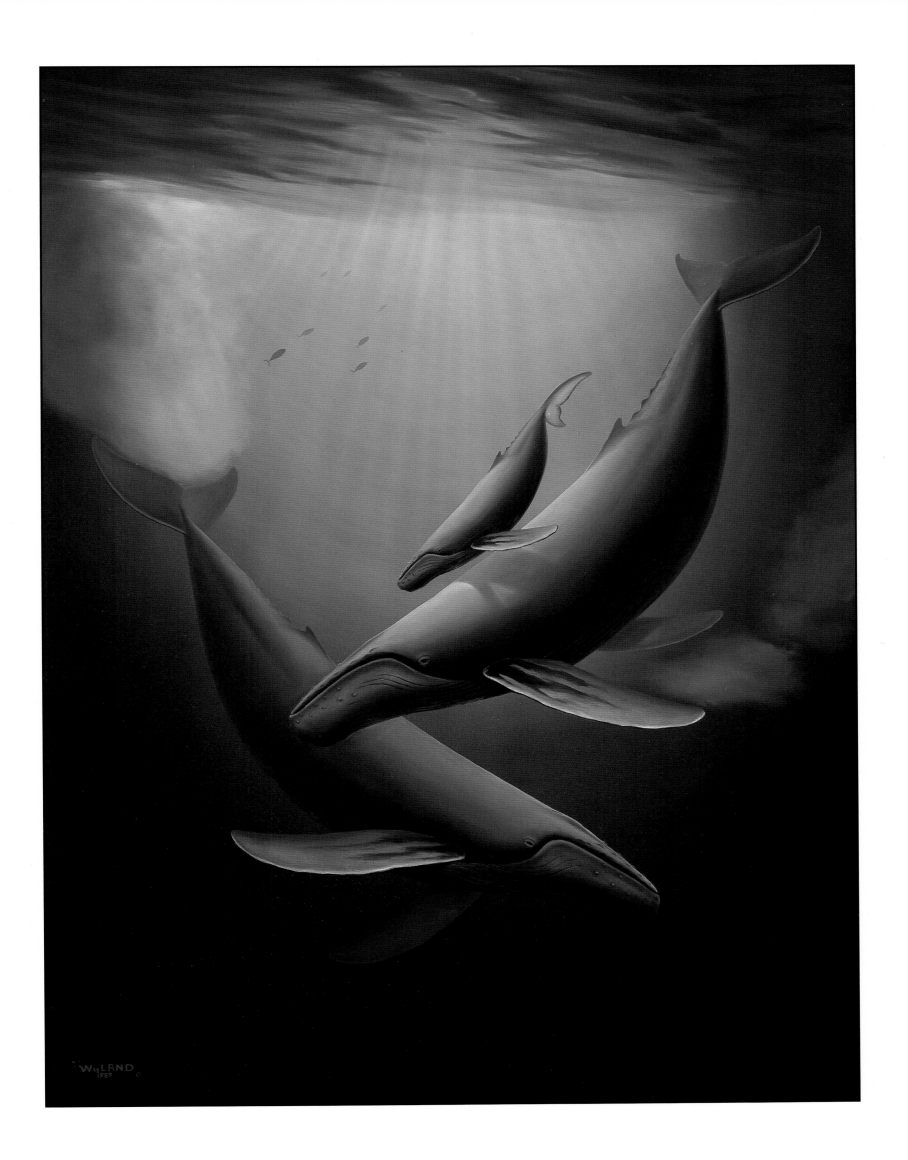

54

Endangered Manatees

In 1985, I was asked to paint a manatee mural at the Orlando International Airport. I was invited by my friends from the "Save the Manatees" organization to visit Blue Springs, Florida, where the endangered animals live.

As I was snorkeling in the area's brackish waters, I noticed in the distance a strange-looking being approaching. I had seen many films and pictures of manatees, but I never thought I'd come face-to-face with one. Yet, there I was, up close and personal with a real manatee for about 20 minutes. Of course, I didn't have my camera with me to photograph my subject before he swam away.

Then, several minutes later and to my great surprise, my new friend returned with four more manatees, including a mother and a baby. This was a dream come true! I spent over four hours swimming with this group of curious creatures. And when I painted the mural the next day, I felt enlightened forever by their gentle presence. Endangered Manatees represents that day in Blue Springs.

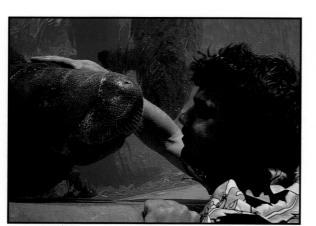

ARTIST MEETS MANATEE

▲ **Endangered Manatees** — Oil 48" x 60" ©1991

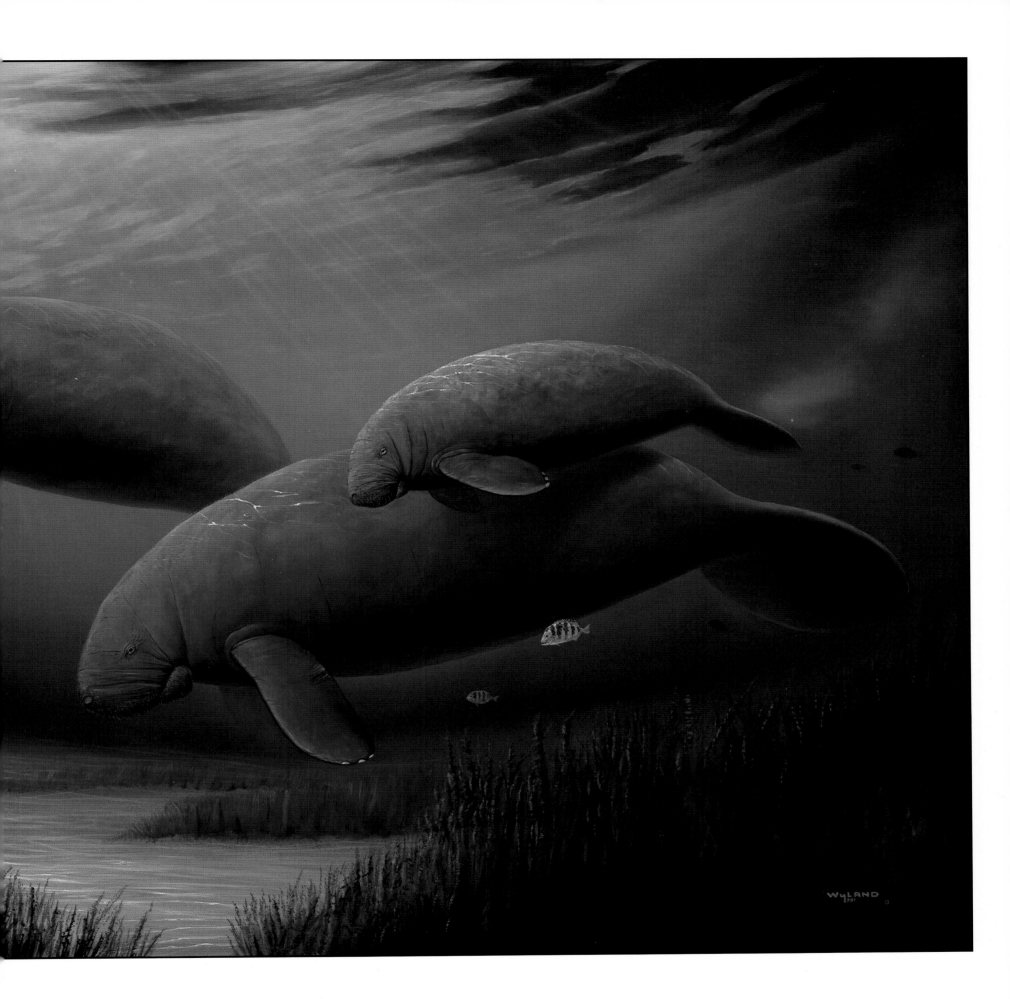

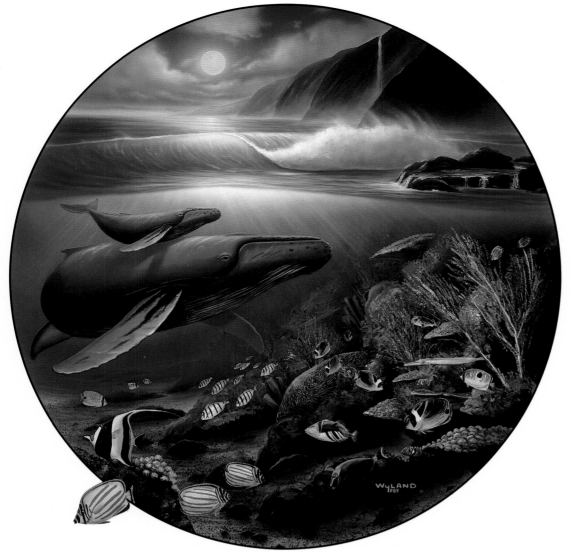

DIVING KAUAI

Islands

I painted Islands and Dolphin Paradise side by side with the self-imposed challenge of creating the two scenes with contrasting times of the day. First, I painted the full moon glowing over Kauai's magnificent Na Pali Coast. The moonlight reflects through the clear water and dances across the backs of a mother humpback and her baby. These shallow, protected waters are ideal breeding grounds for whales and other marine life.

Dolphin Paradise

The setting for this painting is Hanalei Bay during a beautiful "Bali Hai" sunset. The warm rays from the dipping sun reflect through the clear waters of the bay, where dolphins, sea turtles and many species of colorful tropical fish live together in harmony.

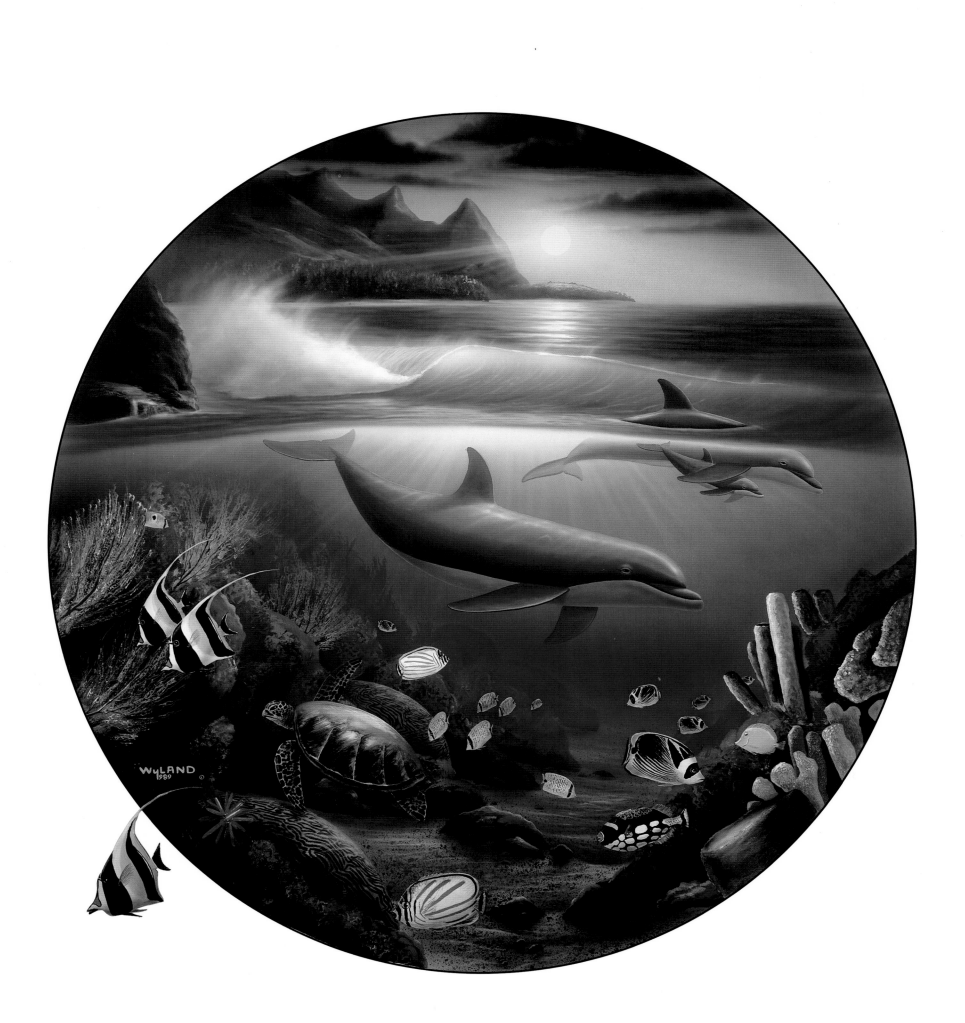

ORCA SPYHOPPING, VANCOUVER ISLAND

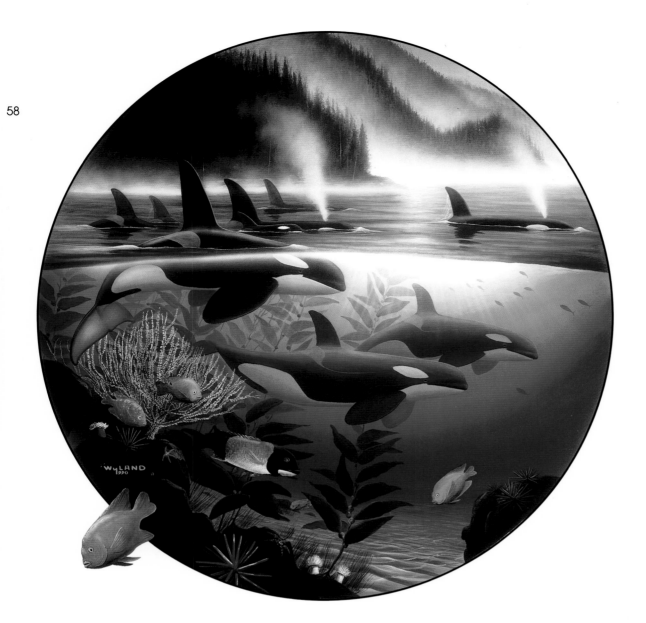

Orca Journey

Orca Journey was inspired by my visit to northern Vancouver Island, where I had been invited to be part of a dive team for a French film entitled "Atlantis."

For eight days, we swam with and photographed several pods of killer whales. The whales swam in tight formations through the cold north Pacific waters. As we dove to depths of 60 and 70 feet, I remember being amazed at the variety of marine life, including garibaldis, sheep's head and many other fascinating fish. In many ways, this environment is as spectacular as any other on the planet.

Orca Trio

This painting has been a favorite of mine for many years because it captures the power and simplicity of nature's most powerful beings. I painted it in a Seattle hotel room overlooking Elliott Bay, during the completion of my fifth Whaling Wall.

The hotel room was very dark as I worked, and the contrast between lights and darks was extreme, enhancing the overall starkness and effect of the painting.

58

▲ Orca Journey — Oil 48" Round ©1990

▶ Orca Trio — Oil 48"x 60" ©1984

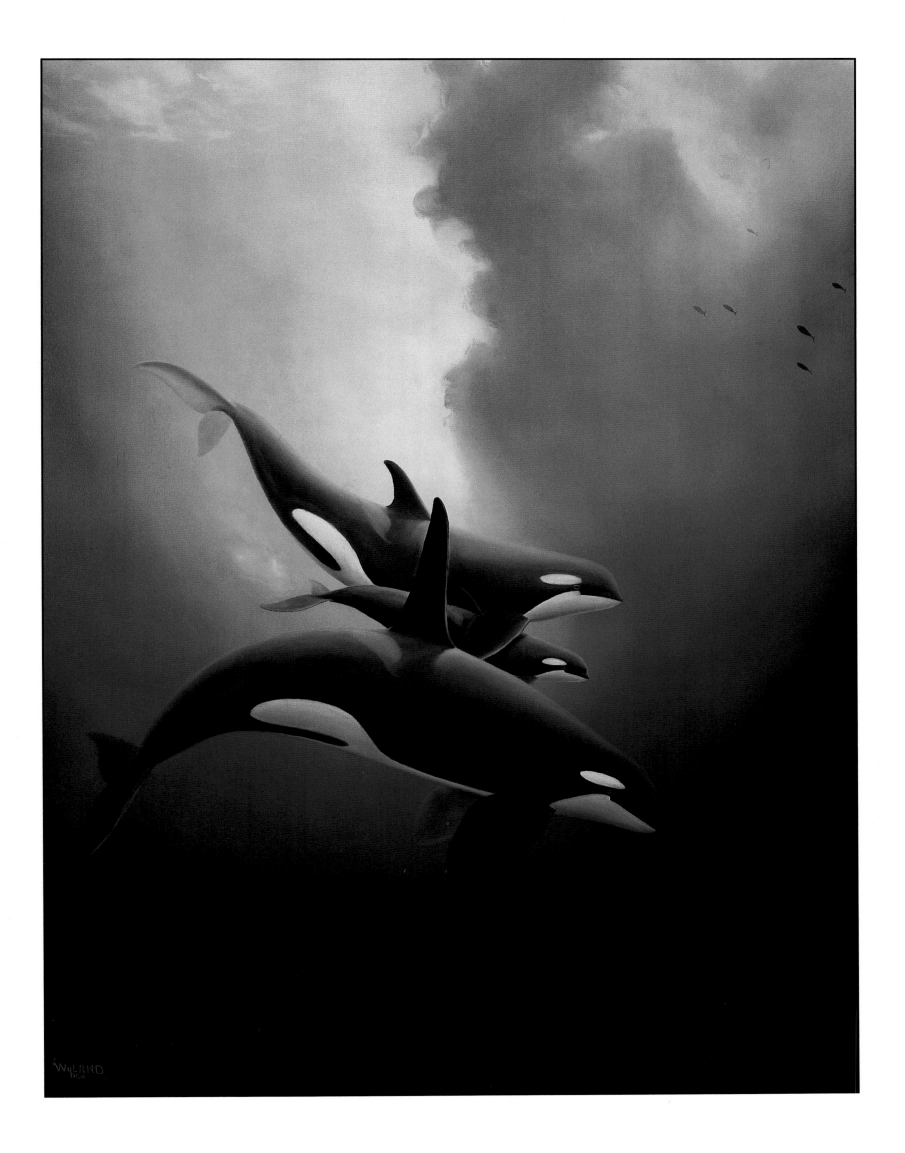

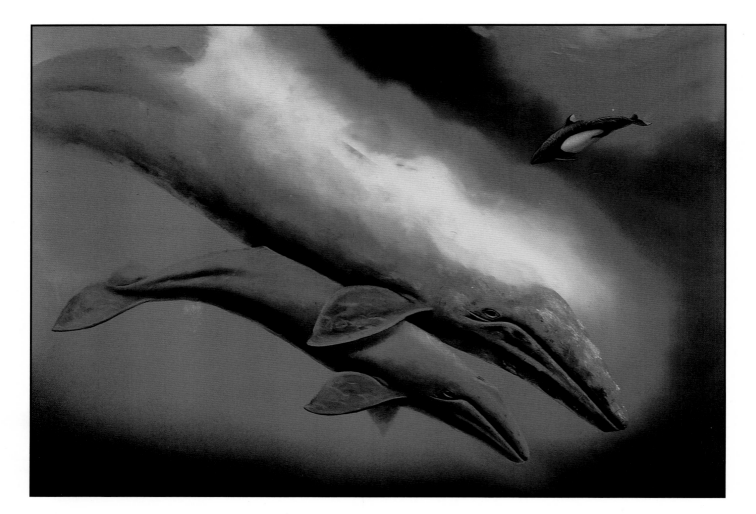

...Grey Whales have been called the friendly whales in recent years, sometimes bringing their newborn calfs to the surface to be touched by man...

Grey Whales

I was asked by Greenpeace to paint a portrait of a mother grey whale and her baby, with the Dall's porpoise to create an advertisement to run in Time Magazine. The ad was never used, but I was so pleased with the portrait that I later published it in a limited edition print. To me, it's a classic portrayal of a mother protecting its young calf.

Great Whites

I had a fascination with the great white shark long before the movie "Jaws." I wanted to capture the power and beauty of these legendary beasts and, at the same time, create an eerie feeling of being there and not only encountering, but being encountered. As the second shark circles back, I look to the sandy bottom and the shadow of death.

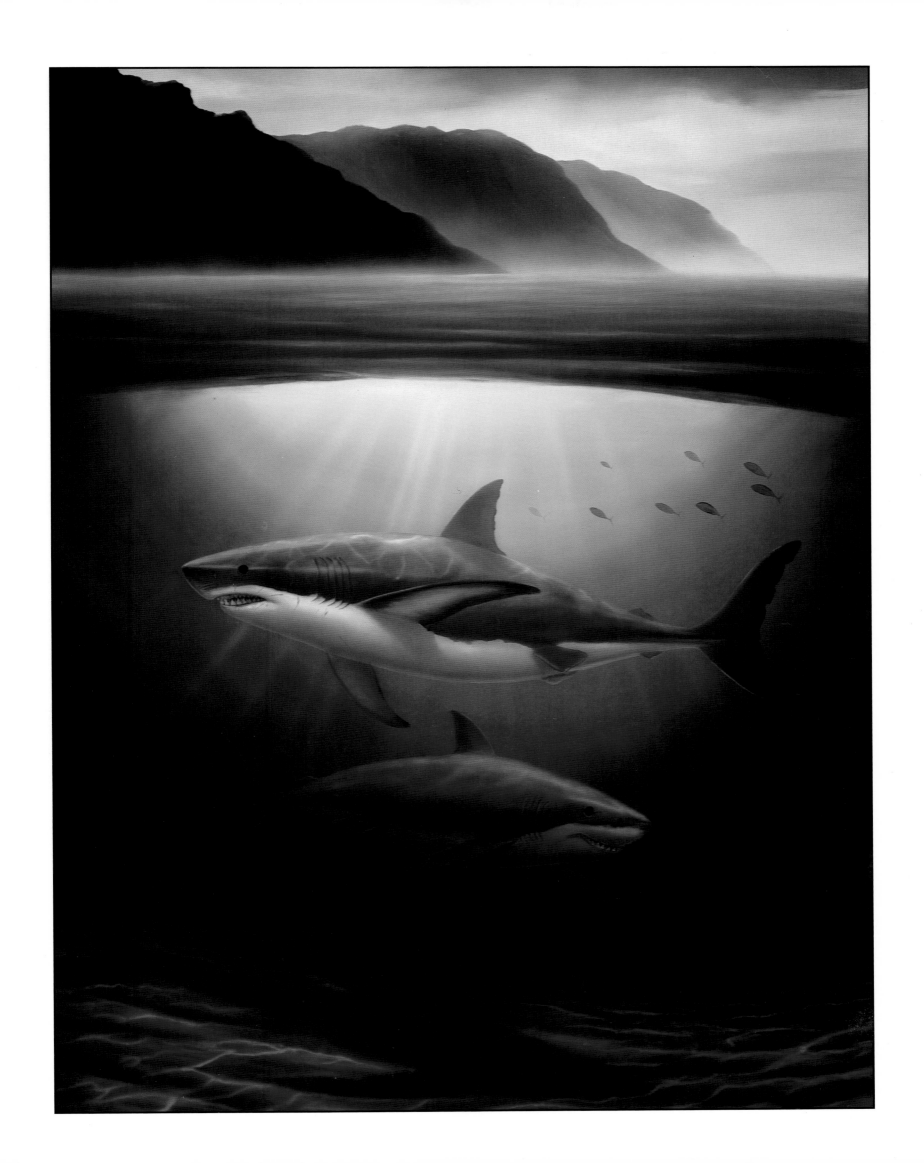

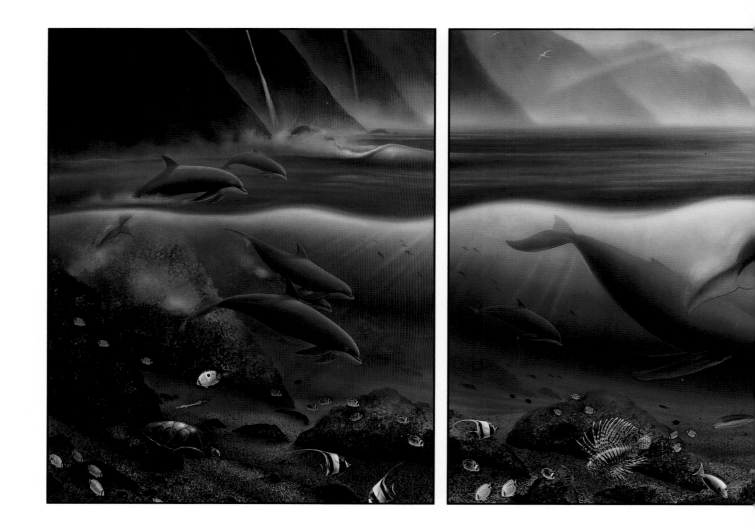

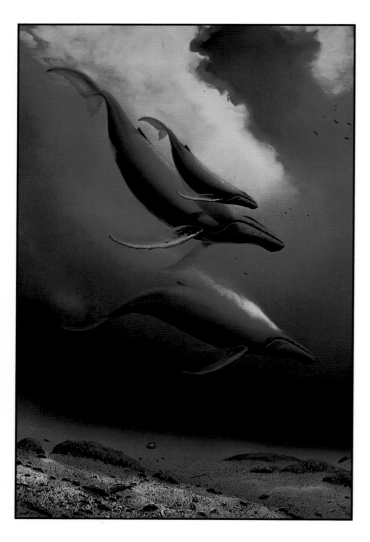

Hawaii

Sometimes a painting goes beyond its boundaries. In Hawaii, I wanted to address Kauai's Na Pali coastline, both above and below the surface. As an artist and diver, I'm anxious to share my view of the two worlds.

Humpback Whale Family

As a mother and baby humpback dive through the clear blue water, their escort blows bubbles warning of the presence of others — others being me. I've had the privilege of witnessing different humpback families and each time have been awed by their gentle nature.

▲ Humpback Whale Family — Oil 36"x 48" ©1984

▲ Hawaii — Oil 4'x 12' ©1987

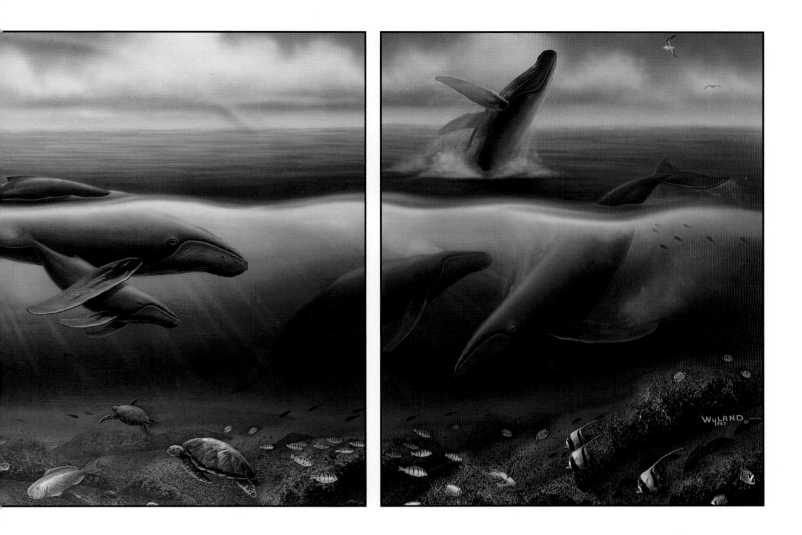

Sounding

Whales and dolphins sometimes pass each other as they navigate through the vast oceans of the world. Capturing that special moment when the two relatives cross paths is the purpose of this painting. They seem to be communicating that they will continue to live in peace and harmony, just as they have for millions of years.

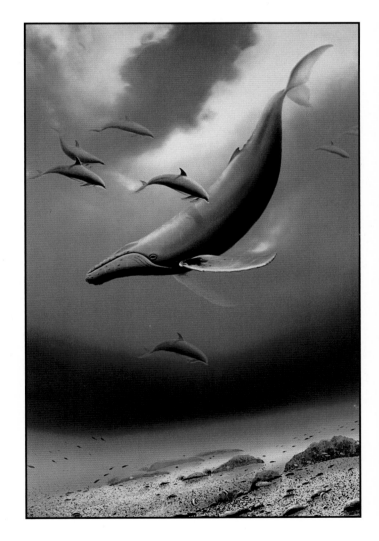

▶ **Sounding** — Oil 36"x 48" ©1984

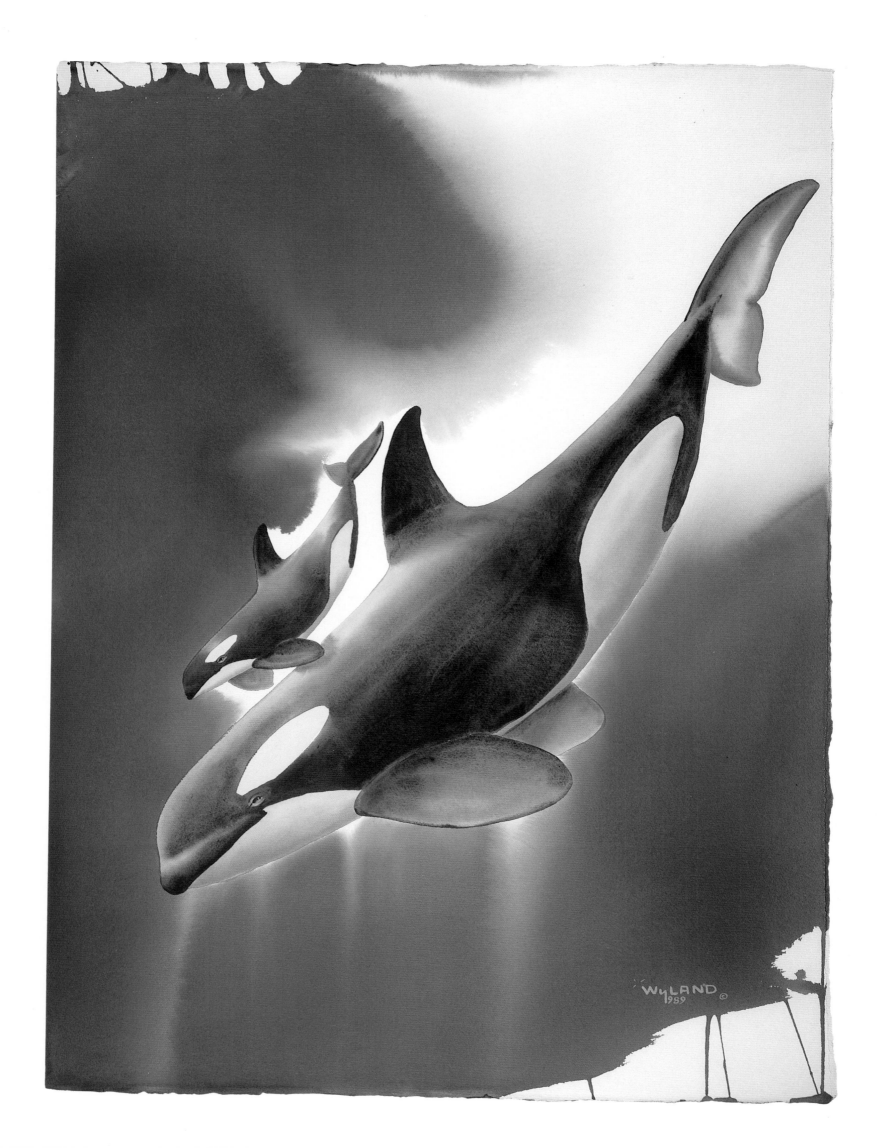

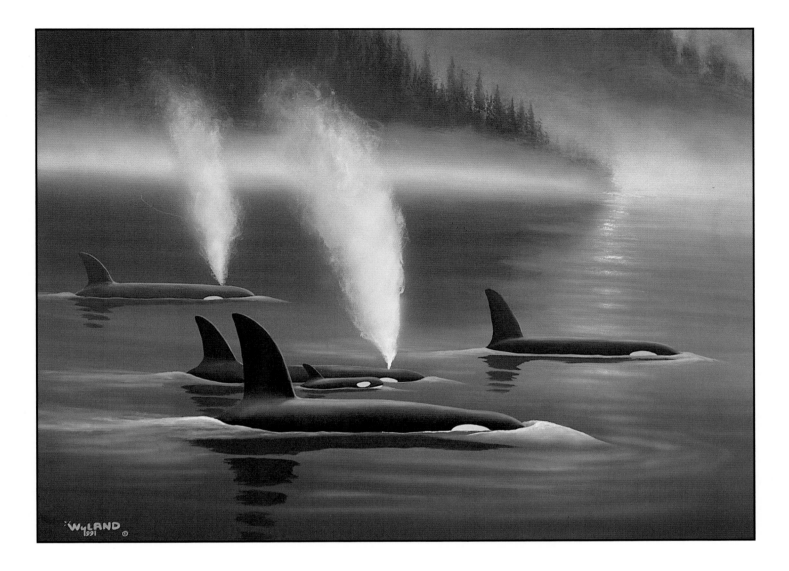

Watercolor Orcas

Here the medium, watercolor, in its liquid quality, achieves a natural feeling of fluid motion. The orcas appear to swim through an aura of energy captured forever in the transparent colors of water.

Northern Passage

The waters of the Pacific Northwest have been traveled for millions of years by native tribes of orcas. For me, this region, with its many moods, represents a pathway of one of God's most awesome creatures.

As the light and shadows dance over the chilly flat waters, one can hear the sounds of orcas breathing. And the breath of life just hangs in the cool air.

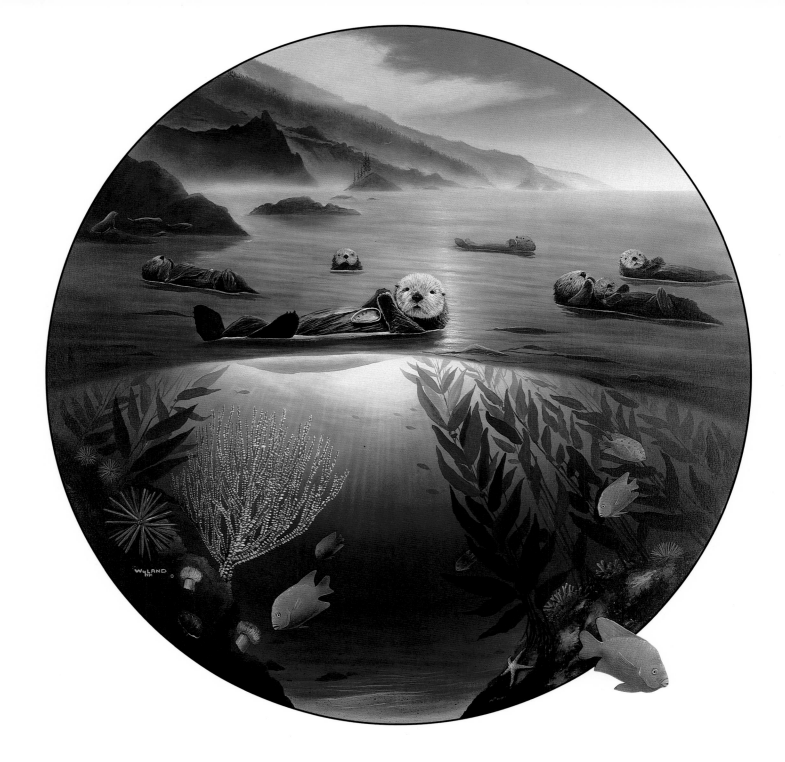

Sea Otters

Monterey is home to the playful sea otter, and I've spent many years there watching these remarkable animals of the sea. I am reminded that each sea otter is as individual as we are, and I tried to portray in this painting their different behaviors, as well as their underwater environment.

Sea Otter with Abalone

After completing the painting, "Sea Otters," I decided to create a series of bronze sculptures to capture the spirit of these remarkable animals. The first was a Sea Otter with Abalone. I later added a rock which is a favorite tool of the Otters. The rock allows the Otters to open the abalone shell.

▲ Sea Otter with Abalone — Bronze ©1991

▲ Sea Otters — Oil 48" Round ©1991

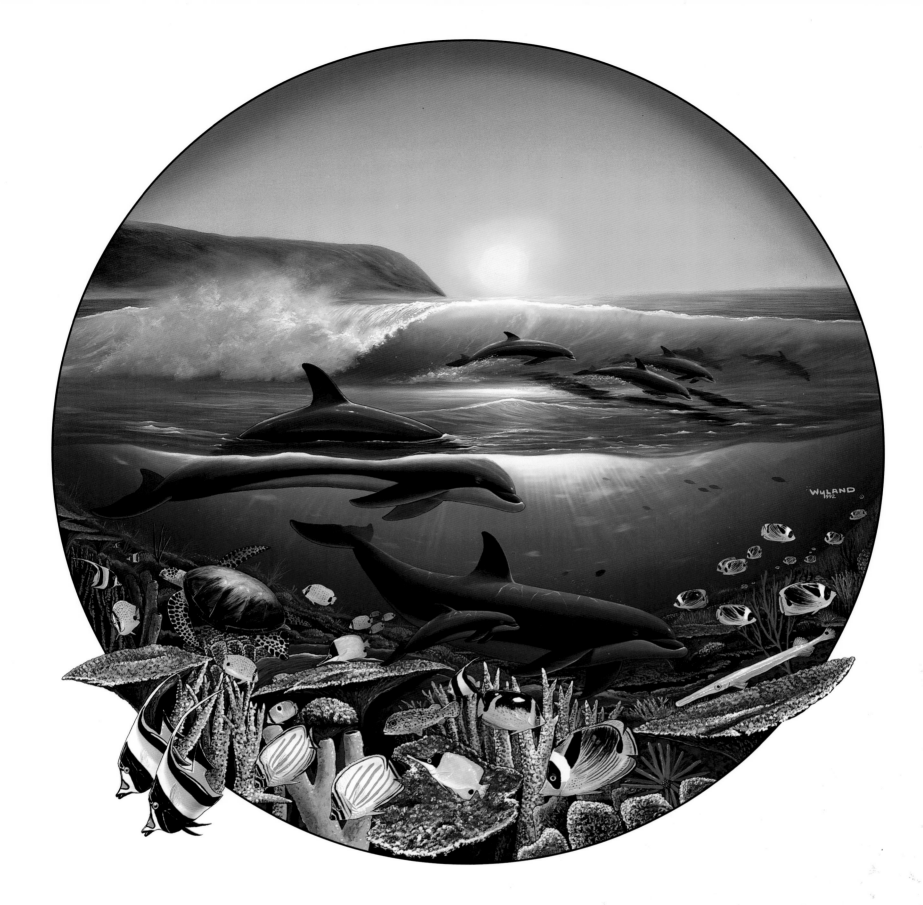

Surfing

For the past few years, I was asked to create the original artwork for the "Triple Crown of Surfing." In 1991, we sponsored our first Wyland Galleries Hawaiian Pro on the North Shore of Oahu. This years painting captures the spirit of dolphins surfing the perfect wave; as the sun sets off of Kaena Point. The North Shore is home to the largest waves in the world and each winter the worlds top surfers migrate there to compete in the Worlds Championship. Surfing gives us a unique perspective beneath the waves to observe the magnificent coral reef that shapes the perfect waves and is home to many colorful sea creatures.

▲ **Surfing** — Oil 48"Round ©1992

Maui Dawn

As the sun rises over the West Maui Mountains, a pod of Humpback Whales travel through the warm, protected waters. Humpbacks have returned to this magic place each winter for millions of years to mate and give birth.

68

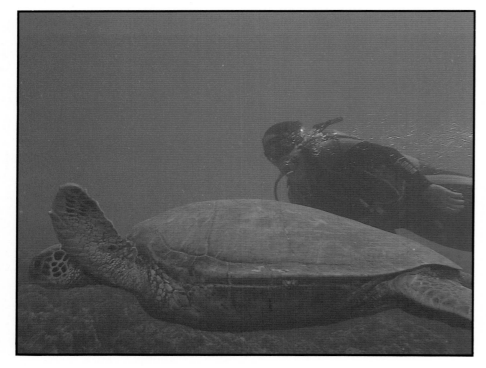

WYLAND DIVING WITH GREEN SEA TURTLE OFF MAUI

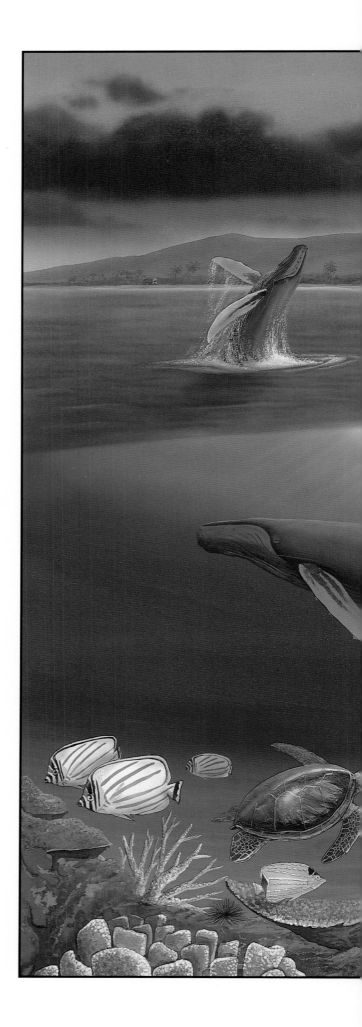

▲ **Maui Dawn**— Oil 72" x 48" ©1991

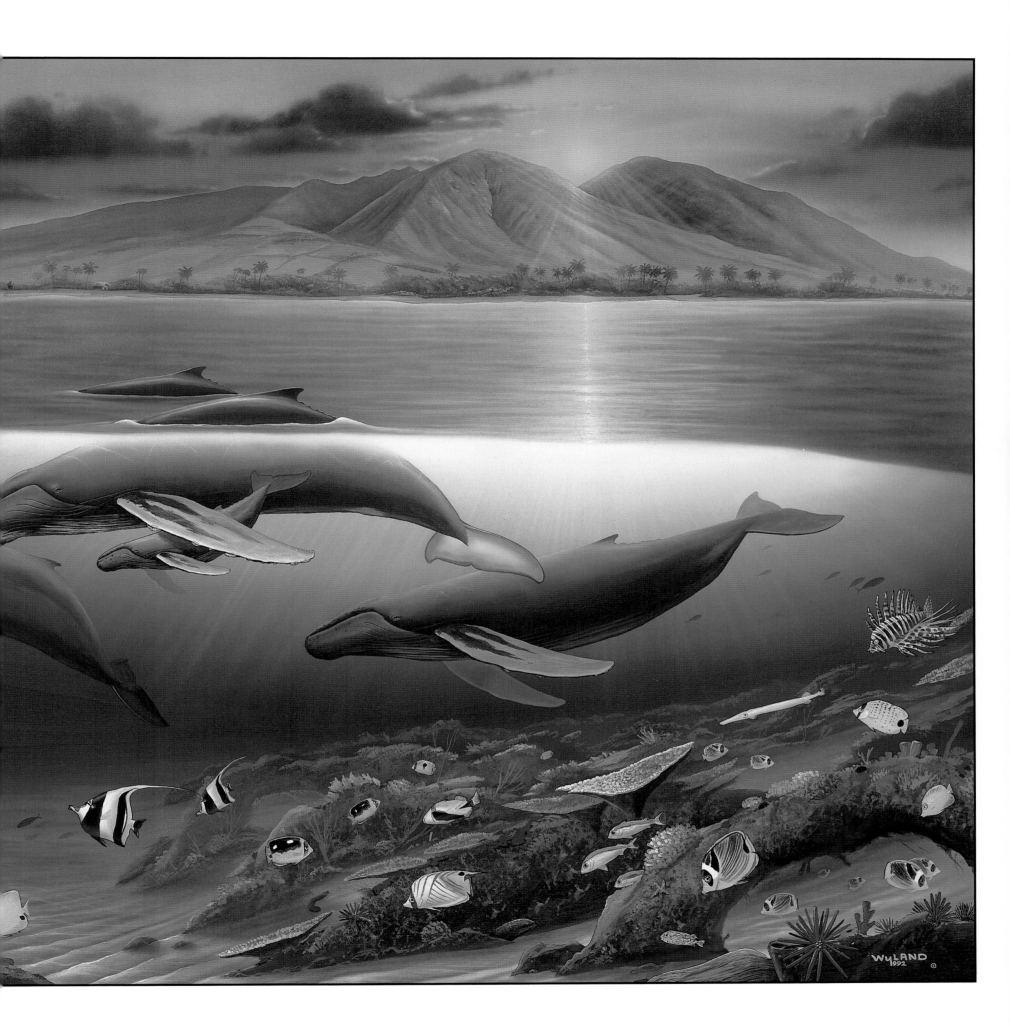

Whales travel the path of consciousness, not convenience...

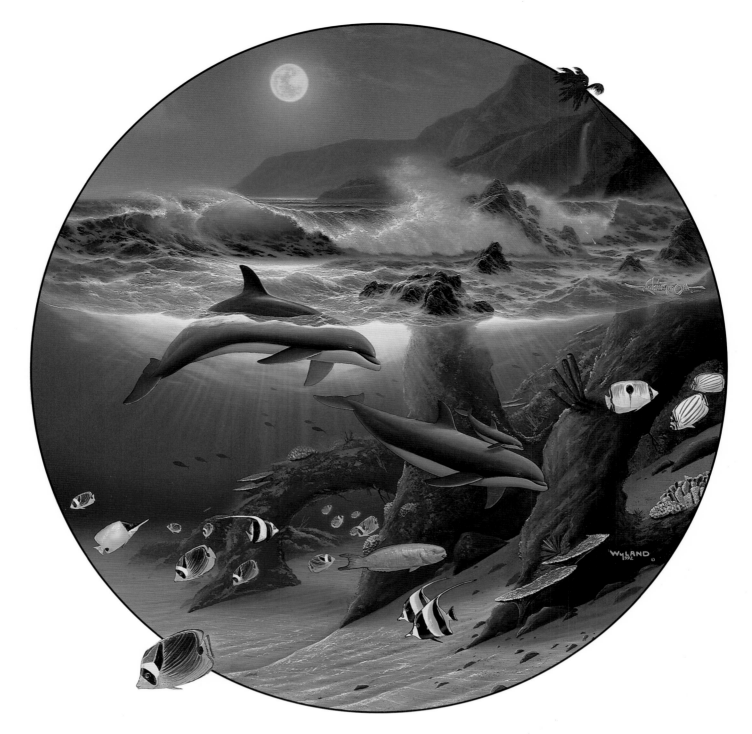

Dolphin Moon

Once again, Tabora and I collaborated to create our vision of the two worlds "Above and Below." The challenge of using two distinct styles of painting on one canvas has brought our creativity to new levels. I am now developing future collaborations with other renowned artists, continuing to explore new frontiers in fine art.

Above and Below

Above and Below started out as an agreement between myself and artist Robert Bateman in that he would paint the world above the ocean, and I would paint everything below. The idea stuck so I contacted Roy Tabora, a fabulous seascape painter who, like myself, kept a studio on the North Shore of Oahu. We took turns painting the single canvas. And when it was finished, we both felt we had achieved the best of both worlds.

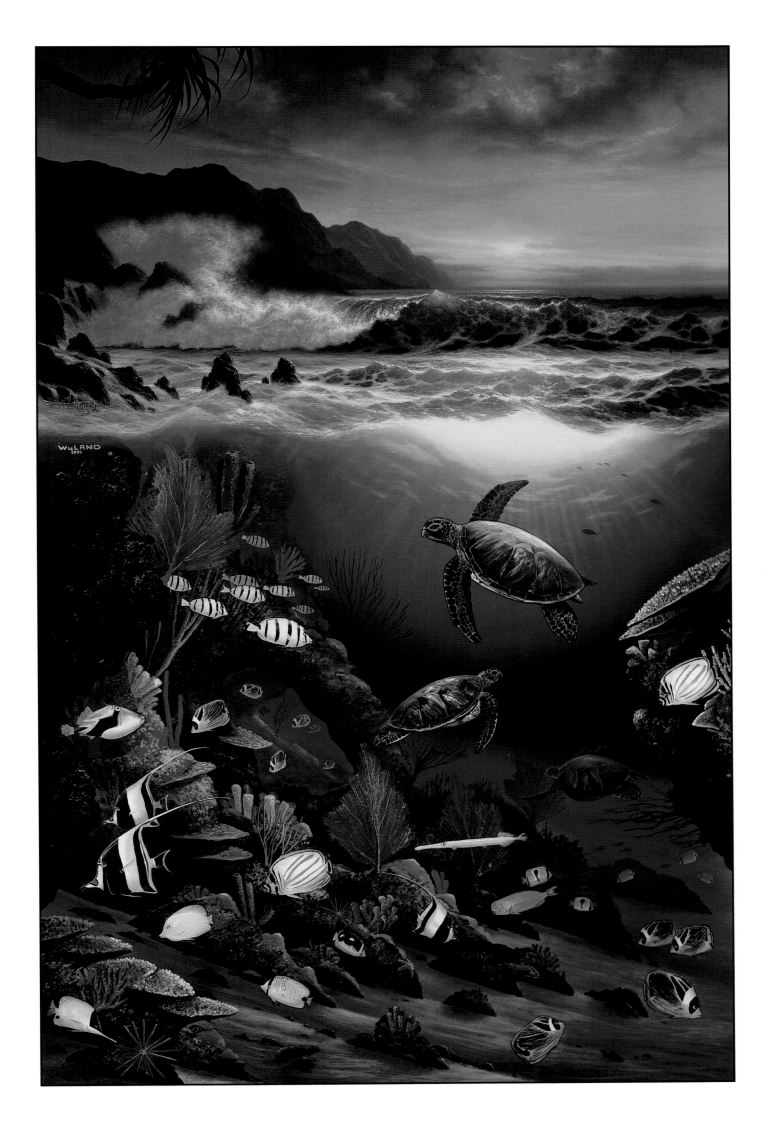

▲ **Above and Below** — Oil 48"x 72" ©1991

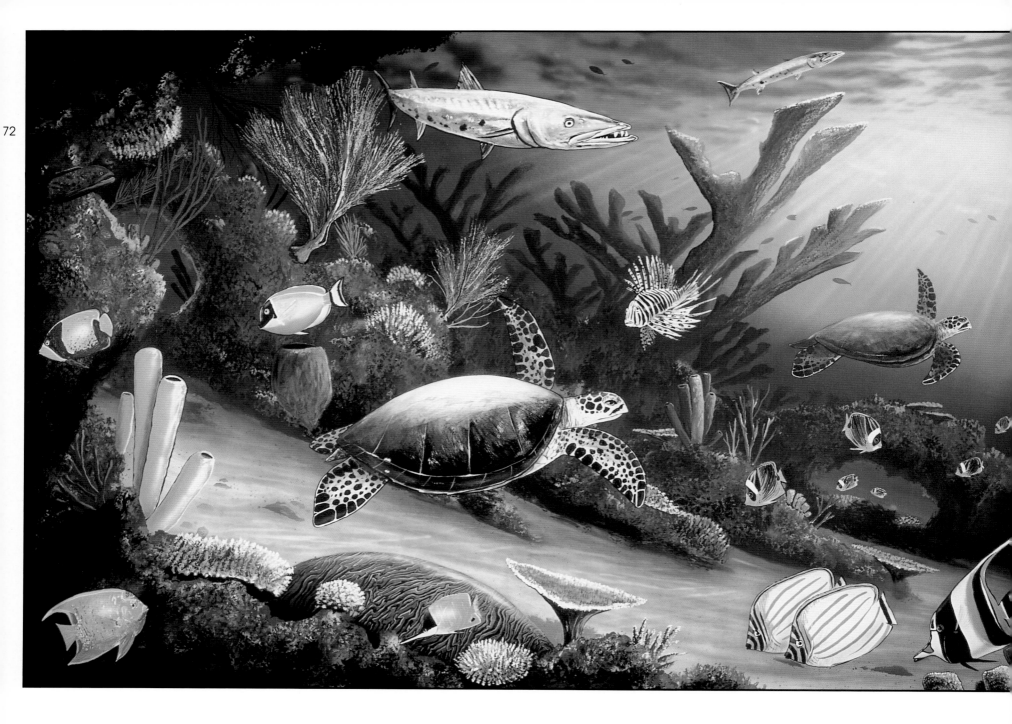

The Living Reef

The idea in Living Reef was to depict as much of Florida's marine life and coral as possible to bring attention to the area's endangered reefs.

The unrivaled beauty beneath the sea, where massive coral reefs team with the diversity of fascinating marine creatures is captured in brilliant colors. Atlantic bottlenose dolphins, sea turtles, great barracudas and other fantastic reef fish live in this undersea world.

QUEEN ANGELFISH

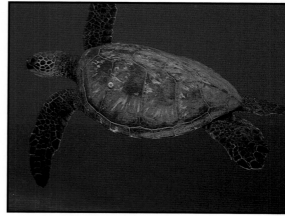

GREEN SEA TURTLE

▲ **The Living Reef** — Oil 4' x 12' (Diptych) ©1991

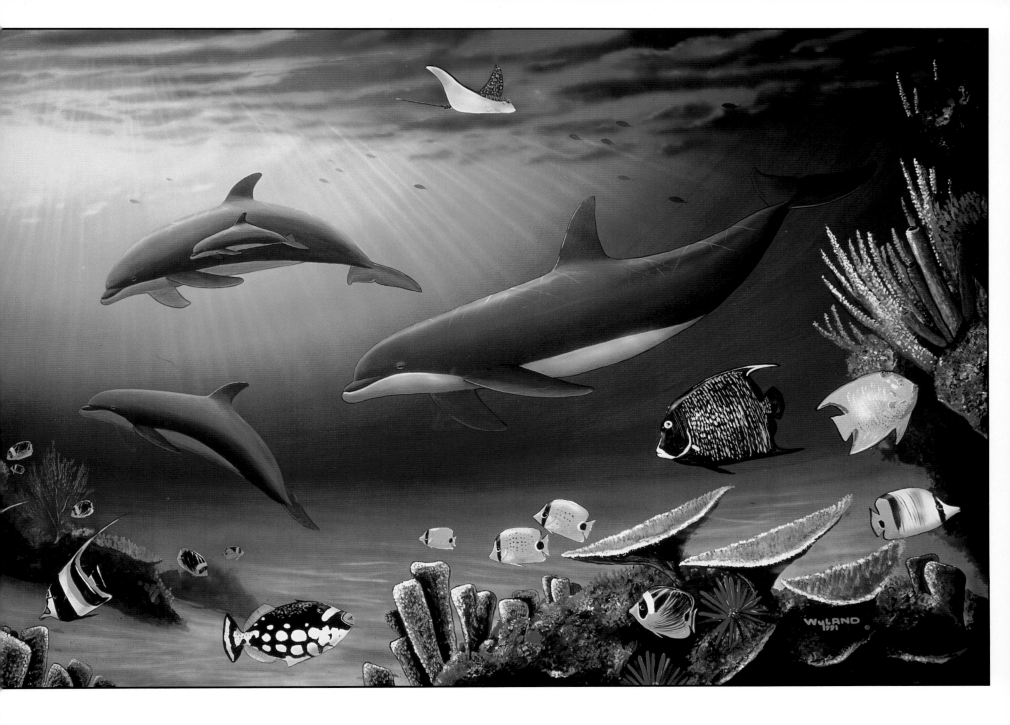

DIVING THE LIVING REEF

FEEDING EEL, MEXICAN CARIBBEAN

. . . Some have said how can an artist make a difference,
· Others have said they may very well be the only ones
that can . . .

IV
THE WHALING WALLS

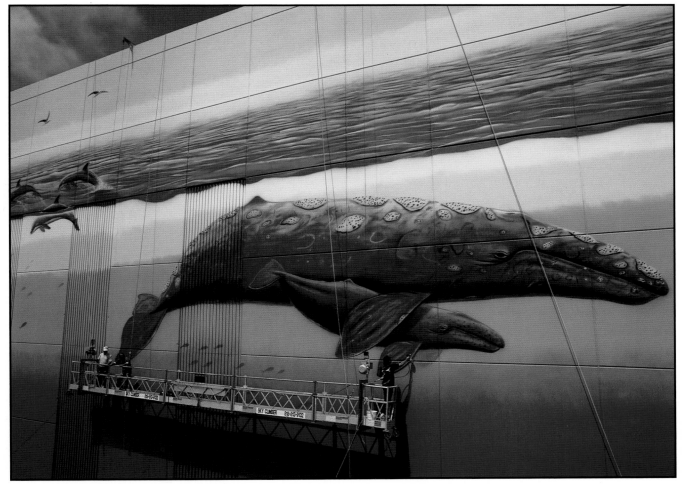

ARTIST PAINTING SECTION OF REDONDO BEACH WALL 1991

A series of 100 lifesize murals by Wyland dedicated to the great whales and saving our oceans.

WHALING WALL I

G R E Y W H A L E S

Wyland's idea for painting whales on the sides of buildings developed quite naturally from the difficulty he was having in portraying the mammoth creatures on small canvasses. In 1978, his desire to paint whales lifesize led him up and down the Pacific Coast Highway from San Diego to San Francisco until he finally found the "perfect wall" in Laguna Beach.

Laguna's long history as an internationally known art colony, its coastal location and the fact that the grey whales migrate along its shoreline each year made it the best choice for Wyland's first lifesize mural.

Depicting a lifesize California grey whale and her calf, the mural was completed on the side of the Hotel Laguna on July 9, 1981. The dedication ceremony was held amid great public adulation and considerable fanfare. And it also happened to be Wyland's 25th birthday.

"While I was finishing this mural, I realized the kind of impact it was having on the people who were looking at it," he says. "There was nothing like it in Orange County, or anywhere else for that matter. The public's response was just fantastic, and this was when I decided to paint 100 of these Whaling Walls throughout the world."

Five years later, Wyland returned to repaint Whaling Wall I because cars from the hotel's parking lot were continually bumping into it. While refurbishing the wall, he surprised everyone by repainting the whales so that they faced the opposite direction, toward the ocean.

"I just wanted the public to view the mural in a new perspective," he says of the reversal. "People told me something looked different, but they couldn't figure out what it was."

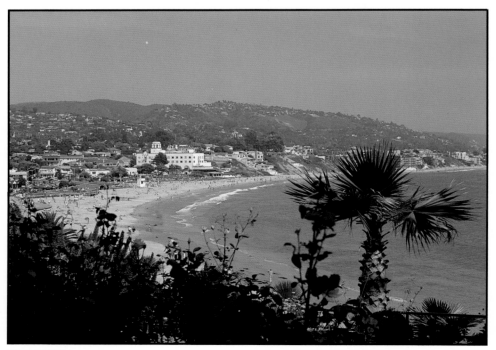

LAGUNA BEACH

WALL BEFORE MURAL

▲ **1981 Whaling Wall I** — Laguna Beach, California — 140 feet long x 26 feet high — Dedicated July 9, 1981 by Mrs. John Wayne

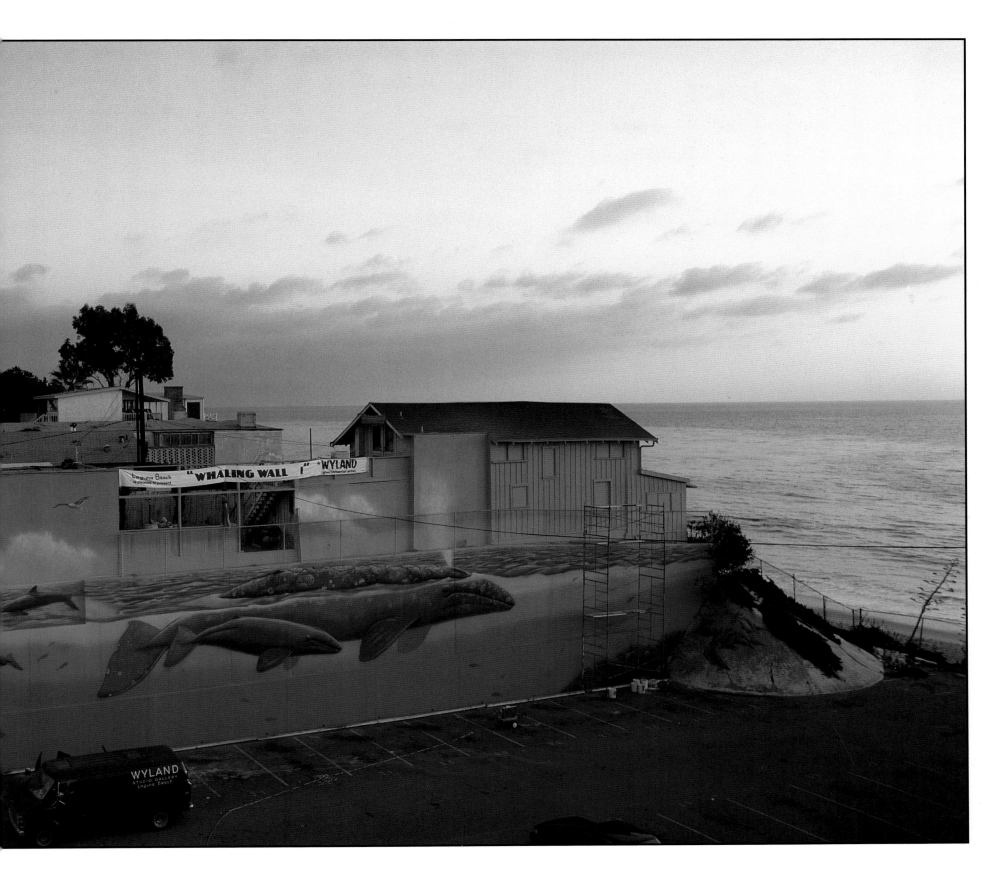

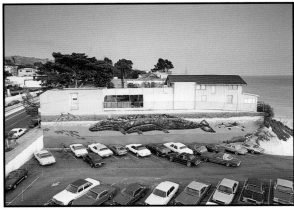

FIRST WYLAND WALL 1981

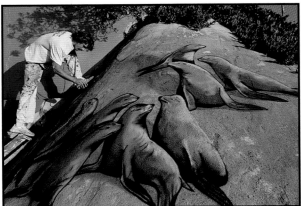

CALIFORNIA SEA LIONS ON ROCK

78

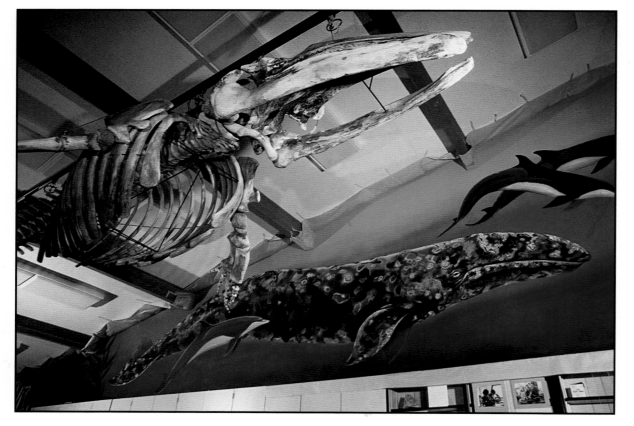

FROM QUINN INOUYE, AGE 9

WHALING WALL II
Y O U N G G R E Y W H A L E

After seeing Wyland's first Whaling Wall in Laguna Beach, the director of the Orange County Marine Institute, Dr. Stan Cummings, asked Wyland if he would paint a mural at the institute in Dana Point, California.

Upon visiting the facility in 1982, the artist was struck by the skeleton of a young grey whale suspended from the ceiling. It was a grey whale that had washed ashore in 1980 in Huntington Beach and had been reconstructed and placed on display.

"I immediately wanted to paint that whale as if it was living, and in its true size, so that one could look up at the wall and relate the bones to the exterior anatomy," Wyland recalls. "I think this is another idea where art and science can work together to achieve a higher purpose. Students at the institute can now study the living whale alongside the skeleton and gain a much better understanding of these mammals."

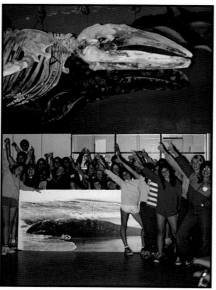

CLASS ROOM

WHALING WALL I
S P Y H O P P I N

When Wyland was asked to paint a mural at Marineland in Palos Verdes, Californ he had his choice of walls. After walking by one wall that he found rather interesting because of its height, he walked out to the peninsula that overlooks Palos Verdes.

Just as he looked out over the bay, a grey whale stuck its head completely out o the water in a behavior called "spyhopping The whale, and the wall he had viewed minu earlier, suddenly came together in his mind. "At that moment, I had my painting," Wylar says. "It was just a matter of creating it. The image was there."

It took nine days for Wyland to complete the 20'x30' mural, which is located in park's whale pavilion. "The interesting thing about painting at Marineland was that ther were so many people watching me work," the artist says. "It was a lot of fun and very inspirational to talk to all of them about the different experiences with whales. I think we all learned something."

▲ **1982 Whaling Wall II** — Orange County Marine Institute, Dana Point, California — 45 feet long x 10 feet high — Dedicated March 20, 1982 by Bill Toomey, Olympic Decathalon Champion

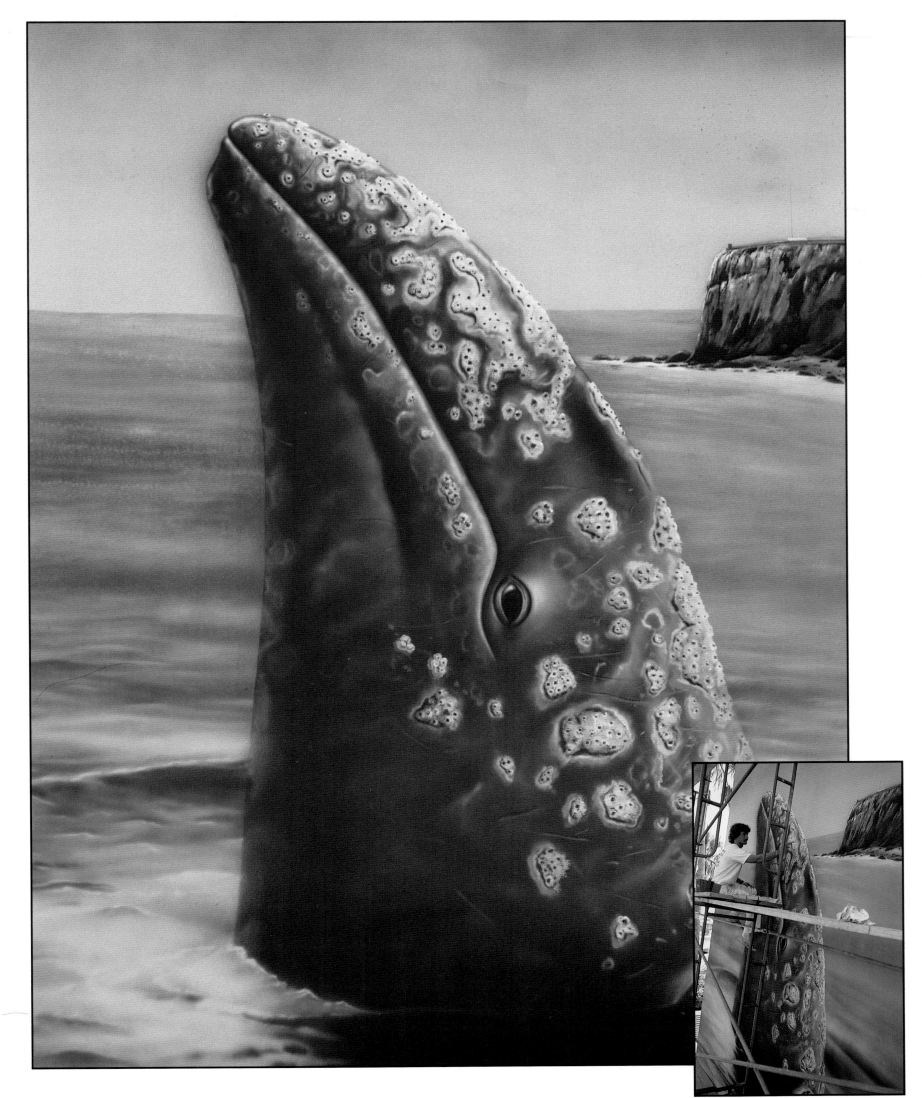

PAINTING BARNACLE

Whaling Wall III — Marineland, Rancho Palos Verdes, California — 20 feet long x 30 feet high — Dedicated June 27, 1984. By Cleveland Armory, FUND FOR ANIMALS

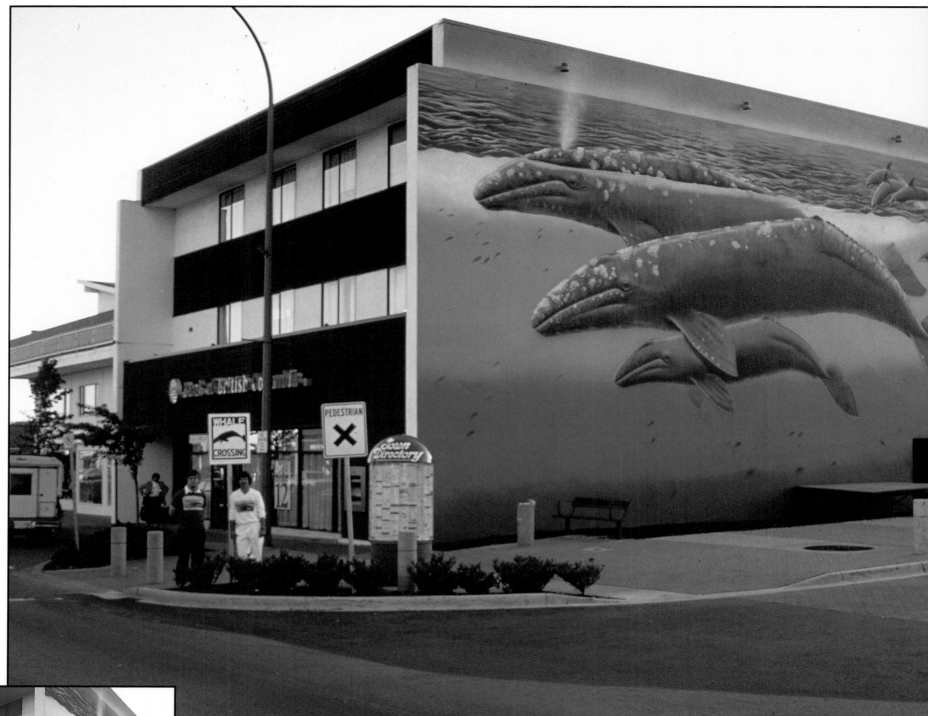

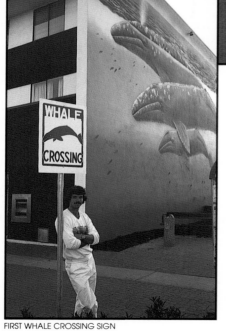

FIRST WHALE CROSSING SIGN

...Breath of life...breath of whales...

▶ **1984 Whaling Wall IV** — White Rock, British Columbia, Canada — 70 feet long x 30 feet high — Dedicated September 29, 1984 by Gordon Hogg, Mayor of White Rock

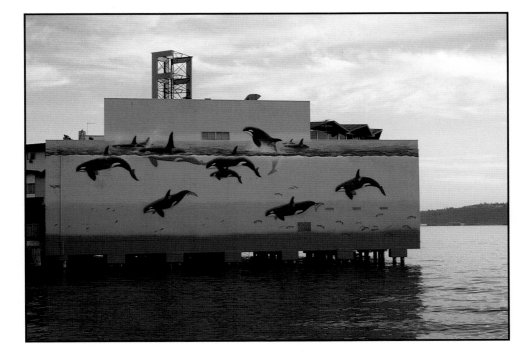

WHALING WALL IV

THE GREY WHALE FAMILY

In 1984, the mayor of White Rock, Canada, Gordon Hogg, was looking for public art. The death of seven grey whales that year in the White Rock area had alarmed the community and heightened their awareness of the animals' plight. As it so happened, Wyland was in town for an exhibition of his work at the Vancouver Aquarium. He was looking for walls to paint.

It didn't take long for Wyland and the mayor to meet one another and start collaborating on a Whaling Wall project for the city. Hogg arranged for the necessary permits and quickly generated a groundswell of community support, which, much to Wyland's delight, was a complete reversal of what he had encountered in Laguna Beach for his first Whaling Wall.

"It was very inspirational for me to receive warmth and encouragement from the people of White Rock," Wyland says. "They had such a tremendous appreciation for what I was doing, and I really wanted to give something back to them."

The 30'x70' mural was the artist's first international Whaling Wall. It depicts a mother grey whale, her calf and their male escort as they pass by White Rock on their annual migration from Baja, Mexico, to the Bering and Chukchi seas off Siberia. The 6,000-mile trip takes the whales six to eight weeks at speeds of 160 kilometers (100 miles) per day.

During the painting of the wall, the city took care of Wyland's lodging and meals, and afterwards Mayor Hogg gave him the key to the city at the dedication ceremony. Because of his special relationship with the people of White Rock, Wyland returns often to visit this Whaling Wall, and also to see his good friends.

WHALING WALL V

THE ORCAS OF PUGET SOUND

After completing the mural in White Rock, Wyland and his volunteer crew drove to Seattle, Washington, where he had been invited to paint a wall that was suspended over water on Seattle's Alaskan Way.

"The big challenge was getting the scaffolding across the water and over to the wall," the artists recalls. "Finally, this guy suggested we use some buoys and float the scaffolding over to the wall, and that's how we did it. A crew of volunteers then had to rappel down from the top and jump into the ice cold water to set it up."

Logistics aside, the mural was completed on the 50'x140' north wall of the Edgewater Inn showing an entire pod of orca whales, also known as killer whales, frolicking in the cool waters of Puget Sound.

Wyland remembers seeing numerous orcas swimming in the water nearby as he painted, and it occurred to him that perhaps the whales were watching him. "My idea was that maybe the orcas could see me painting a tribute to them, and that inspired me even more."

Unfortunately, the mural was later painted out by the new owners of the hotel, despite a furious protest from the community. "The mural is now extinct," Wyland laments. "Hopefully, that won't happen to the whales."

▶ **1984 Whaling Wall V** — Seattle, Washington — 140 feet long x 50 feet high — Dedicated November 10, 1984 by Ivar Haglund, Seattle Port Manager

82

Wyland was riding "The Bus" heading into Waikiki when he spotted in the distance exactly what he had been looking for — the perfect canvas on which to paint the humpback whales. As the bus drew closer, the artist got so excited that he pulled the stop cord as if there were an emergency and leaped off the vehicle as it pulled to a halt.

"I immediately saw a pod of humpbacks swimming across this huge wall," Wyland says. "At one end there was this tower section, and I envisioned a humpback jumping out of the water in a full breach."

Today, Wyland claims that when he finished painting the wall, it was not much different from this first picture he had formed in his mind. The majestic mural, 300 feet wide and 20 stories high, displayed life-size humpbacks cavorting across a clear blue ocean that looked like an extension of the real Hawaiian waters in the background. The painting also included a group of playful dolphins, false killer whales, green sea turtles and a variety of tropical fish. The 60-foot whale breeching up into the tower section looked so real that one expected to be splashed at any moment as the great beast cannoned back into the water.

The public's response to the Whaling Wall was no less phenomenal. Painted on the side of the Ilikai's Marina Condominium Building, literally millions of wide-eyed tourists were met by the mural as they entered Waikiki. Those who watched Wyland use 900 gallons of paint to complete the half-acre wall found themselves being pulled into the energy and excitement generated by the project, with over 4,000 attending the dedication ceremony.

"At that time, the wall was next to Kaiser Hospital," Wyland says. "Some of the terminal cancer patients would watch from their windows as I painted the mural. I was told that a few of them stayed alive a little longer just so they could see the wall completed."

Alas, all was not completely well in Honolulu. The project was opposed by one group called The Outdoor Circle, and also a developer who wanted to build a luxury hotel next to the wall. The two groups dragged Wyland into court in a well-publicized lawsuit to stop the mural, but the artist won and was allowed to complete the work.

Development on the hotel continued, nonetheless. Most of the mural is now blocked from public view by the Hawaii Prince Hotel. Wyland says that by blocking out the wall, the developer has created an appropriate metaphor for what has happened to the whales — they are being closed out by man.

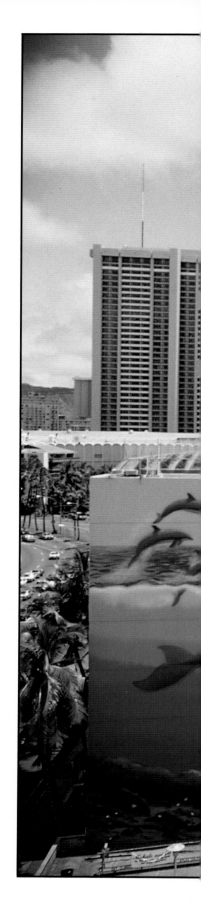

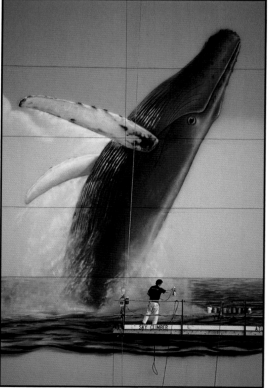

PAINTING "LIFESIZE" BREACHING HUMPBACKS

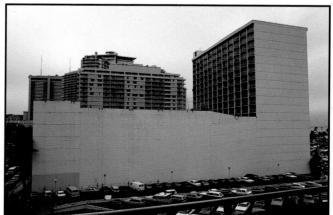

HONOLULU WALL UNPAINTED, CHRISTMAS DAY 1984

▲ **1985 Whaling Wall VI** — Honolulu, Hawaii — 300 feet long x 20 stories high — Dedicated April 21, 1985 by Russ Francis, San Francisco 49ers

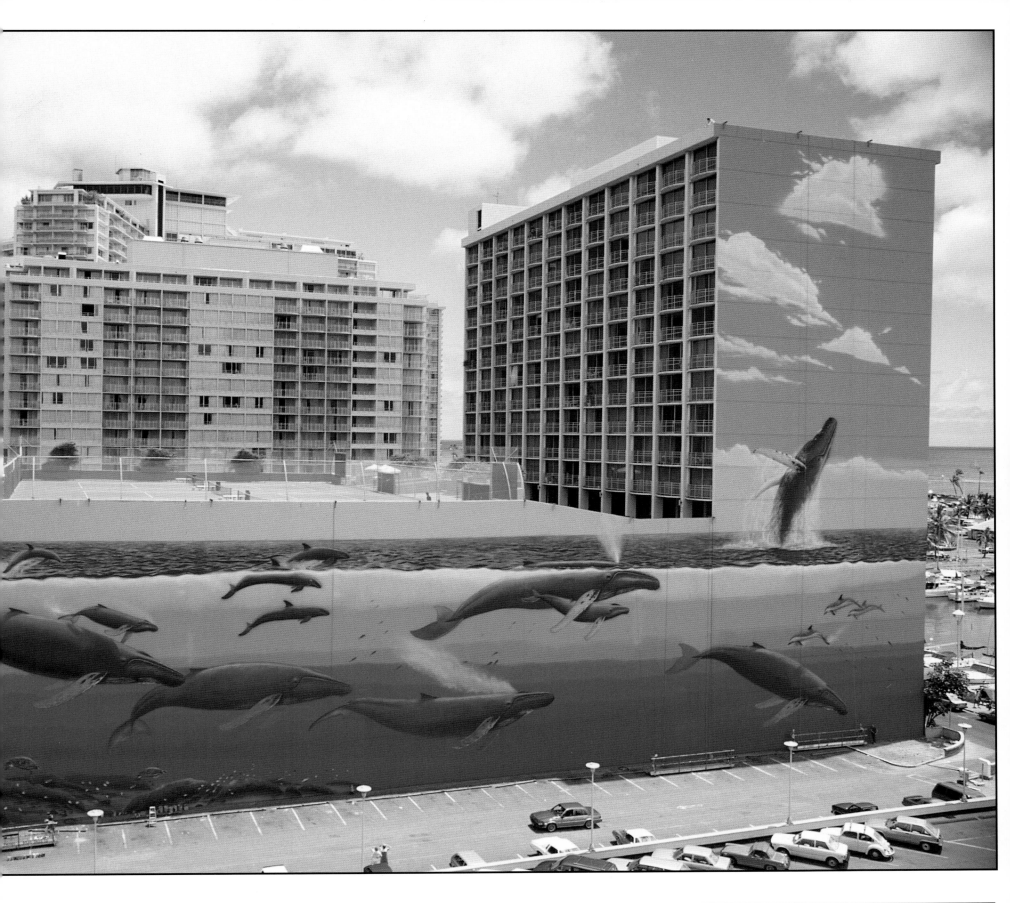

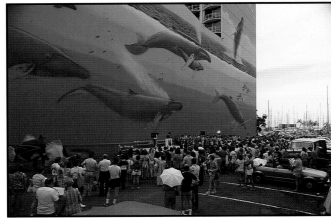

DEDICATION CEREMONY

SIGNING THE MURAL, DEDICATION DAY

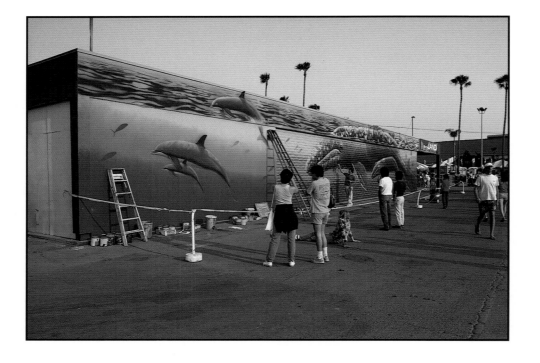

WHALING WALL Ⅶ
C A L I F O R N I A G R E Y W H A L E S

WHALING WALL Ⅷ
O R C A S

After painting the internationally famous mural in Honolulu, Wyland returned to his goal of painting 100 Whaling Walls around the world. His next stop was Del Mar, California.

In trying to expose as many people as he could to his environmental message, he chose a 100'x16' wall on Del Mar's Gem and Minerals Building, close to where an Amtrak train passed by every half hour. The mural shows grey whales swimming behind three playful dolphins.

"One of the most satisfying aspects of doing this wall was that Glenn Frey dedicated the wall and said some very nice things about the project," Wyland says, referring to the popular singer/songwriter and former Eagle. "Like me, he is from Michigan and makes one of his homes in Hawaii. He was a wonderful spokesperson for the mural."

The side of the Canada Life Insurance Company building in Vancouver, British Columbia, provided the surface for Wyland's eighth Whaling Wall. The artist says he wanted the mural to incorporate the environment of Vancouver and its local pods of orca whales swimming through the cool, flat waters.

"When you look at this mural from a distance, it actually blends into its surroundings," Wyland says. "I think the highest thing I can achieve in my work is to make the painting a natural extension of the beauty in the area."

The mural conveys the mystic haze that often hovers over the water near Vancouver in the mornings, and the group of orcas represents a local pod that frequents the region.

Canada Life, the company that sponsored Wyland during the project, was so taken with the mural that they renamed the building. It is now called The Wyland Building.

THE WYLAND BUILDING

▲ 1985 **Whaling Wall Ⅶ** — Del Mar, California — 100 feet long x 16 feet high — Dedicated July 6, 1985 by Glenn Frey, Eagles Singer/Songwriter

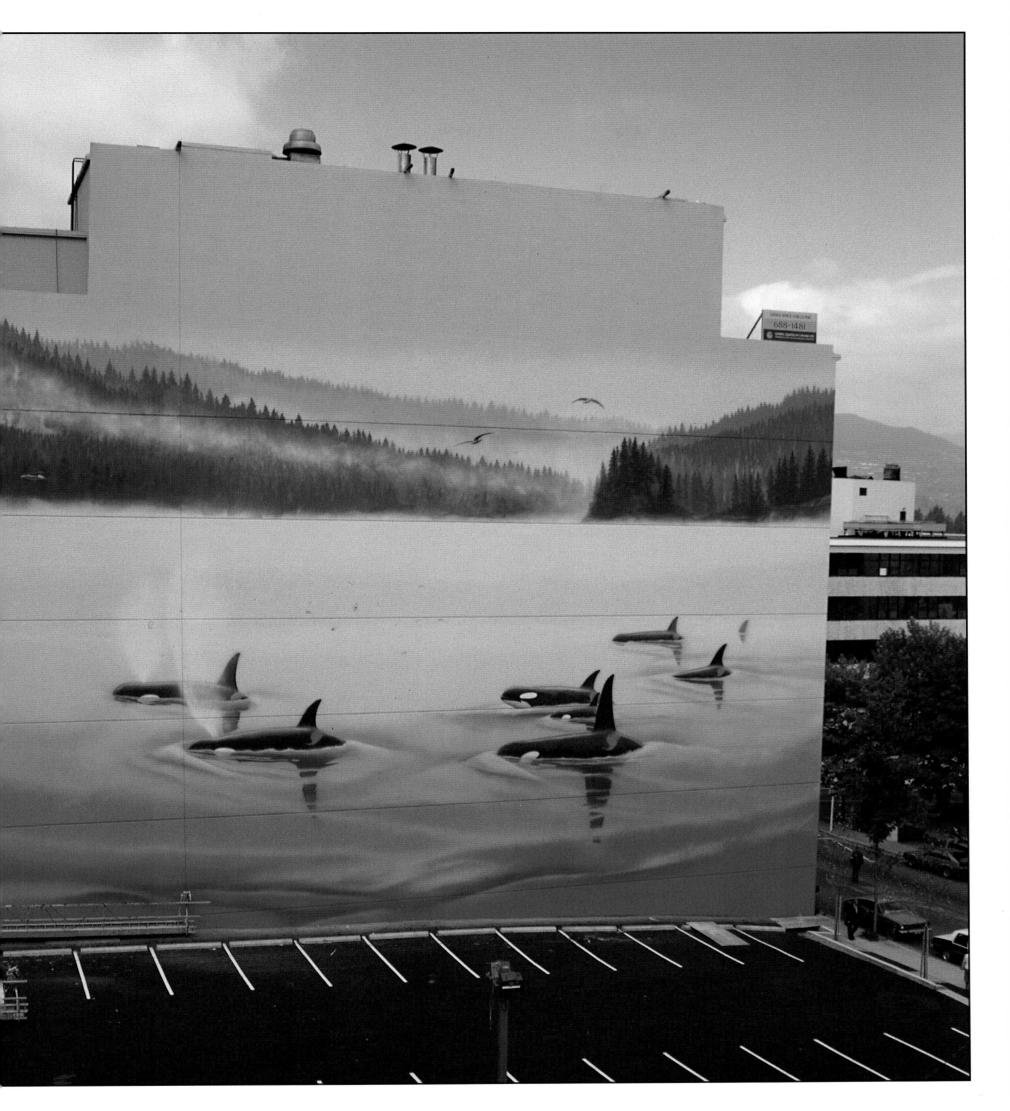

▲ **1985 Whaling Wall VIII**— Vancouver, British Columbia, Canada — 130 feet long x 70 feet high — Dedicated September 10, 1985 by Michael Harcourt, Mayor of Vancouver

"First Voyage," which depicts the Polynesians' discovery of the Hawaiian Islands, was the first time Wyland incorporated humans into one of his Whaling Walls. The double-hulled canoes bearing the sturdy voyagers are escorted into the island by spirited dolphins who, perhaps, had never before seen humans and their sailing vessels.

"I had to do extensive research to make sure these canoes were accurate," Wyland explains. "I also had to be very accurate about the clothing that ancient Polynesians wore at the time. I really enjoy this aspect of my art, studying the subjects and trying to be as authentic as I can."

Magnum P.I. star John Hillerman dedicated this mural at the Polynesian Cultural Center.

Wyland's 10th Whaling Wall featured a different kind of marine mammal — the manatee. The artist was invited by Florida Governor Bob Graham and singer Jimmy Buffett, founder of the Save the Manatees Committee, to paint the endangered manatee at the Orlando International Airport.

Before he painted the mural, Wyland went diving at Blue Springs, Florida, and encountered several manatees up close. After spending four hours face-to-face with a group of the friendly creatures, he not only knew exactly how he would paint his mural, but he also was deeply affected by the experience.

"If you look at the painting, you'll see that I spent a lot of time with the eyes trying to capture the soul of this animal," Wyland explains. "I also painted some of the fungi on the mother's back, and you can see a few prop (propeller) marks as well. Manatees are often hit by sporting boats because they're slow-moving animals, and many of them have prop marks on their backs because they have trouble getting out of the way.

"Jimmy Buffett and the Save the Manatees group have done a tremendous job of raising awareness that these Florida waters are the only natural habitat for the manatees. People need to be more aware because these mammals are very fragile and sensitive to this ever-shrinking environment."

▲ **1986 Whaling Wall IX** — Polynesian Cultural Center, Oahu, Hawaii — 130 feet long x 14 feet high. Dedicated February 4, 1986 by John Hillerman, Actor

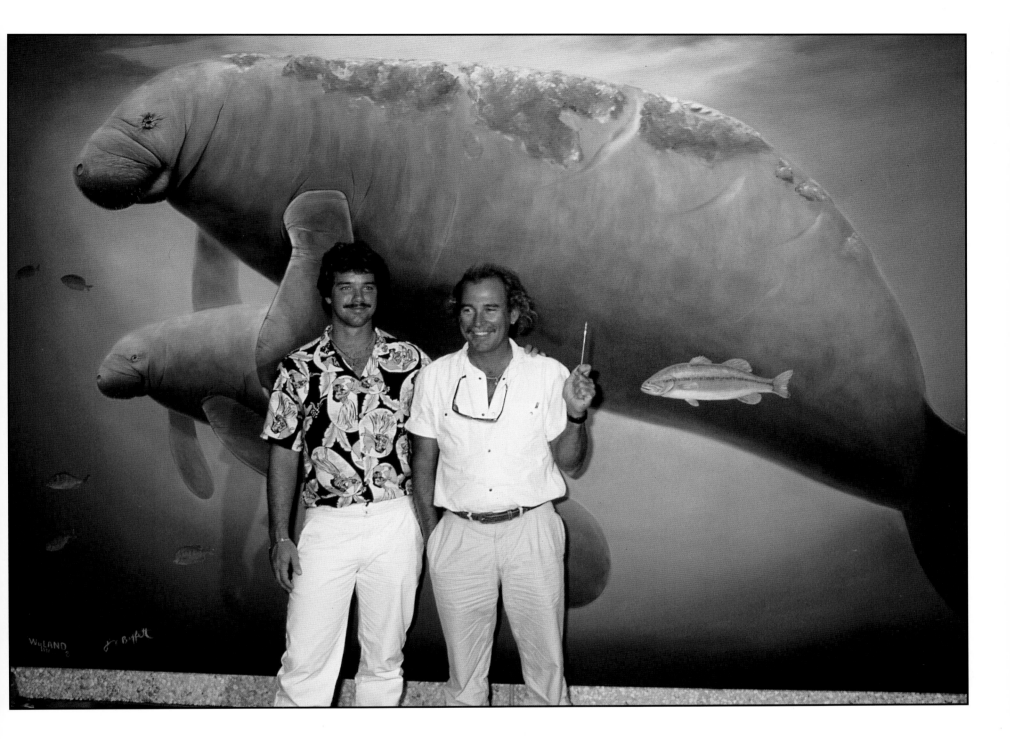

...If we can save our oceans, we have a real chance of saving ourselves...

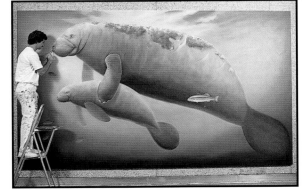

PAINTING LIFESIZE MANATEES, ORLANDO INTERNATIONAL AIRPORT

Whaling Wall X — Orlando, Florida — 14 feet long x 8 feet high — Dedicated 1986 by Jimmy Buffet, Singer/Songwriter

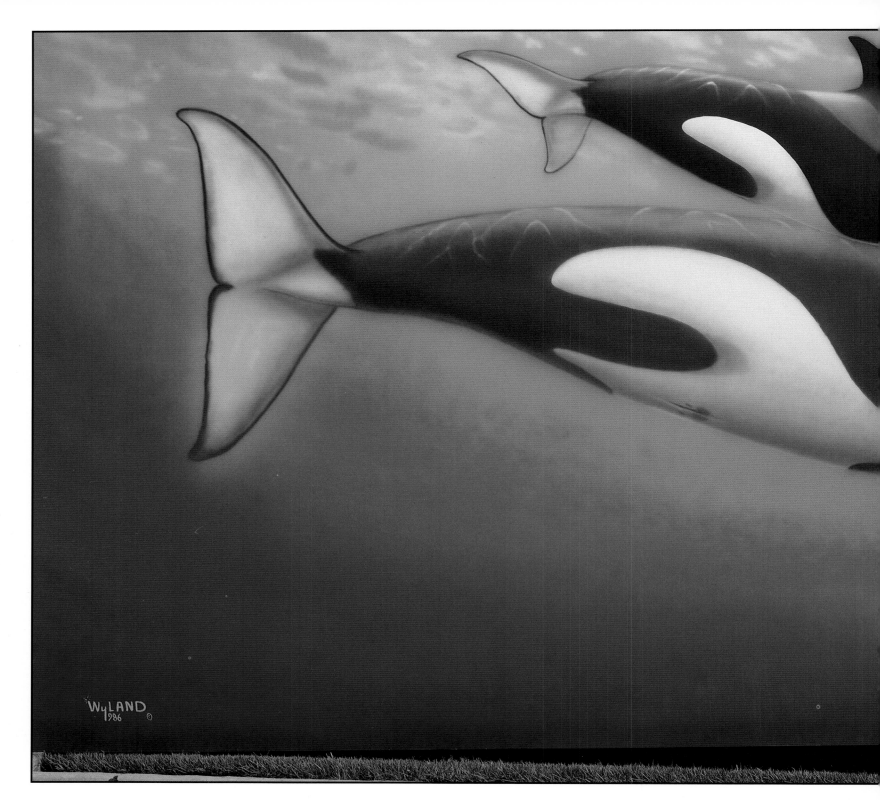

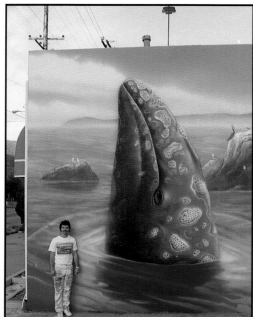

WHALING WALL XII

L A G U N A C O A S T

This mural was painted in 1987 on the side of Wyland's studio gallery in Laguna Beach. In the painting, a grey whale is "spyhopping" and looking at each and every person that drives past her on the way out of town.

"What I wanted to do is leave an impression about the Laguna coast and its fantastic marine life, including whales and the many different kinds of birds," Wyland says. "The wall is painted in such a way that you can't ignore it."

As for "politics and red tape," the likes of which Wyland experienced the first time he painted a wall in Laguna Beach, there weren't any this time. In fact, instead of controversy, the artist was greeted with a resounding proclamation from the city.

"I think the city is now beginning to realize the importance the murals have to the community," Wyland says.

▲ **1987 Whaling Wall XII** — Laguna Beach, California — 20 feet long x 24 feet high. Dedicated February 2, 1987 by Darlene Wyland – Artist's Mom

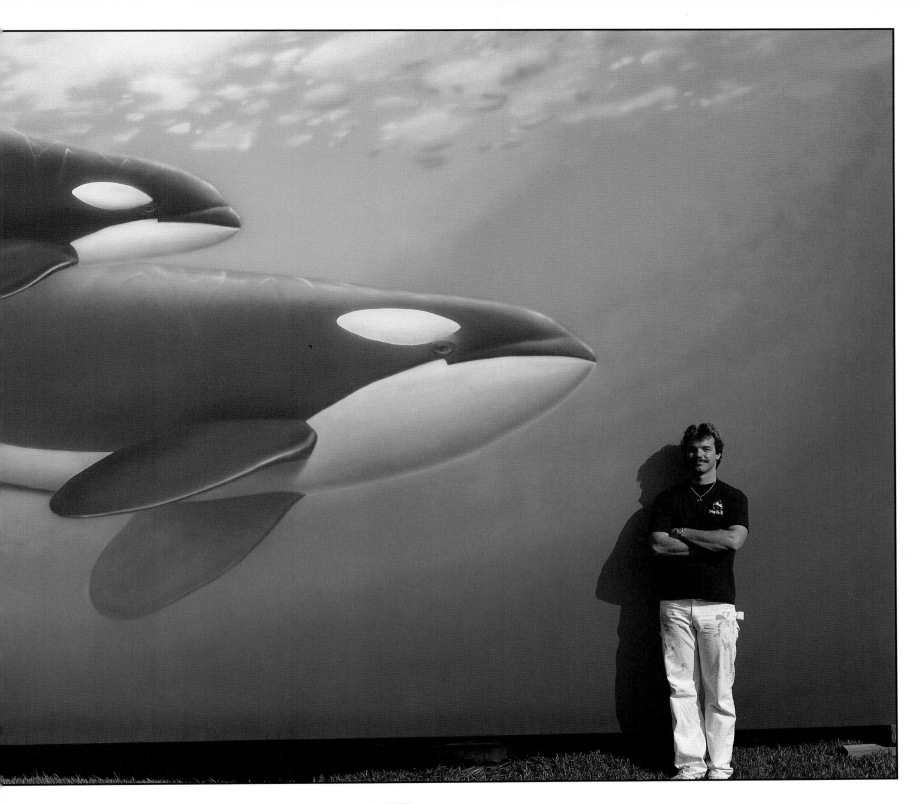

WHALING WALL XI

F I R S T B O R N

When Wyland granted a request from Sea World in Orlando, Florida, to paint a mural of a baby orca whale and her mother, it was the first time the artist had done an actual portrait of his subjects.

The birth of Baby Shamu to her mother, Kandu, demonstrated that killer whales can be born and thrive under the care of man, which is a breakthrough contribution to the preservation of the orca for generations to come.

"The baby was one year old, and the unique thing was that we dedicated this mural at the exact time she had been born one year earlier," Wyland says. "This project was special for me in that I learned so much from studying and drawing these whales before I painted their portrait. The baby actually had some of the same markings the mother had and, to me, that's very special."

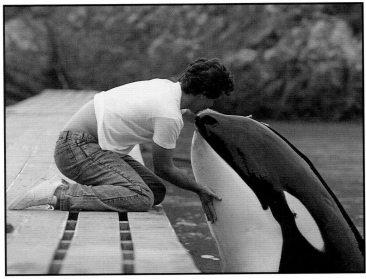

WITH ORCA, TAIJI JAPAN

1986 Whaling Wall XI — Sea World, Orlando, Florida — 30 feet long x 12 feet high. Dedicated September 26, 1986 by Bill Evans, Washington, D.C.

WHALING WALL XIV

SPERM WHALES

After the president of the Tokyo Bay Citizens Council saw Wyland's spectacular Whaling Wall VI in Hawaii, he invited the artist to come to Japan and paint a mural. Consisting mostly of local fishermen, residents and conservationists, the council was alarmed at the rate of development in Tokyo Bay, which they felt had already ruined much of the bay's fishing and marine ecosystem.

Wyland, on the other hand, had been looking for a way to make a statement in Japan. Preferring as always to remain apolitical about his commitment to the world's oceans, he wanted instead to use his art to expose the Japanese to the delicate beauty of whales and other creatures of the sea.

"I chose the sperm whale as my subject because they were being hunted off the coast of Japan at the time," Wyland explains. "I painted two of the whales on the seawall at Funabashi, and I wasn't sure how they would be received. But the Japanese people really appreciate art and artists, and their response was overwhelmingly positive. The mural was very beautiful and unique to them.

"I feel pretty confident in saying that this was probably the first time most Japanese had seen a whale, other than on a dinner plate."

Wyland felt he needed to make yet a bigger statement in Japan, and he took the opportunity during this first trip to visit the old whaling village of Taiji, where Japanese whaling had begun centuries earlier. He met the mayor of Taiji and talked to him about the possibility of one day replacing the country's whaling industry with whale-watching. The mayor appeared receptive, so the artist vowed he would return one day and paint a mural in the village. He even picked out a wall, located on the side of the Taiji whaling museum. Four years later, he fulfilled his vow.

POSTCARD

WHALING WALL XIII

ORCAS A-5 POD

Wyland considers Whaling Wall XIII to be one of his most unique murals because it pictures an actual pod of orca whales that lives off of Vancouver Island. This particular pod contains 13 orcas known as the "A-5 Pod." The dominant male in the group, "A-5," has a large, distinctive six-foot dorsal fin with a nick.

Each member of the pod was painted in its true size with its individual features. The mother of the baby orca in the lower left corner of the mural, for instance, is named "Sharky" because her dorsal fin looks like that of a shark.

"I worked with the top scientists in the world on this project — Mike Bigg, Graham Ellis and John Ford," Wyland says. "Mike Bigg is noted as the top orca researcher in the world, and he has been studying these whales and these waters for 30 years. I actually had Mike get up on the scaffolding with me with a piece of chalk and a photograph of each of the whales to help me correct the anatomy on each whale."

Wyland was particularly pleased that his friend, artist Robert Bateman, who is considered by many to be the world's leading wildlife artist, flew in from his nearby home on Salt Spring Island to dedicate the wall to the city of Victoria. During the ceremony, Bateman looked up and noticed a bald eagle in the painting and said jokingly, "Wyland, I thought we had an agreement — you were going to paint below the ocean, and I was going to paint above. I think you're starting to take over."

Wyland included the bald eagle at the request of a native Indian who showed him one of the great birds pictured on a postcard and asked him if he would consider adding it to the mu... Wyland took the man up on the scaffolding and painted it in for a moment the artist still recalls with great pride.

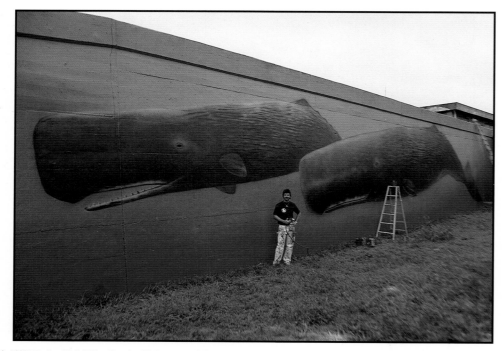

▲ **1987 Whaling Wall XIV** — Funabashi, Japan — 140 feet long x 18 feet high — Dedicated October 14, 1987 by Dr. Goro Tomeraga, Professor Emeritus, and Mr. Ono

1987 Whaling Wall XIII — Victoria, British Columbia, Canada — 130 feet long x 4 stories high — Dedicated June 20, 1987. In memory of Robin Morton, dedicated by Robert Bateman

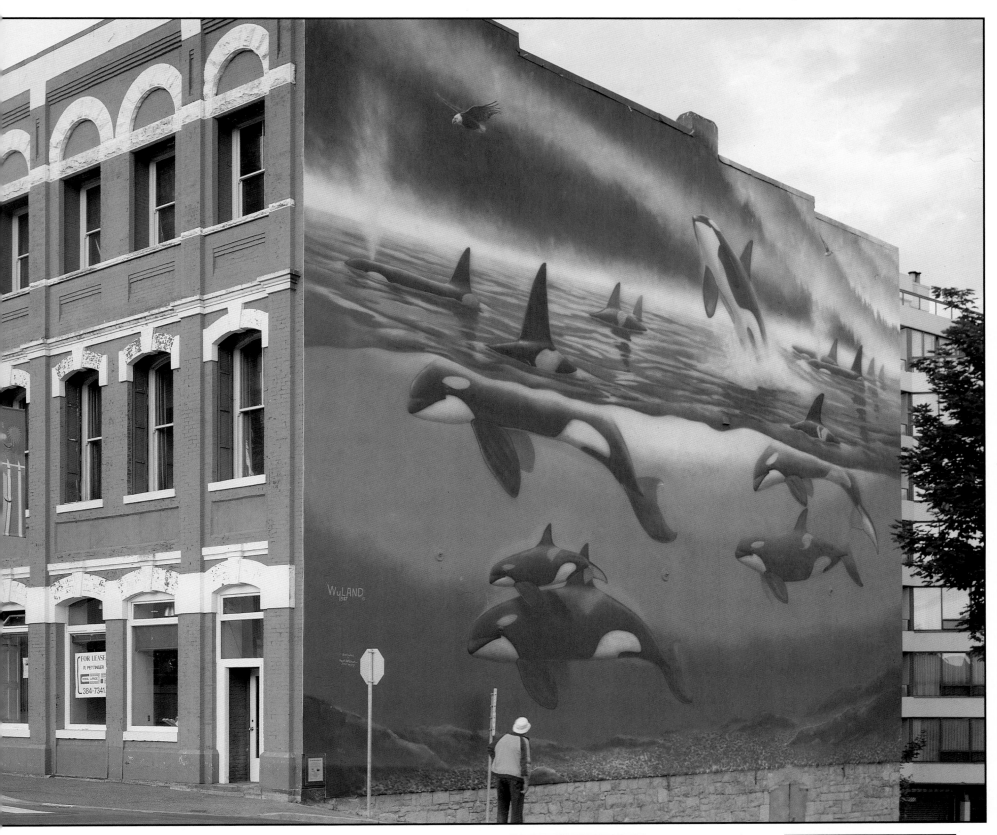

VIEW ACROSS THE STREET, VICTORIA, B.C.

ROBERT BATEMAN DEDICATING MURAL

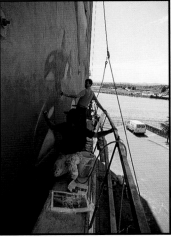

MIKE BIGG EXPLAINING ORCA ANATOMY

WHALING WALL XV

DOLPHINS OFF MAKAPUU POINT

WHALING WALL XVI

ORCAS OFF POINT LOMA

When Wyland climbed up on his scaffolding to paint Whaling Wall XV at Oahu's Sea Life Park, he had planned to paint Pacific bottlenose dolphins only. But, when he turned around and looked back at the sea, he saw a breathtaking view of the beautiful turquoise and azure waters off Makapuu Point, and he changed his mind.

The mural at the popular park now bears the life-size bottlenose dolphins Wyland had wanted to paint, but it also shows the stunning landmark of Makapuu Point in the backgound. "I have a special love for Sea Life Park and this area because this is where I conducted much of my research on dolphins and other sea creatures," the artist says.

Singer/songwriter Henry Kapono, a good friend of Wyland's, dedicated the wall and then gave a concert at the park in honor of the mural. The singer has since written a special song for his friend called "Wyland's Song."

An indoor swimming pool in Mission Beach, California, would provide the stage for Wyland's next mural. Appropriately called "The Plunge," the huge pool had served local residents in the area since the '20s. Having been recently restored, the owners of the pool wanted Wyland to paint the large wall that overlooks the water, which, at one time, had actually borne another mural.

Wyland saw this project as an excellent opportunity to paint the orca whales that frequented the waters off Point Loma. San Diego researchers took him out in a boat and showed him a local pod they had been studying, and soon thereafter, this group of life-size orcas was giving the word "plunge" new meaning as they loomed high above the old swimming pool.

"Most people don't realize that orcas live off of the California Coast," Wyland points out. "In fact, orcas live in almost all of the oceans on earth. I hope people will begin to realize just how precious they are and that they existed on this planet long before man claimed it for his own."

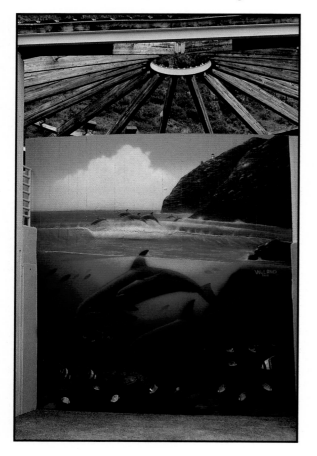

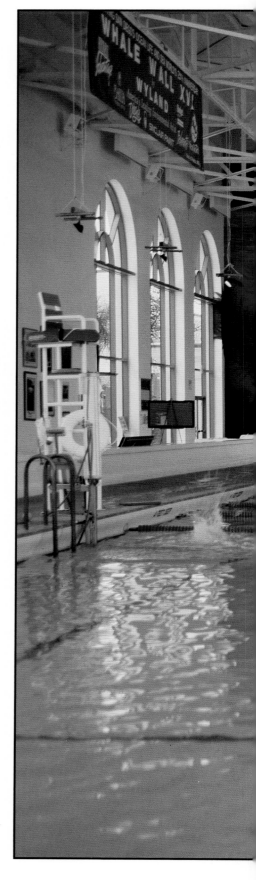

▲ **1988 Whaling Wall XV** — Sea Life Park, Oahu, Hawaii — 24 feet long x 30 feet high — Dedicated by Henry Kapono, Singer/Songwriter

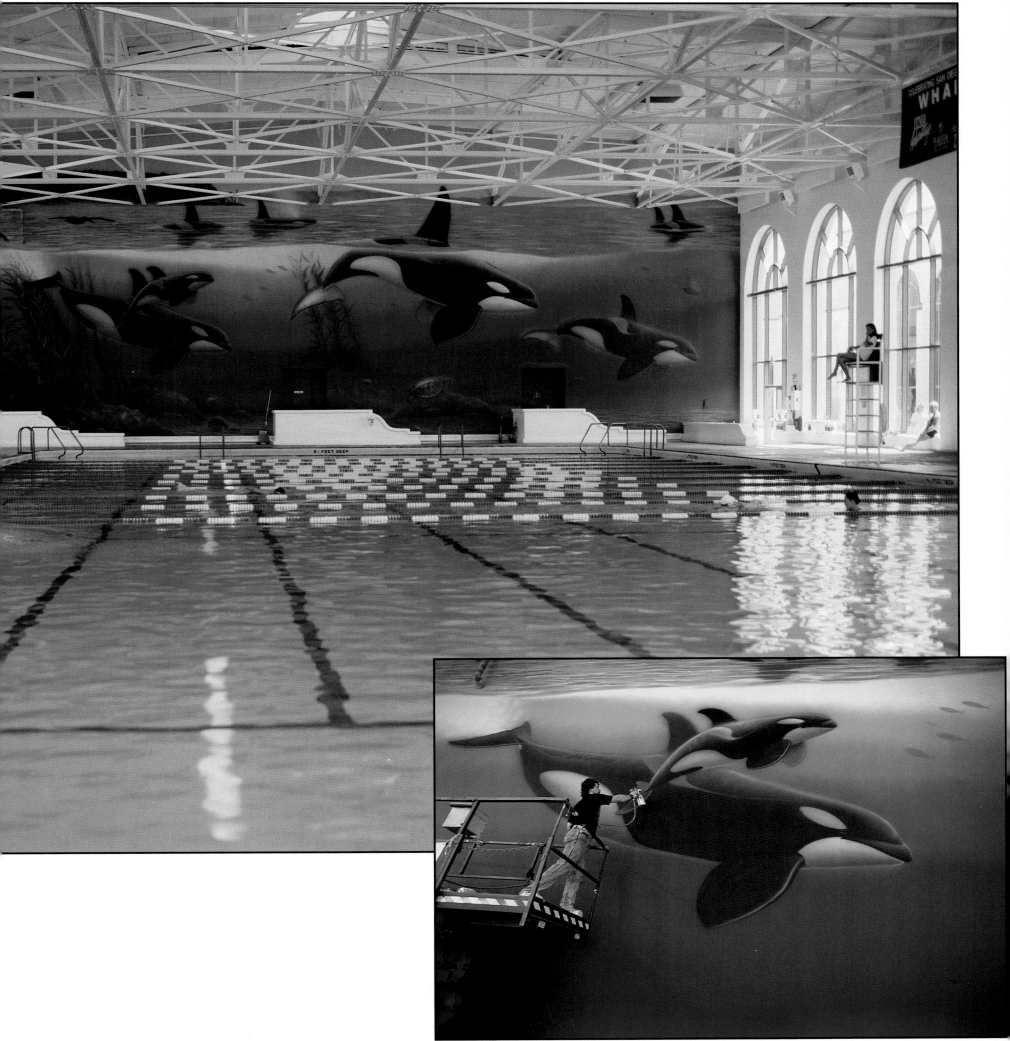

PAINTING ORCAS, SAN DIEGO, CALIFORNIA

Whaling Wall XVI — The Plunge, Mission Beach, San Diego, California — 140 feet long x 40 feet high — Dedicated June 29, 1989 by Bob Gault, President of Sea World

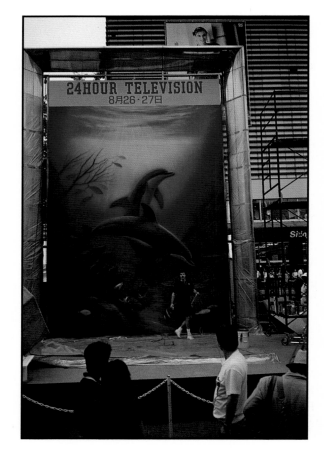

WHALING WALL XVII
BOTTLENOSE DOLPHINS

WHALING WALL XV
SPERM WHALES OFF THE MEDITERRA...

Wyland made his second trip to Japan when he was asked to paint a mural at Sinjiku Station for "24-Hour Television." Essentially, it was a day-long telethon to raise money to help the planet, and Wyland was to complete one of his Whaling Walls within the 24-hour marathon.

"I painted this mural outside in front of literally hundreds of thousands of Japanese citizens," Wyland recalls. "It was carried live over national television, and the message was carried throughout Japan."

The painting depicts two bottlenose dolphins cavorting through the Pacific. Over $70 million was raised during the telethon to fund conservation efforts throughout Japan. Only today have the Japanese begun to realize the impact of over-fishing and misuse of our natural resources. As a result, environmental groups are beginning to emerge within Japan.

Wyland's goal of painting 10 murals throughout the world took ... to Europe, where he painted an 11-s... building in Nice, France. The paint... portrays a mother sperm whale ar... her baby diving through the clear blue waters of the Mediterranean.

Above the ocean looms the French Riviera, with dolphins surfac... "Today, the Mediterranean is dyin... due to pollution and other enviror... mental problems," Wyland says. "... mural is an international symbol to bring attention to these fragile wo... and to educate the public.

"A unique thing happened ... as a result of the building's design... he continues. "Two windows appeared inside the mother and baby whale. I felt the urge to go inside the building and experienc... being inside a whale like Jonah. To say the least, I received a lot of strange looks as people drove pas... their cars."

SUMO WRESTLER KONISHIKI

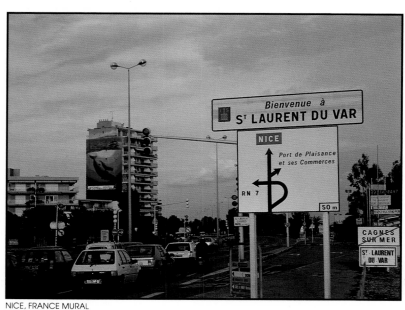

NICE, FRANCE MURAL

▲ **Whaling Wall XVII** — Osaka, Japan — 20 feet long x 30 feet high. Dedicated August 27, 1989 by Mr. Toshita and Kent Fabulous. Wall was painted for a 24-hr. Telethon in Japan

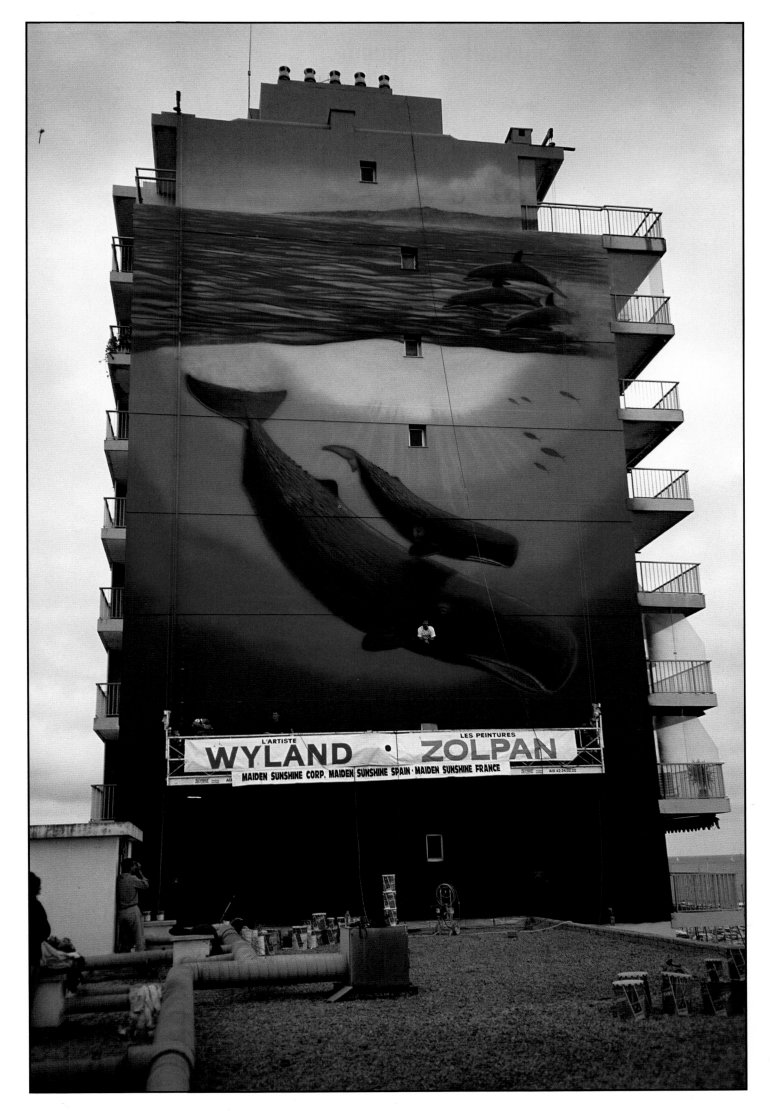

aling Wall XVIII — Nice, France — 42 feet long x 120 feet high — Dedicated October, 1989 by French Government Official

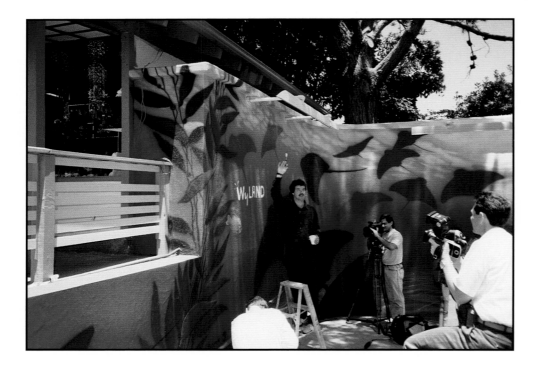

WHALING WALL XIX

FORBIDDEN REEF

Returning from Europe, Wyland began painting two murals for Sea World in San Diego. Forbidden Reef features marine life of Southern California, such as bat rays, eels, garibaldi and other fish of the Pacific.

The exhibit begins with a journey into the ocean realm leading into caverns of natural habitats for these marine creatures.

"Painting the mural was the easy part, and all that was left was to sign my name," Wyland recalls. "I was joking with the media and stated, 'I hope I spelled my name right.' Someone from the audience pointed out that I had, in fact, left out a letter. All I can say is that I tried to buy all the film that was shot that day."

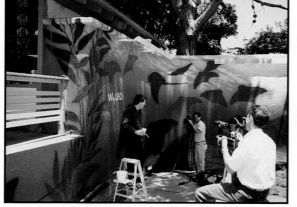

I HOPE I SPELL MY NAME RIGHT

OOPS!

ARTISTS AREN'T KNOWN FOR THEIR SPELLING

▲ **1990 Whaling Wall XIX** — Sea World, San Diego, California — 90 feet long x 14 feet high — Dedicated July 9, 1990 by Michael Peak, Author

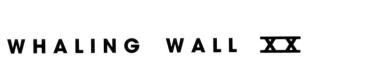

WHALING WALL XX

GREY WHALE MIGRATION

"If I was to build a perfect wall for one of my murals, it would be just like the one I painted at Sea World," Wyland says. "The wall was long enough to feature three grey whales and literally curved around the viewer, creating a three-dimensional quality."

Wyland's 20th Whaling Wall was completed in front of 30,000 people a day during the summer of 1990. The wall has become a favorite photo location for the 4 million who visit Sea World each year.

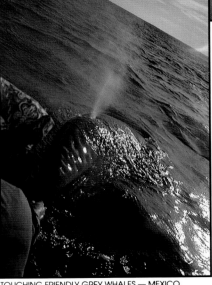

TOUCHING FRIENDLY GREY WHALES — MEXICO

1990 Whaling Wall XX — Sea World, San Diego, California — 80 feet long x 15 feet high — Dedicated July 9, 1990 by Bob Gault, President of Sea World

W H A L I N G W A L L XXI

W A S H I N G T O N O R C A S

During the Goodwill Games in the summer of 1990, Wyland traveled to Washington to complete Whaling Wall XXI. He began by painting Mount Rainier and the Pacific's cool waters, home to many pods of killer whales.

"I wanted to portray a family of orcas travelling the waters off the Washington Coast," explains the artist. "A mother orca teaches her baby to breach as a bald eagle soars by, a scene very familiar to local residents."

As he neared completion of the mural, it occurred to Wyland that the Goodwill Games should thereafter be called the "Goodwhale Games."

W H A L I N G W A L L XXII

O R C A H E A V E N

"This by far is my most unique mural in that it's the first one I painted on a ceiling," says Wyland. "When I first saw this ceiling, I had an immediate vision of orcas swimming overhead. And I wanted to give the illusion of being under-water looking up at the surface of the ocean as the powerful orcas swam above."

The background colors developed naturally until the artist began painting the first whale. Having trouble with the perspective, Wyland's brother, Bill, suggested that he tape a piece of chalk onto a yardstick and lay on his back to sketch in the whale.

"At first, I resisted," Wyland explains. "But, finally, I decided to try this technique and found it to be the solution to the problem. From there, it was simply a matter of painting in the chalk drawing. I was able to complete the ceiling in only three days."

▲ **1990 Whaling Wall XXI** — Tacoma, Washington — 120 feet long x 45 feet high — Dedicated July, 1990 by Tacoma Mayor, Karen Vialle

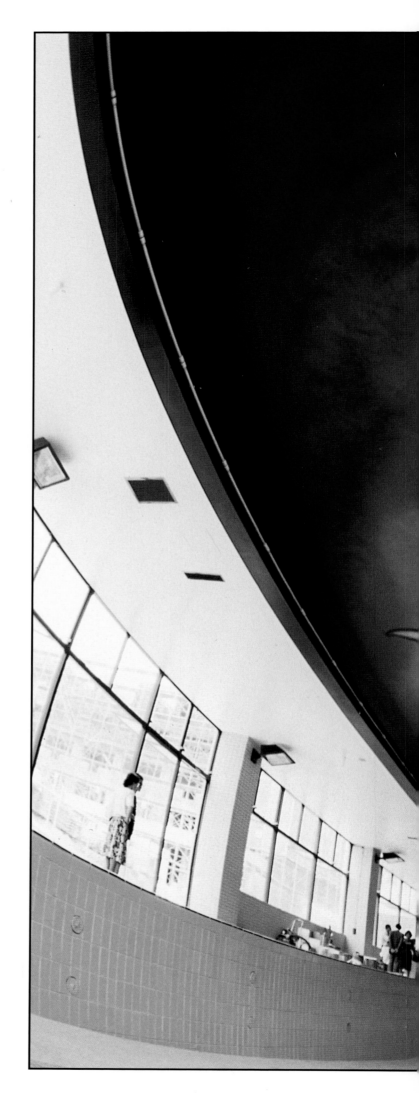

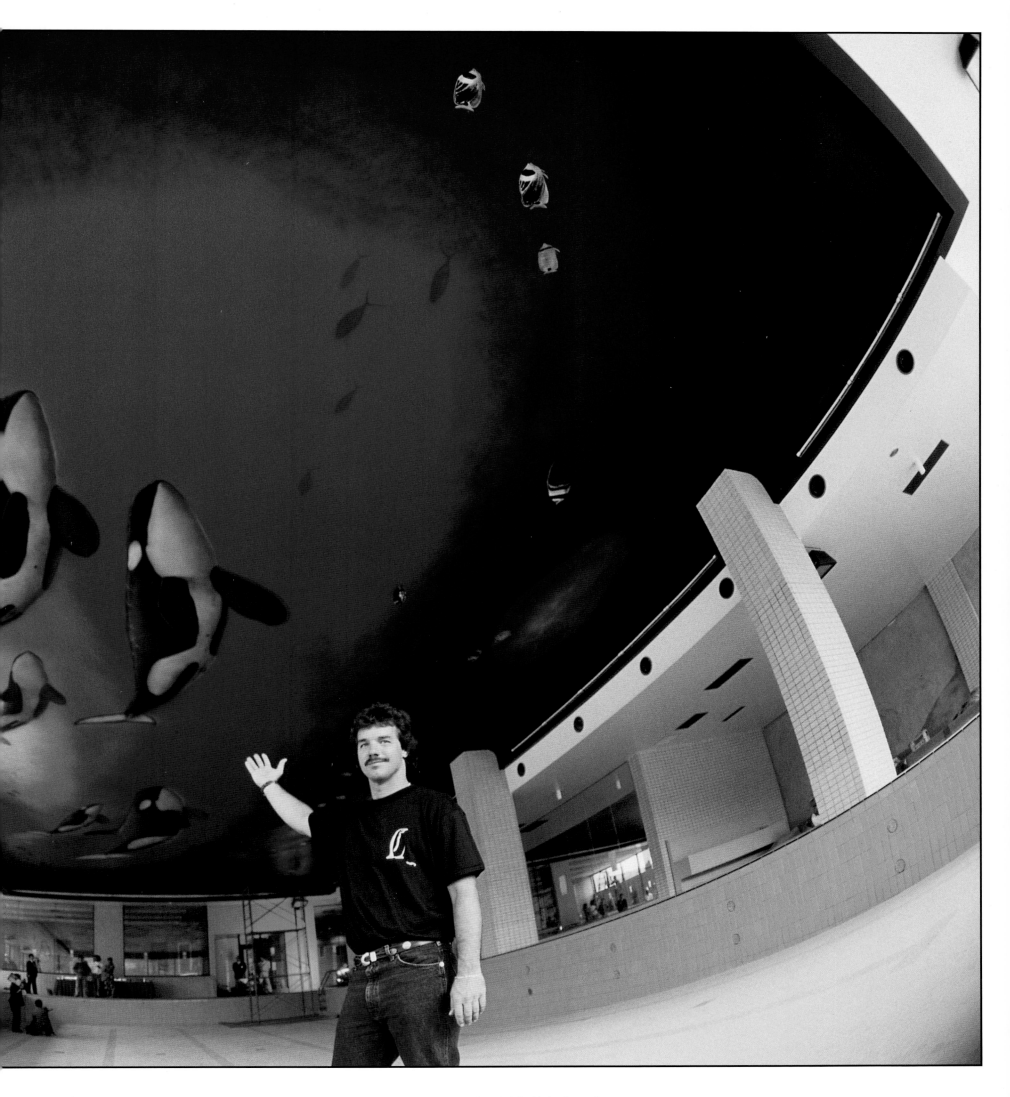

1990 Whaling Wall XXII — Yamagata, Japan (Ceiling) — 145 feet long x 45 feet high — Dedicated 1990 by Mr. Kawada, President, Sun Marina Corporation

WHALING WALL XXIII

100

After completing the ceiling mural in Yamagata, Japan, Wyland boarded a plane to begin painting his first mural in the Southern Hemisphere. The city of Bundaberg, Australia, rolled out the red carpet for Wyland and crew as he began painting a huge building in the center of the city.

Wyland spent a lot of time diving the Great Barrier Reef in preparation for the mural. Humpback whales frequent these waters along with loggerhead turtles and other diverse marine life. Upon completing the mural, the city hosted the artist in a lighting ceremony that was attended by over 5,000 people.

"It was the warmest reception I have ever received," he says. "It seemed the entire community became involved in this project, and I was invited to paint a second mural in Australia at the Sydney Aquarium."

WHALING WALL XXIV

HUMPBACK AND CALF

The Sydney Aquarium in Darling Harbor hosted Wyland's second mural in Australia. Upon entering the famous aquarium, visitors encountered for the first time a life-size portrait of humpback whales.

"This painting represents my most realistic portrayal of a mother humpback with her baby swimming through a cathedral of light," Wyland says.

Darling Harbor — one of Sydney's most populated areas — is visited annually by millions of international travelers as well as local citizens. As a result, the mural offers a far-reaching message about the ocean's gentle giants.

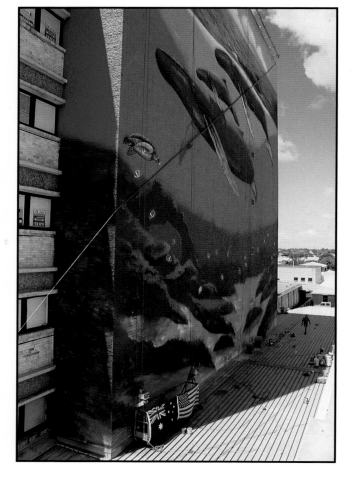

▲ 1990 Whaling Wall XXIII — Bundaberg, Australia — 125 feet long x 95 feet high — Dedicated September 28, 1990 by John Nielsen

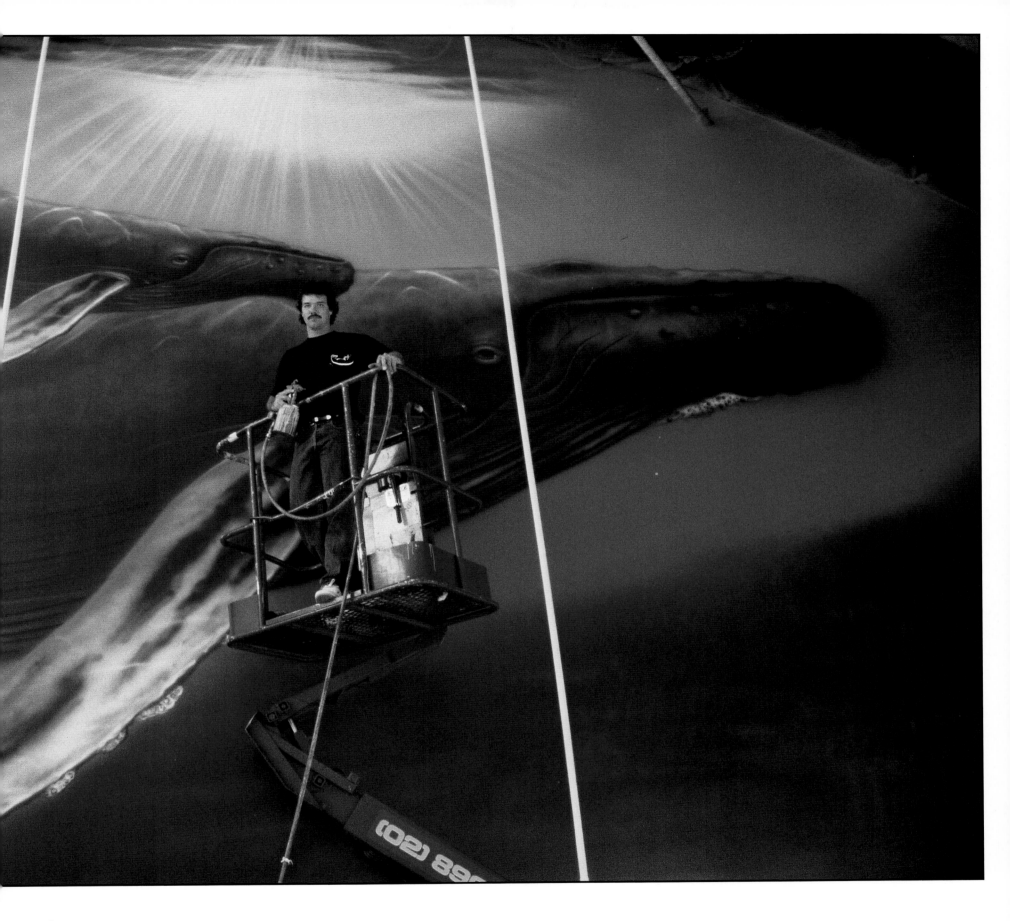

...Whales swim through a cathedral of light pyramiding through the deep blue ocean, creating a spiritual sensation unequalled...

1990 Whaling Wall XXIV — Sydney Aquarium, Sydney, Australia — 90 feet long x 35 feet high — Dedicated September 28, 1990 by Jim Longley, Parliament, New South Wales

WHALING WALL XXV
HUMPBACKS

At his 15-year high school reunion, Wyland was asked by his former high school principal, Jim McCann, to paint a mural for his alma mater. Wyland agreed. After presentations to the students of Lamphere High School and Page Junior High School, Wyland and a group of art students began painting Whaling Wall XXV.

Wyland taught his mural technique to the students as they completed the painting on a large wall overlooking the school's swimming pool. The mural was finished in an 18-hour marathon, attended by hundreds of Wyland's former classmates and teachers, as well as his dad.

"It felt great to give something back to my school and share my work with the young artists," Wyland says proudly. A art scholarship in his name was established to support and encourage aspiring young artists.

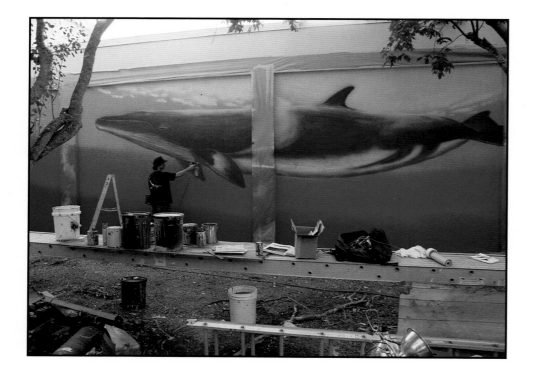

WHALING WALL XXVII
MINKE WHALES

A second mural in Marathon in the Florida Keys was completed at the Natural History Museum in only three hours. The painting features a minke whale with a green sea turtle and a large manta ray.

"The mural reveals windows into the ocean allowing the viewer to encounter these fascinating creatures," says Wyland. "The museum has many classrooms of students, and this mural provides them with a firsthand look at these animals in their true size."

▲ **1990 Whaling Wall XXV** — Lamphere High School, Detroit, Michigan — 110 feet long x 15 feet high.
Dedicated October 31, 1990 by James McCann, Principal

▲ **Whaling Wall XXVII** — Marathon, Keyes, Florida — Museum of Natural History — 40 feet long x 8 feet high
Dedicated October 30, 1990 by Mandy Rodriquez, Dolphin Research Center

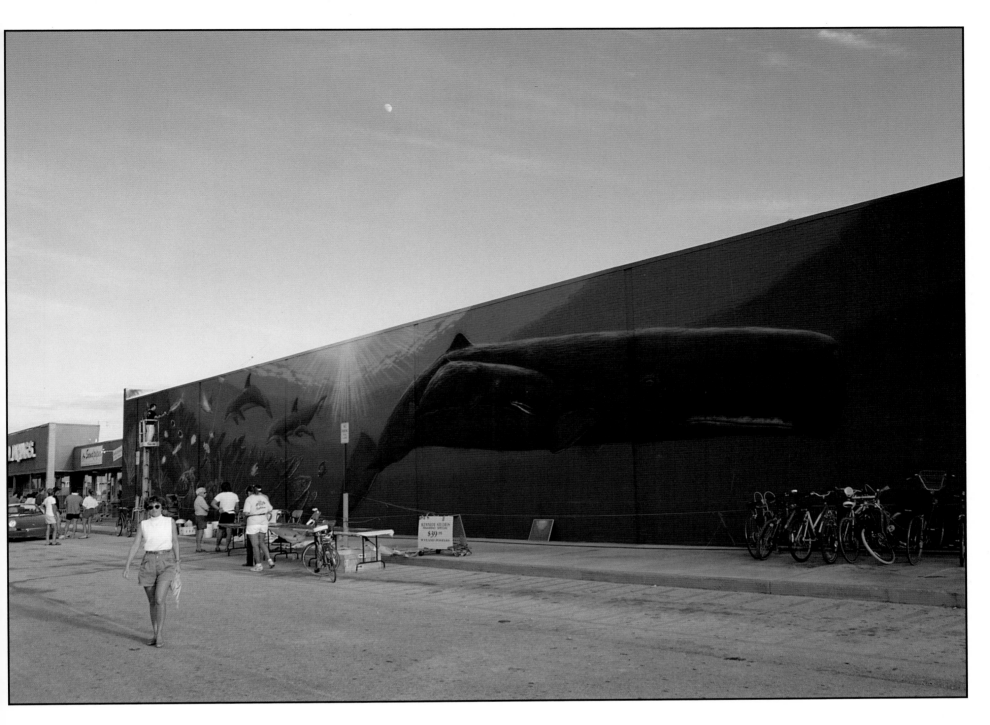

WHALING WALL XXVI

S P E R M W H A L E S A N D F L O R I D A R E E F

Dolphin Research Center director and longtime friend Mandy Rodriquez secured two wall locations in the Florida Keys for Wyland murals. By far the largest wall in the area was on the K-Mart building fronting the A1A Highway.

"I wanted to showcase the variety of sealife found in the Florida Keys, and this wall was ideal for that purpose," Wyland says. "Having spent years diving in the area, I was anxious to paint the many living reefs and animals that inhabit these waters.

"This sensitive ecosystem is being destroyed by man's misuse and over-development, and I wanted to bring attention to this critical situation. I hope in some small way the mural will be a reminder to all who view it that we must save our living reefs."

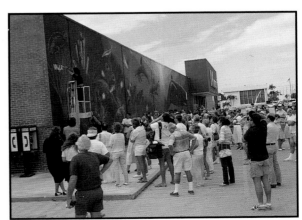

DEDICATION FLORIDA KEYS MURAL

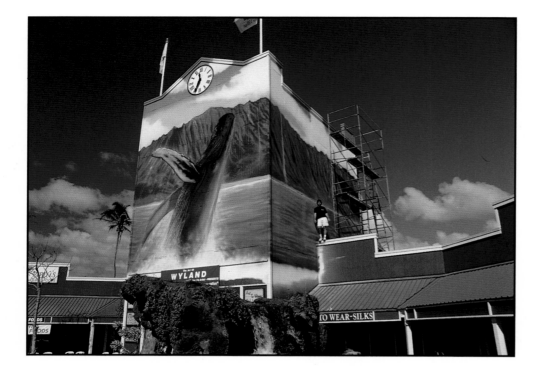

WHALING WALL XXVIII

A TIME FOR CONSERVATION

Again feeling the need to express his art, Wyland completed two murals in Kapaa, Kauai. The first was a clock tower and, as he began painting around the 360-degree tower, a message rang out loud and clear to him: "It's time for conservation."

As a humpback whale breached across the rugged Na Pali coast, the painting came alive. "As I stood on the scaffolding painting this great whale, I realized how magnificent these creatures are," Wyland recalls. "The only thing that compares to painting the animal lifesize would be witnessing the living whale clearing its 40 tons out of the ocean. You could almost feel the salt spray as the mural was completed." This is the first time I've used the Hawaiian landscape in one of my Whaling Walls."

WHALING WALL XXIX

HUMPBACKS OFF THE NA PALI COAST

After completing the clock mural in Kapaa, Kauai, Wyland painted a companion mural nearby. The painting depicts the long, rugged Na Pali coast and offers a view of the shore from above and below the ocean.

Featured in the mural are a life-size green sea turtle and Wyland's first Hawaiian Monk seal, which is indigenous to the waters of Kauai.

"The monk seal is very endangered, and I wanted to bring some attention to this incredible native of the islands," says Wyland. "The mural seems to blend into the natural environment as the clouds drift across the sky and into the painting, becoming one with the land."

WATCHING WHALES

▲ **Whaling Wall XXVIII** — Kauai Village, Kauai, Hawaii — 44 feet high walls, 360 degree mural on clock tower — Dedicated January 8, 1991 By Ron Kouchi, County Council Chairman

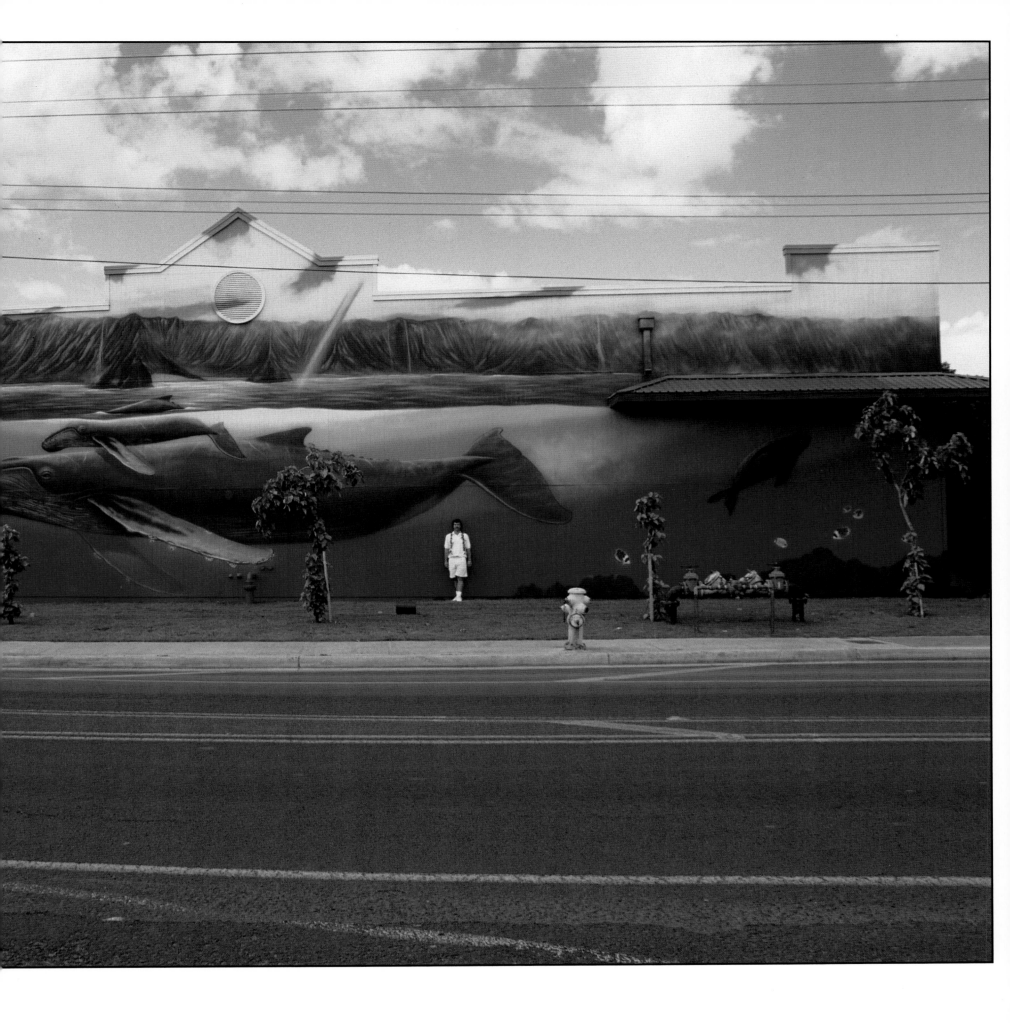

Whaling Wall XXIX — Kauai, Hawaii — 150 feet long x 24 feet high — Dedicated January 8, 1991 By Peter Alevizos, Kauai Village President

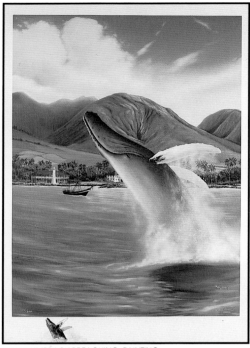

MAUI HUMPBACK BREACHING, PAINTING

WHALING WALL XXX

MAUI HUMPBACK BREACHING

"When I moved to Lahaina, Maui, to study the humpback whales, I had read about Lahaina's whaling days and the waters off of Maui that were breeding grounds of the humpbacks.

"I rented a small studio on Front Street in downtown Lahaina. Each day I'd try to learn about the history . . . I wanted to paint a realistic depiction of Lahaina's whaling past and present.

As soon as I arrived, I noticed a wall rising from the seawall on Front Street. The wall offered me the perfect opportunity to paint a life-size humpback. I did a rendering of what the wall would look like completed and approached the Lahaina Restoration Society with my plans.

"To make a long story short, the mural was rejected. After nine years, I decided it was time for conservation, and the heck with politics. At 3 a.m. on a Friday night, myself and a volunteer crew assembled scaffolding at the base of the wall and began painting. It was dark, and I could barely see the wall, but I had painted the mural in my mind's eye so many times that I could have done it blindfolded. When the sun came up, I was amazed at the detail and beauty of the painting that I had wanted to paint for so many years.

"I knew that I would be subjected to substantial opposition from the 'Lahaina Hysterical Society,' but felt in my heart that the vast majority of people supported our efforts to paint the first Whaling Wall in Lahaina. At a special dedication ceremony and blessing, I was asked how long the mural took to paint. I can honestly say nine years and two days. Today the mural is endangered as are the humpbacks themselves."

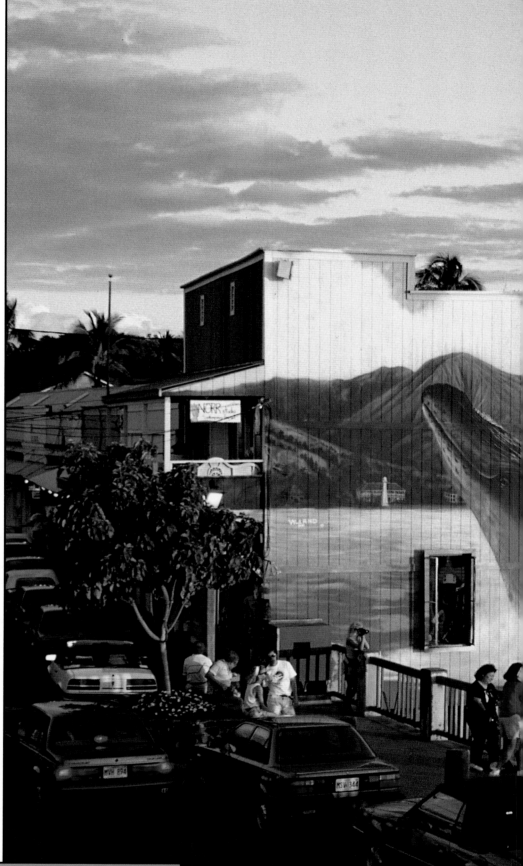

BLANK SEA WALL, LAIHAINA, MAUI

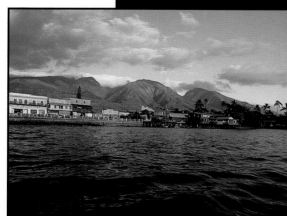

WHALES EYE VIEW OF LAHAINA WALL

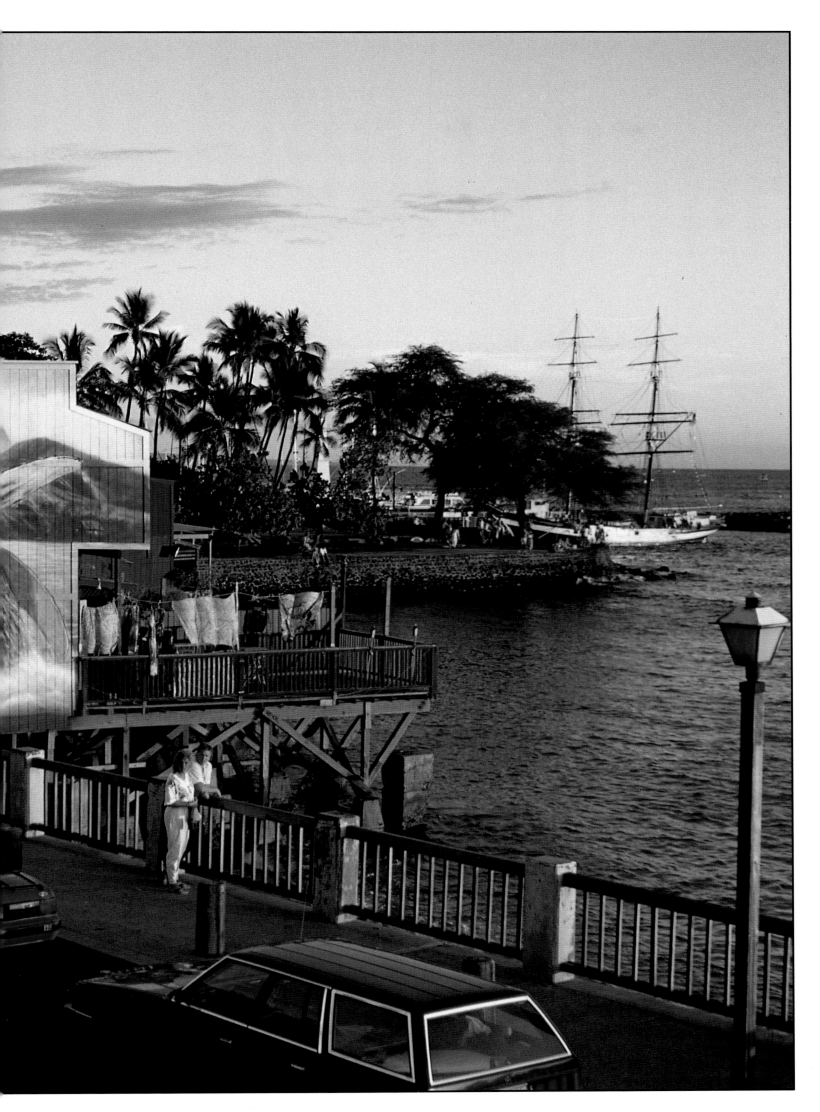

aling Wall XXX—Lahaina, Maui, Hawaii— 26 feet long x 30 feet high. Dedicated January 21, 1991 by John Pitre and Jerry Lopez

WHALING WALL XXXI

GREY WHALE MIGRATION

The city of Redondo Beach, California, asked Wyland to paint a giant mural on the side of the Southern California Edison Power Plant. The massive wall was an industrial eyesore in the community, and the chamber of commerce, along with numerous city officials, invited Wyland to Redondo Beach to see it.

"This, by far, was the ugliest wall I had ever seen," Wyland recalls. "But at the same time, I was awed by its sheer size and potential for a Whaling Wall. I immediately envisioned an entire pod of grey whales migrating across the wall."

Wyland began painting the mural in June of 1991. The city felt it would take 12 months to complete the mural, but Wyland insisted he could complete it in 12 days. After spraying over 3,000 gallons of paint and covering nearly an acre and a half, the 622-foot-long by 10-story-high wall was completed in a record 11 days.

Along with nine life-size grey whales, Wyland painted his first blue whale, over 100 feet long, accompanied by Pacific bottlenose dolphins and giant kelp forests 70 feet high and reaching the surface of the ocean.

The mural, considered the largest of its kind in the United States, can be seen from Catalina Island, 26 miles away.

"Probably the most unusual thing about this mural is the unique Halogen lighting that Southern California Edison provided to enhance its beauty at night," Wyland says. "Now the mural can be enjoyed 24 hours a day."

▶ **Whaling Wall XXXI** — Redondo Beach, Califonia — 622 feet long x 100 feet high (1-1/4 acre). Dedicated June 24, 1991 by John Bryson, CEO, Southern California Edison

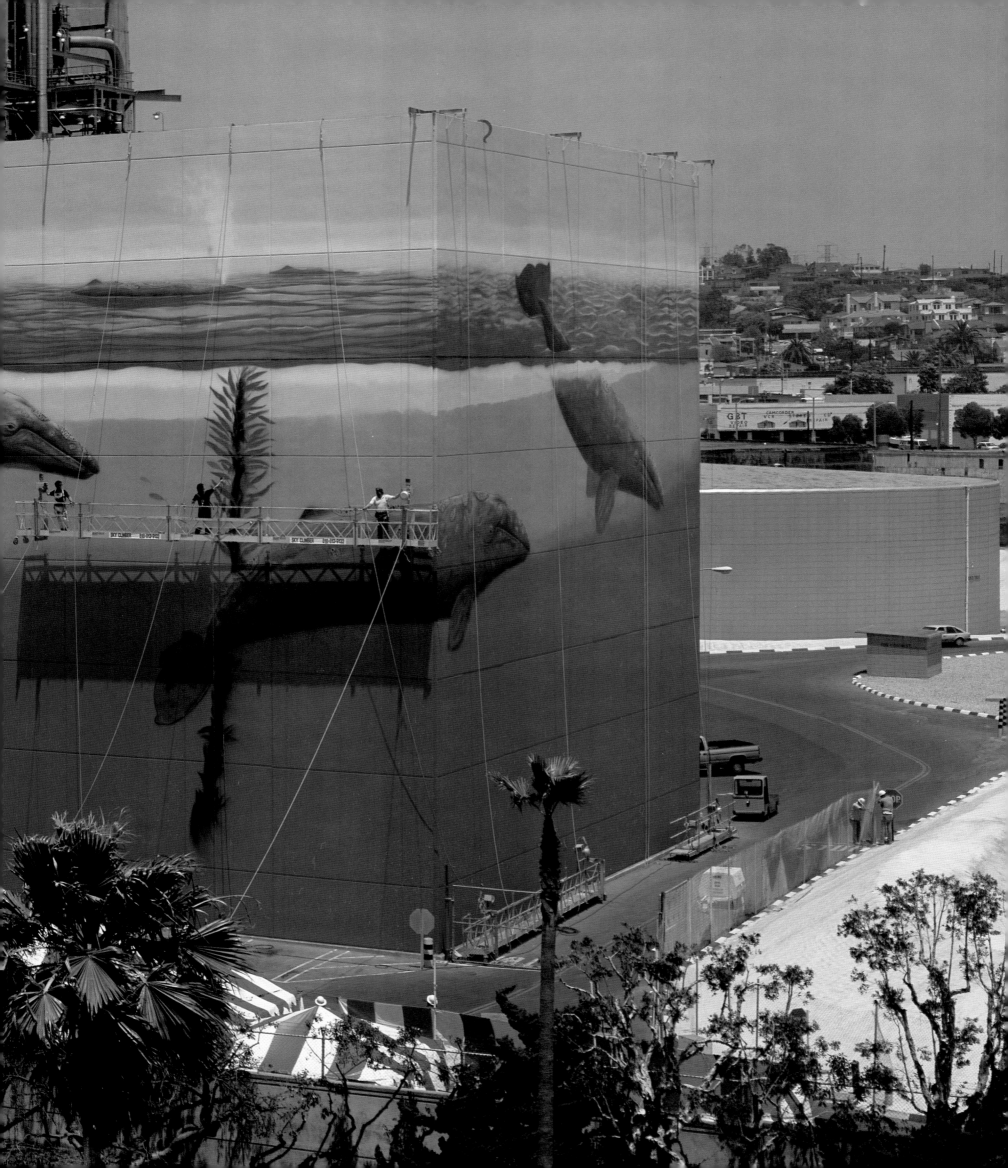

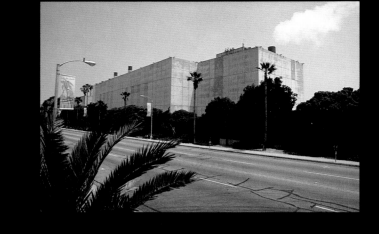

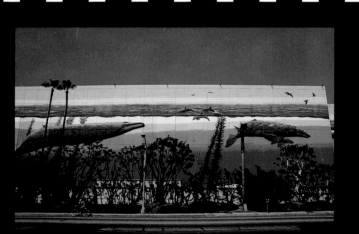

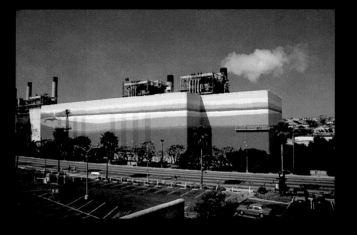
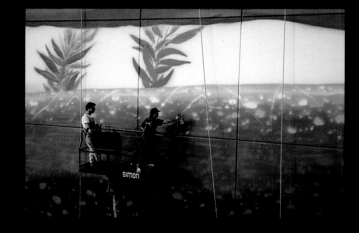

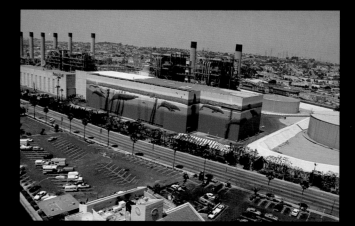
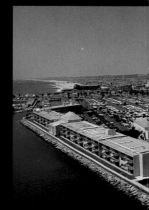

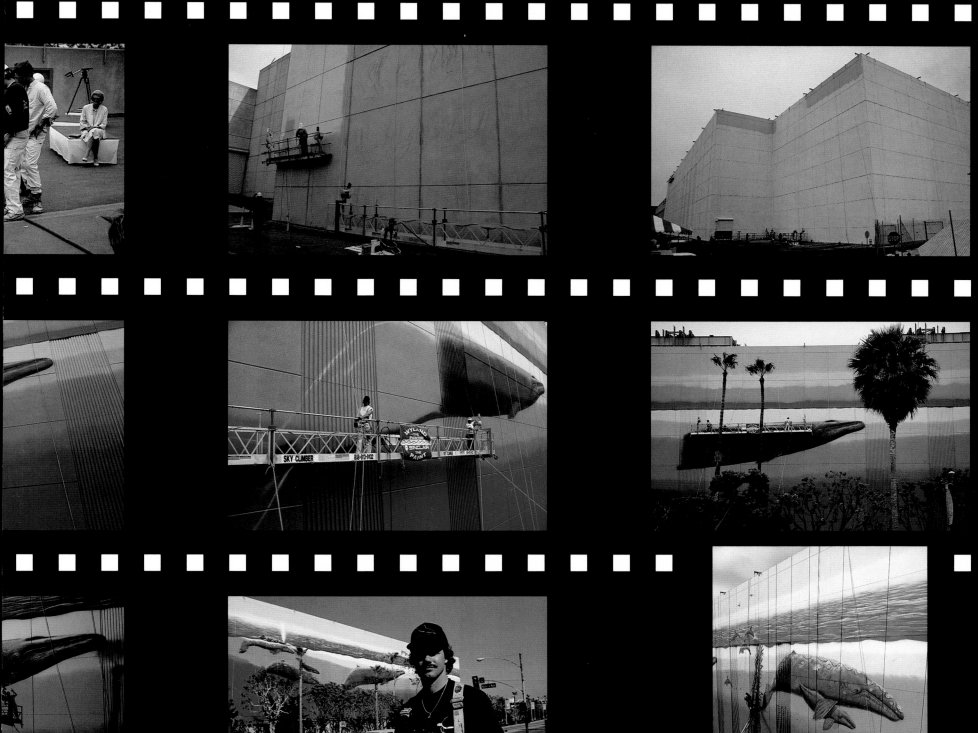

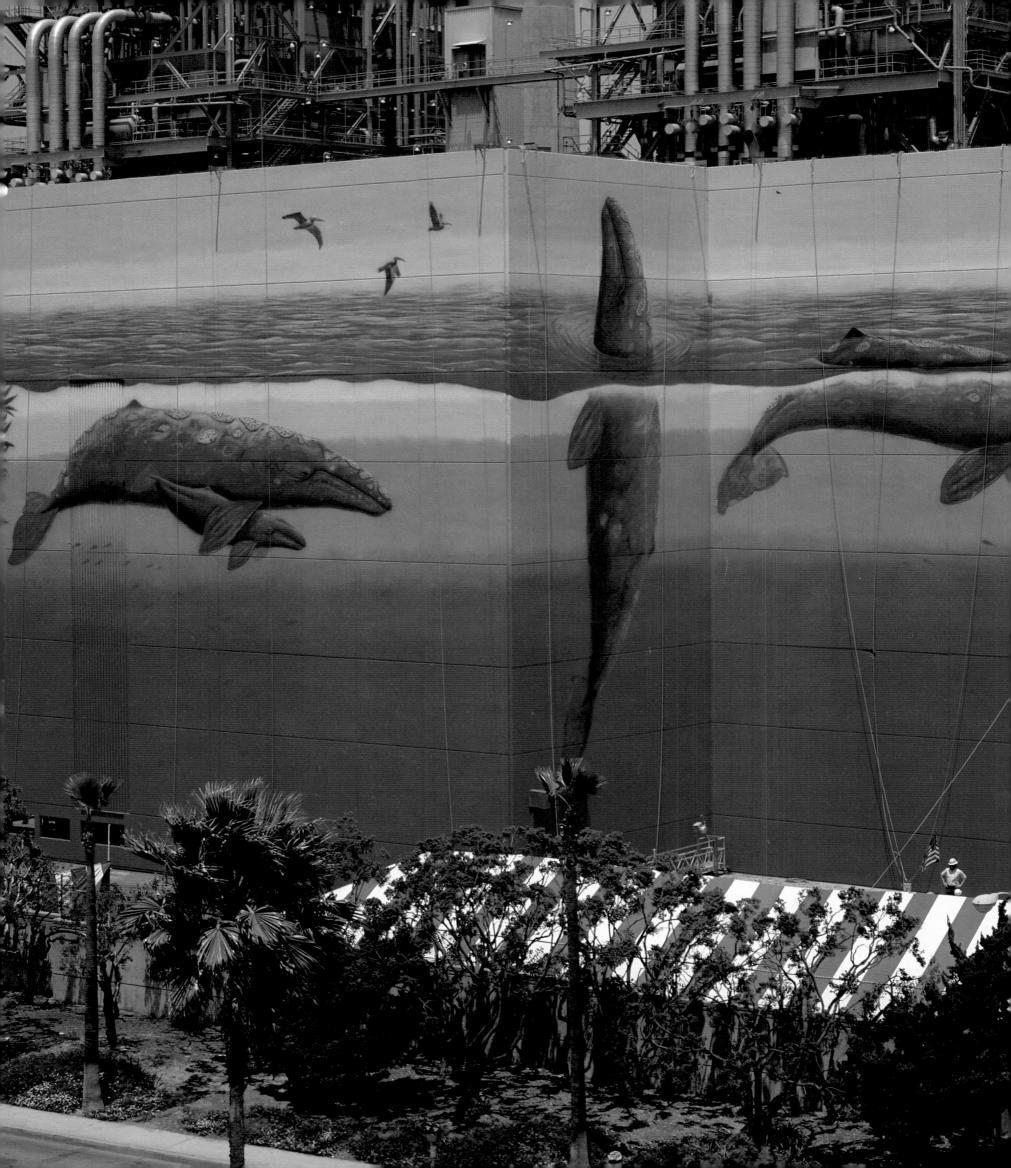

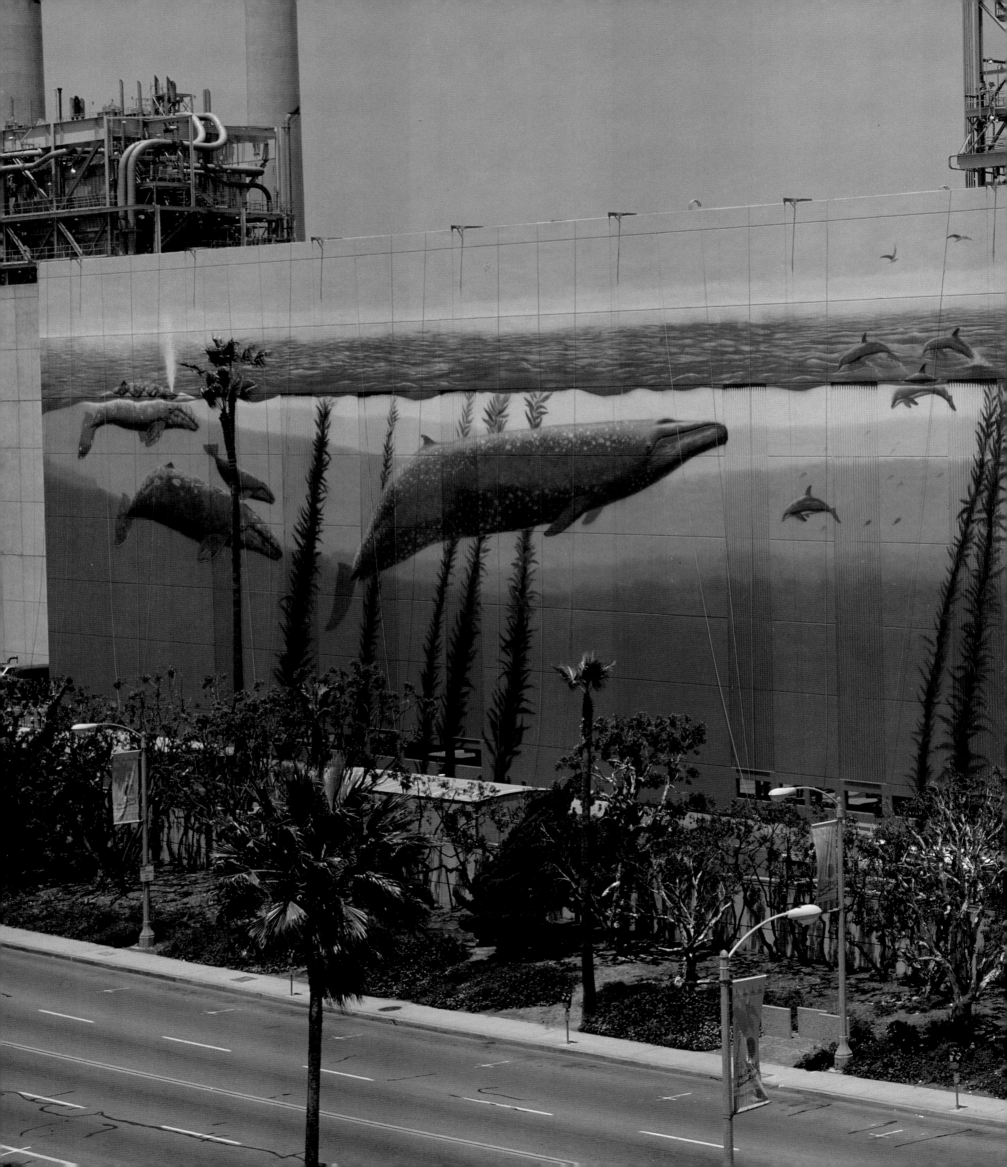

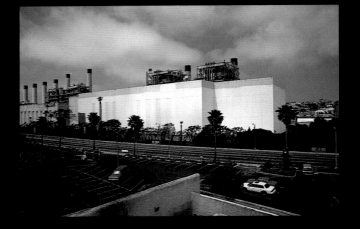
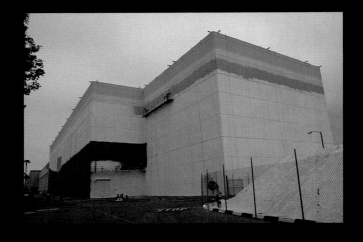
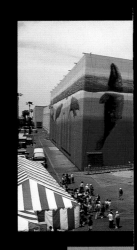
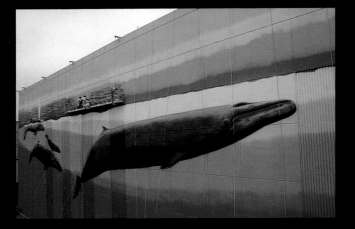
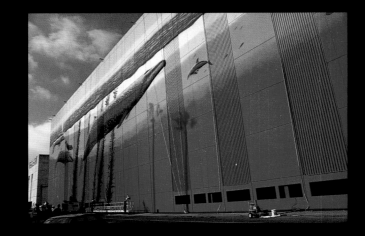

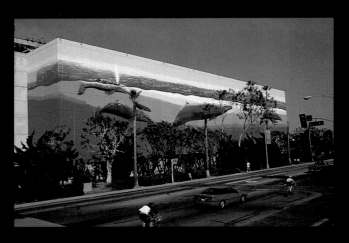
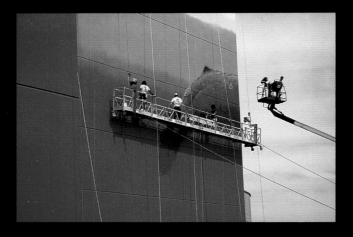

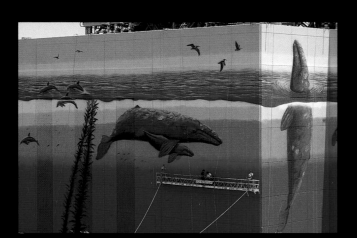

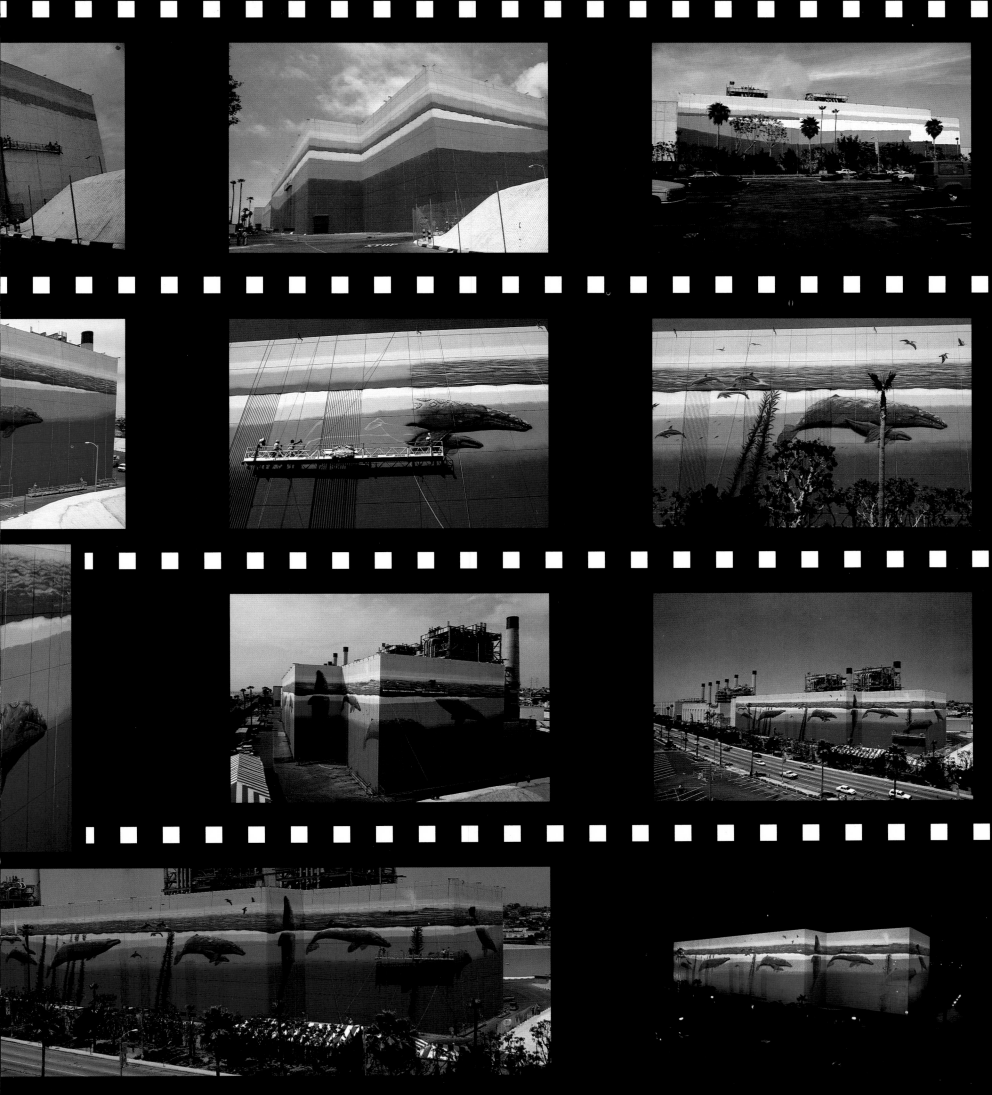

JUNE 14, 1991 — 11 DAYS LATER

112

Wyland first visited Taiji in 1984 after completing his first mural in Japan in Funabashi. Four years later, in August 1991, he fulfilled a dream by painting a historic mural on the exterior of Taiji's whaling museum. Japanese whaling started in Taiji in 1606 when the first right whale was harpooned. Whalers called them "right whales" because they were the only large whales that floated after they were killed.

Right whales were the symbol of Taiji whaling, and after much thought and conversation by the people of Taiji, Wyland decided to paint a life-size mother right whale and her baby.

"I wanted to paint the living whales and show the people of Taiji the beauty of these gentle giants," Wyland says. "I felt if I could paint the right whales swimming free in their own environment, the Japanese and many visitors to this coastal community would see what I see when I look at whales."

The artist was assisted by one of the Japanese whalers who provided photos and books of right whales and guided Wyland's hand from across the street, helping with the proportion and anatomy of each whale. When it was completed, the whaler commented on the beauty of the whales' eyes.

"I hope that this mural will begin a new understanding of how we view God's greatest creatures," Wyland concludes.

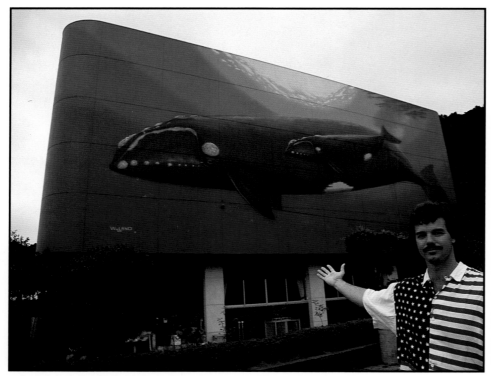

DEDICATION AT TAIJI WHALING WALL, JAPAN

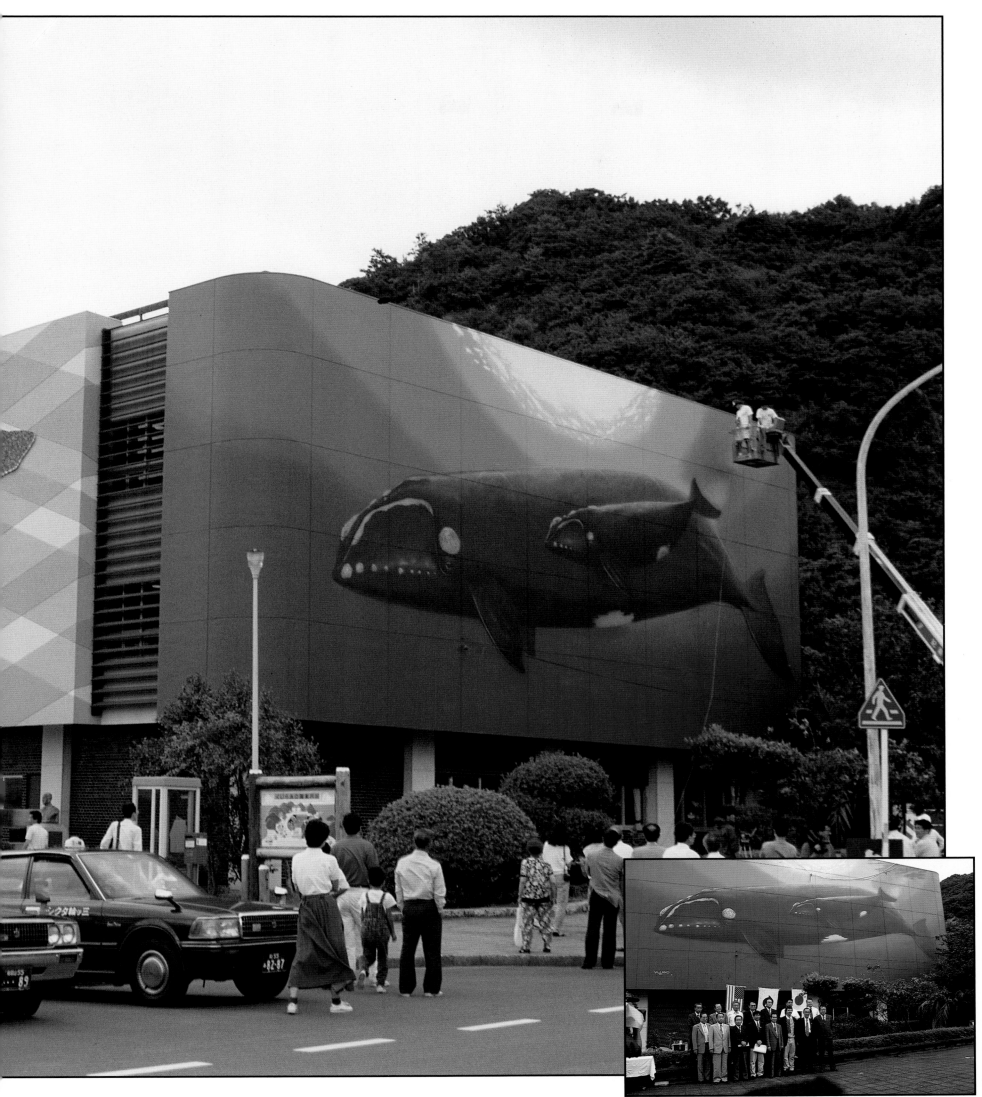

Whaling Wall XXXII — Taiji Whaling Museum, Taiji, Japan — 35' high x 100' long — Dedicated August 29, 1991 by Taiji Town Mayor

ARTIST AT DEDICATION WITH TAIJI MAYOR AND CITY OFFICIALS

114

May 3, 1992 Wyland completed painting the Largest Mural in the world at the Long Beach Convention Center on the Long Beach Arena.

Entitled "Planet Ocean," it was completed in only 6 weeks and required 7,000 gallons of paint. "This mural, Whaling Wall XXXIII, to me is a symbol of our environmental times and carries a message that in order to save the Whales, we must first save our "Planet Ocean."

Featuring marine life indigenous to Southern California, the finished mural included a pod of Grey Whales, Orca Whales, Blue Whales, Pilot Whales, Pacific Bottlenose Dolphins, California Sea Lions, Sharks, Garibaldi and a variety of other fish. Everything in the mural is painted life size. The mural itself is over ten stories high and 1,225 feet in diameter (almost 3 acres). It covers the entire 360 degree surface of the Long Beach Arena. Monday, May 4, 1992, the Guinness World Book of Records certified Wyland's mural as the largest ever created.

The dedication ceremony was attended by Team Wylands' 200 Volunteers and thousands of supporters. This brought Wyland closer to realizing his goal of 100 walls by the year 2011.

..."Its No Big Thing"... **WYLAND**

This Certificate Is Presented by
The Hollywood GUINNESS World of Records Exhibition
for
The GUINNESS Book of World Records
In acknowledgement of the new record
as of this date for
THE WORLD'S LARGEST MURAL
"Planet Ocean"
painted by
WYLAND
for
The Long Beach Convention Center
Completed May 4, 1992
Acknowledged this 9th day of July, 1992

for the Hollywood GUINNESS World of Records Exhibition

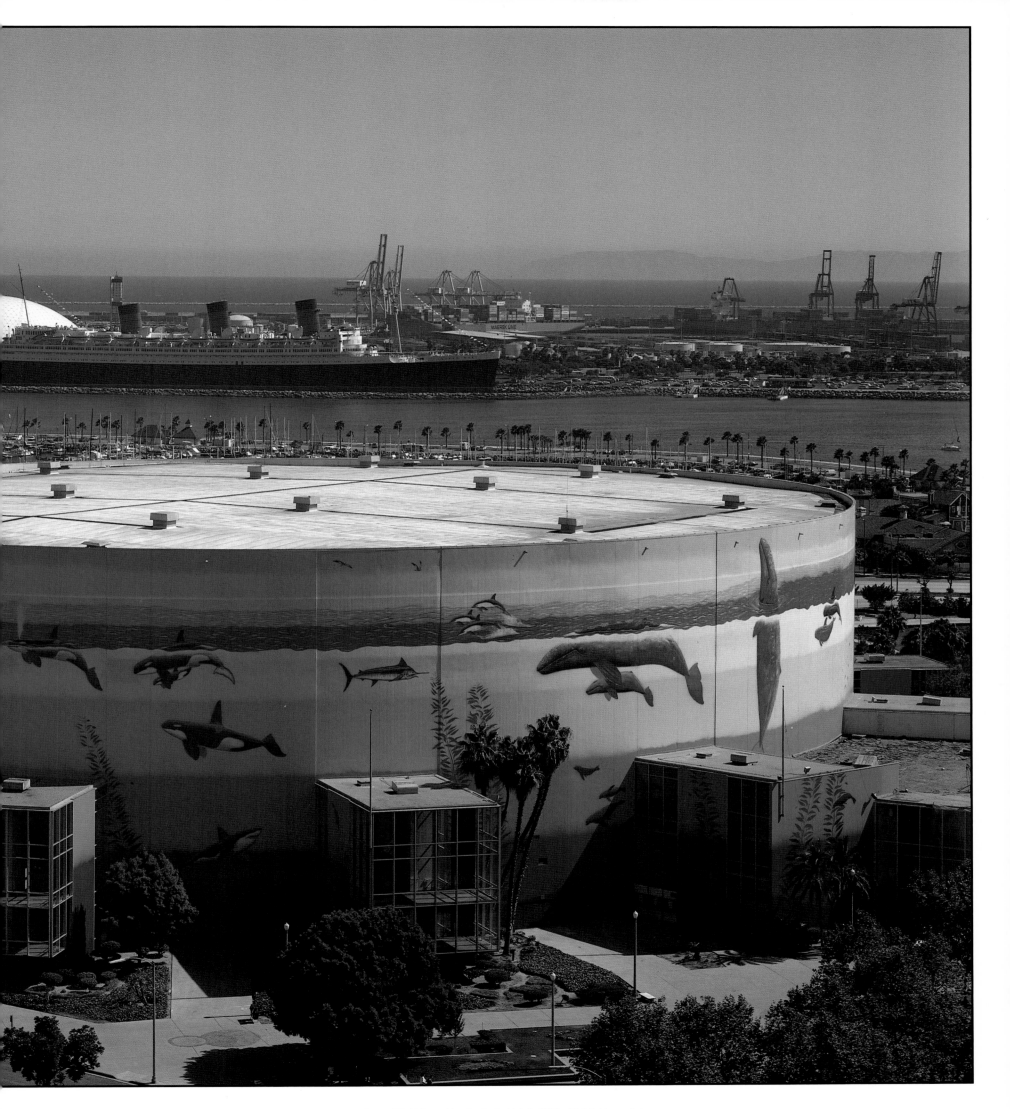

aling Wall XXXIII — Long Beach, California — 1,225 feet in diameter x 110 feet high (Guinness Book of World Records) — Dedicated July 9, 1992 by Chris Robinson, Actor

. . . Artists throughout history have always interpreted past, present, and future. It is our job now to bring people to the side of the Whale . . .

V

THE ANATOMY OF A WHALING WALL

PAINTING HONOLULU WALL, 20 STORIES HIGH

WYLAND'S
KITCHEN

The idea for the Whaling Walls arose from the difficulty of trying to paint such a large animal on such a small canvas. In my quest to paint these animals in their true size, I started looking at the sides of buildings. Where a "canvas" can be stretched to a particular size, a wall is generally predetermined in size and location, and each one is unique. So I try to incorporate the murals into the wall design. My ultimate task is to make the mural an extension of the natural environment.

The first step for a Whaling Wall is to find the perfect wall, determined not only by its size and shape but by its geographical location and its visibility to the public. My goal from the beginning has been to impact as many people as possible with my art and conservation. One can choose not to go into an art gallery or museum, but you can't ignore a 600-foot painting. It demands attention, and that's the point.

I believe that if people are going to save the whales or our oceans, they must first see the beauty in them. And that is what I create.

When I first look at a blank wall, I get an immediate image of my subject moving across the surface. Next, I begin to paint masses of background colors. If you can envision a large Polaroid picture developing before your eyes, this is how I work. When all the background colors are completed, the first whales are ghosted in, one at a time until the anatomy is correct. I then start blocking in areas of color and detail. Slowly the painting comes into focus with final highlights and more definition.

I try to create a three-dimensional quality in my paintings because that is how these creatures appear in their real habitat. I complete each mural with a signature, and each wall has its own individual dedication ceremony. The overall mural goes far beyond a painting on a wall — it is a window into our fragile ocean environment.

WHALE SIZE CANVAS

BACKGROUND COLORS

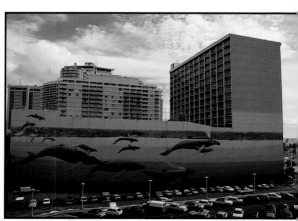

FIRST WHALES APPEAR

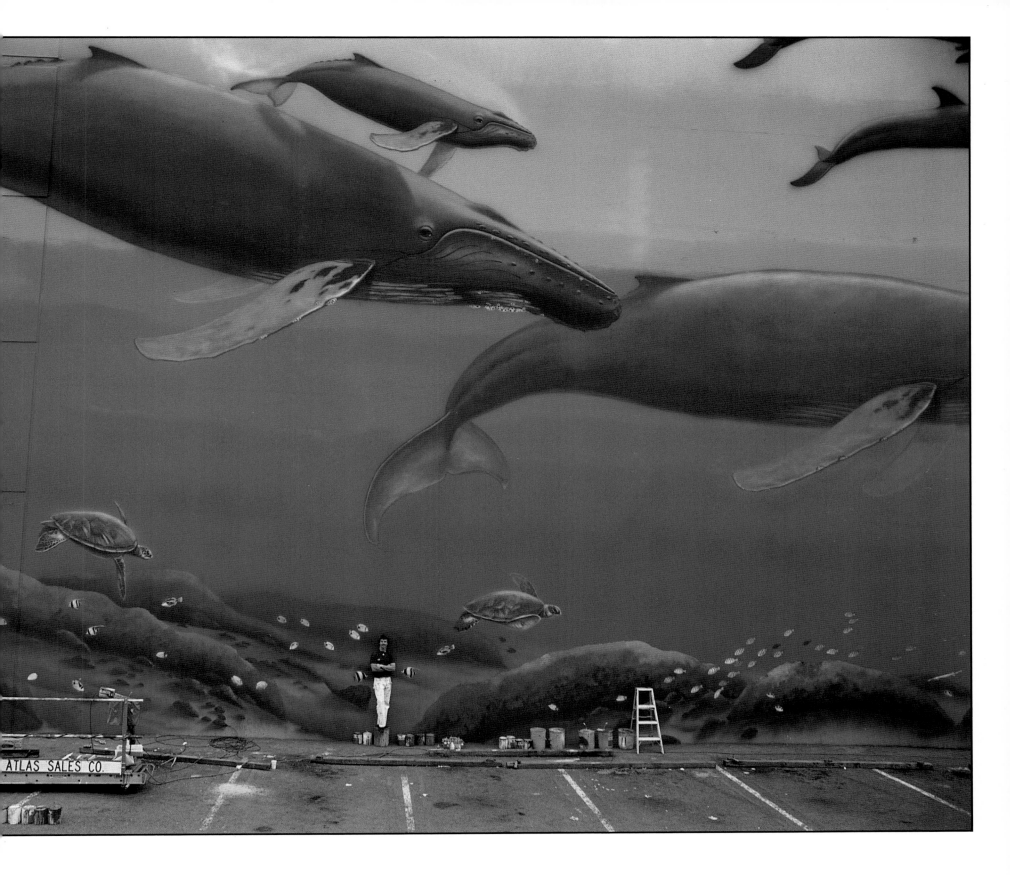

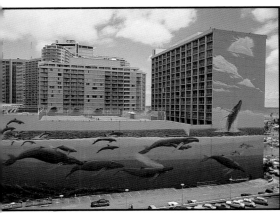

COMPLETED WHALING WALL

HONOLULU, HAWAII

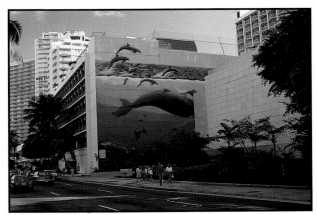

EXTINCTION OF A WHALING WALL

ATLAS SALES CO.

FIRST DAY PAINTING

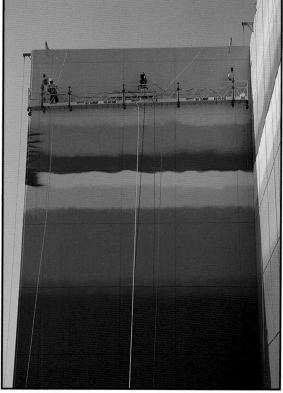

BACKGROUND COLORS

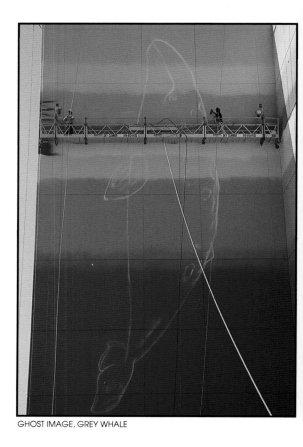

GHOST IMAGE, GREY WHALE

…The mural develops as a polaroid, slowly
coming into focus…

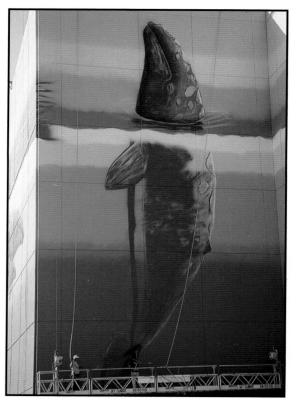

GREY WHALE, SPYHOPPING

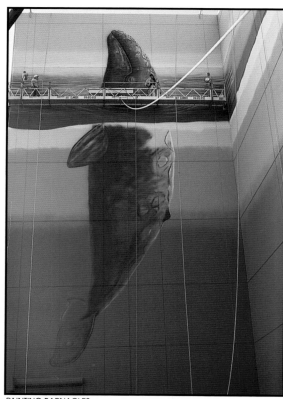

PAINTING BARNACLES

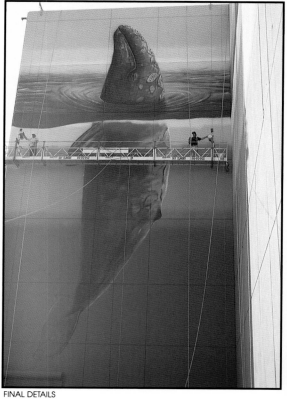

FINAL DETAILS

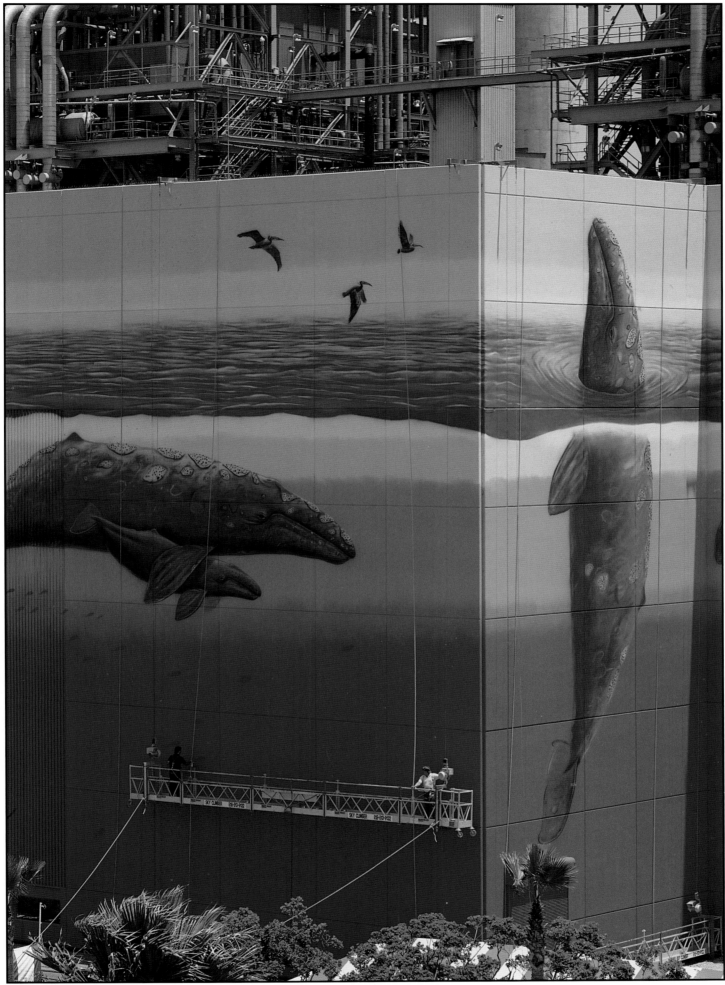

CALIFORNIA GREY WHALES, LIFESIZE

. . . Whales have navigated the world's oceans for 50 million years using only their brain for a compass . . .

VI

THE MIND'S EYE

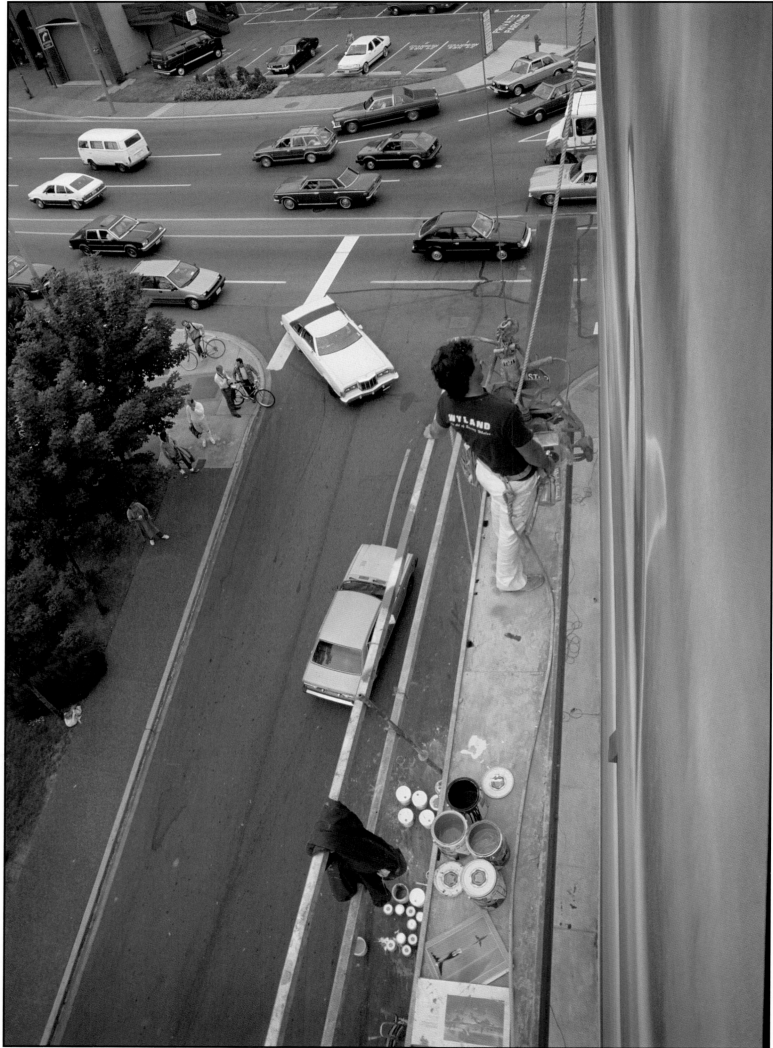

I am often asked if I use grids or preliminary drawings to help me paint a Whaling Wall. I do have a grid, but it's in my mind. I work from the mind's eye.

The best way for me to prepare for a mural is to see my subject in its natural environment. When I'm diving, I'm painting pictures in my mind's eye that will later be reflected in my art.

Many people can't understand how I can be up on the scaffolding, standing so close to the wall, and still be able to paint such a large subject. I can only explain it this way — I believe I have an "out-of-body experience." While my physical body is up on the scaffolding with the spray gun, my mind's eye is far away, down on the ground viewing the wall from a distance. I have to go with my gut instincts when I'm up there painting. People have asked if I step back and take a look at my work. I think that would be a big mistake, since I'm up on scaffolding 10 stories high! Besides, I'm afraid of heights.

PREPARING TO DIVE

WHALE EYE VIEW

EYE OF THE WHALE

. . . Even after years of slaughter, Whales have always been friendly to man . . .

VII

A TIME FOR CONSERVATION
POLITICS AND CONTROVERSY

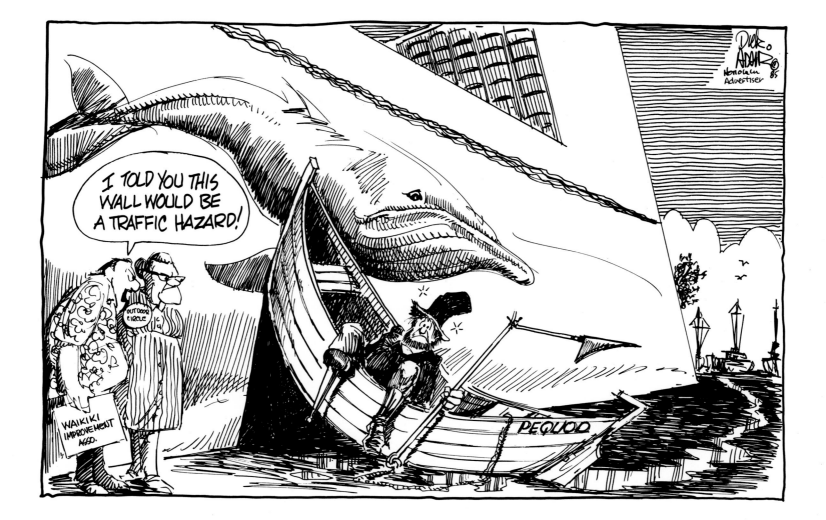

WYLAND WALL

In 1978, after months of scouting locations for my first Whaling Wall, I found the perfect public place in Laguna Beach, California. After three years of politics, controversy and a change of locations, I finally began painting my first life-size mural. This was my first experience dealing with red tape and bureaucracy.

The simple idea of giving a gift of art to the city had been shrouded, and a tidal wave of propaganda ensued, leaving me and my small group of supporters frustrated beyond belief. After attending numerous meetings and being scrutinized by the entire community, we finally finished Whaling Wall I on July 9, 1981, through persistence and grassroots support.

My gift of public art to the city cost me three years of my life and literally every dime I had and more. But to me, the struggle was worth all the blood and sweat. When it was completed, the very people who opposed it were the first to commend it!

After 32 walls, my belief in environmental art is as strong as ever. Although numerous cities have invited me to paint murals, the struggle continues today. I have been dragged into court, spent thousands of dollars defending my right to display my art in public places and have had my battles with various groups and the media.

Through it all, my support has grown internationally, and many people share the vision. It is my hope that the Whaling Walls in some way will have an impact on generations to come, but there's still much to be done.

I would especially like to see the people of Japan turn their whaling industry into a whale-watching industry. When visiting Taiji, Japan, in 1987, I met with the mayor and brought up the idea of whale watching. The mayor liked the idea, but coastal whaling still exists in his country.

SWIMMING WITH CAPTIVE WHALES

That same day, I was allowed to view a capture, in which a pod of about 30 short-fin pilot whales were herded into a small cove. Later that night, I couldn't stop thinking about the whales. Early the next morning, I persuaded a reporter from the Japan Times and a photographer to go with me down to the water, where I stripped down and jumped in to take a closer look.

As I swam among the whales, I noticed two babies, and I remember being very sad. Then I noticed one of the scout whales up against the net trying to find a way out. I wanted to release the net and set the whales free, but my friend, the Japanese reporter, persuaded me that if I wanted to stay and do work in Japan, I should not let them go.

For many months afterward, I was depressed and guilty to the point of distress. It was the hardest decision I had ever made. But eventually, I realized that I could make a more long-term impact with my paintbrush. And sure enough, in August 1991, I returned to Taiji and painted my 32nd Whaling Wall on the side of the city's whaling museum.

This mural of a right whale has created quite a sensation in Taiji, and I hope it will help convince the Japanese that whales are much more valuable to us alive than they ever were as products.

CAPTURED WHALES, TAIJI, JAPAN

SHORT FIN PILOT WHALE

. . . Looking at Whales many years, one begins to see not only physical differences as people, but different personalities, too . . .

VIII

WITH THE WHALES

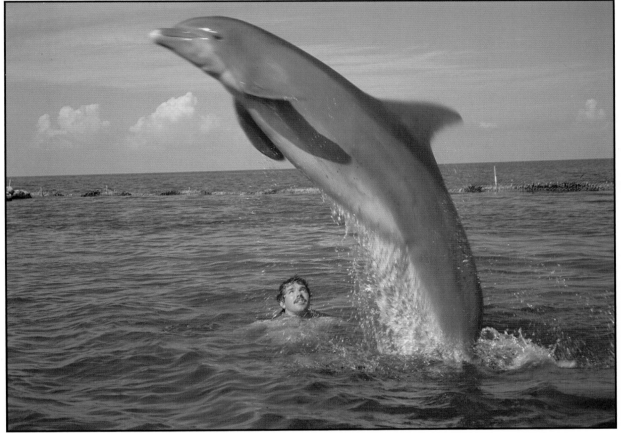

ARTIST WITH DOLPHIN, "NAT" IN FLORIDA KEYS

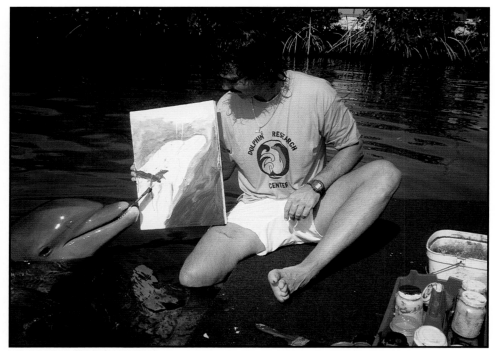

NAT AND WYLAND PAINTING TOGETHER

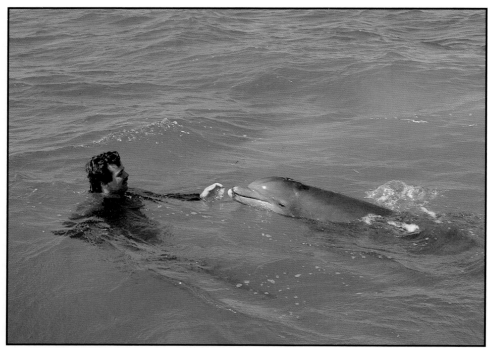

AFTER PAINTING, KIBBY BROUGHT WYLAND A GIFT FROM THE SEA — A ROCK

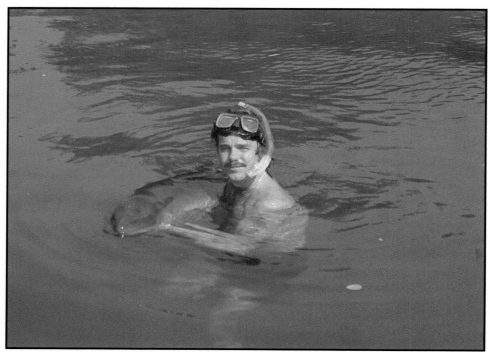

HELPING A STRANDED PYGMY SPERM WHALE, FLORIDA KEYS

I am more comfortable in the water than out, and over the years I have had the pleasure of swimming and diving with many whales and dolphins. Each time, I am reminded of the awesome beauty and strength of our ocean friends.

After numerous years of observing and studying these animals, one begins to understand their individual characteristics. Though I hate to personify whales and dolphins, sometimes it is impossible not to. They do things that are so much like us. Some are shy, some are curious, some are even friendly. Some have overbites, others underbites. I feel I am blessed when I'm in the presence of whales and dolphins. The only way you can be with them is if they want it to happen.

I truly believe these sea creatures are the symbol of our environmental time. I have never claimed to be an expert on whales. I don't believe there is such a thing — the people who know them best will tell you we are only beginning to understand our ocean friends.

Once I was visiting some dolphins at the Dolphin Research Center in Florida, where one dolphin in particular was very creative and liked to experiment with water paint. We painted together on several canvasses, and when we were done I was given a gift from the sea — a rock.

I also had the privilege of helping a stranded pygmy sperm whale, which we later named Bullet. We took turns swimming with the whale all night until she had enough strength to swim by herself.

NATURE ARTIST MEETS HIS SUBJECT...
Marine artist Wyland sketches Baby
Shamu at Sea World in San Diego in
preparation for Whale Wall XVI (top).
The artist began his latest work in May
at San Diego's Mission Beach Plunge.
The 40-foot high, 120-foot long mural,
completed June 29, 1989, depicts
killer whales in a Pacific coast setting.
Wyland is donating the mural to the
City of San Diego in honor of Sea
World's 25th anniversary and the birth
of killer whale calf Baby Shamu.

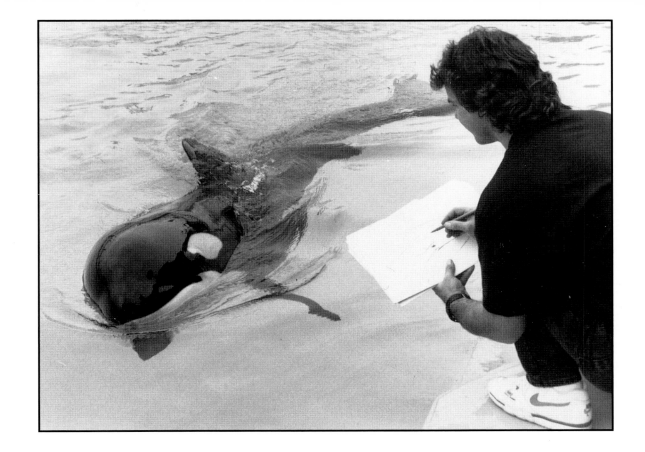

ORCA ART CRITICS

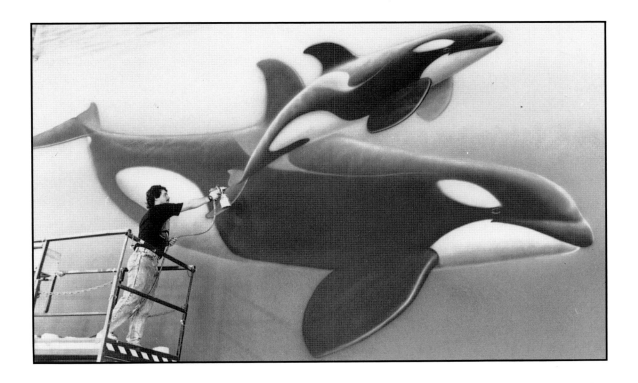

...Some Whales are very shy, some curious
and some even friendly...

GREY WHALE SPYHOPPING, BAJA, MEXICO

GREY WHALE, SAN IGNACIO LAGOON

YOUNG GREY WHALE

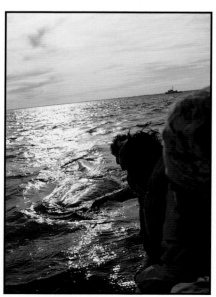

TOUCHING FRIENDLY WHALE

I saw my first grey whales migrating along the southern California coast back in 1970 while I was on vacation. Later I went down to San Ignacio Lagoons in Mexico, a breeding ground for grey whales. We were surrounded by them, and I remember the first time a mother whale pushed her baby to the surface for me to reach out and touch. This was the most special feeling I had ever experienced. I spent 10 days studying the friendly grey whales.

From Mexico, I traveled to Hawaii to study the humpback whales. I remember the first time Mark and Debbie Ferrari, a world-renowned ocean research team, came into my Lahaina studio and invited me to swim with humpbacks. We went out in a boat off of Maui and spotted a group of whales traveling very slowly. As they dove they left a footprint in the water. We slowly put on our masks and fins and slipped into the clear blue waters. I remember the light was pyramiding far below the surface, and the visibility was incredible — 150 feet.

Then I saw my first humpback. The escort was very, very close. I was anxious and swam close to the whale, and the whale swam towards me and had to lift its flipper to avoid hitting me. Then the mother and baby swam very slowly towards me, and I remember looking into the eye of the mother whale — it got very large, and I felt like it looked straight into my soul. The songs of the humpbacks were unforgettable. The whole experience was too incredible to put into words, and it changed forever my perspective of how the whales actually look.

Those first images continue to reflect on my art today. Mark and Debbie Ferrari have continued their fabulous work researching humpbacks, and I have been fortunate enough to be a part of their research team each winter in Maui.

HUMPBACK WHALES FROM ABOVE

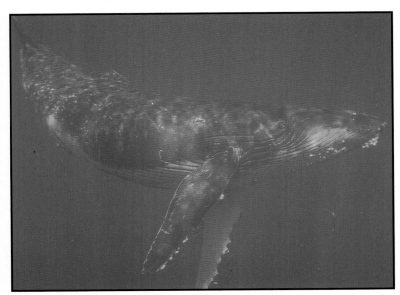

HUMPBACK ENCOUNTER

MAUI RESEARCH

. . . I try not to personify the Whales and Dolphins but sometimes it's impossible . . .

IX

MARINE ART HUMOR

Dolphin™ — Acrylic 48" x 60" ©1980

140

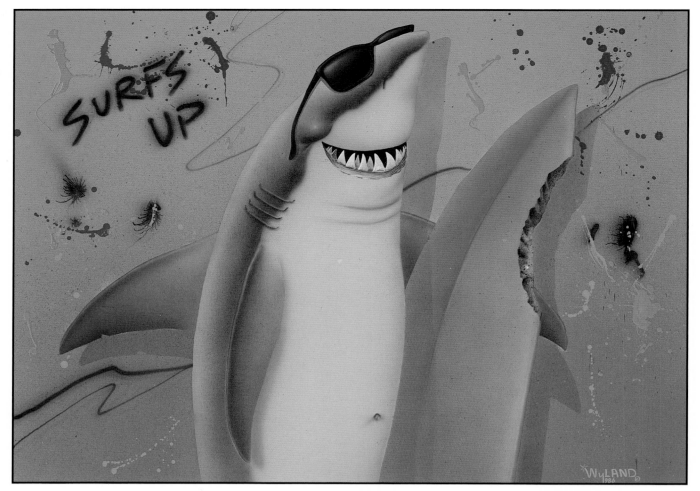

...This is what happens when I stay up too late and paint...

. . . Only in today's times have our great oceans become threatened, we must now save man from himself . . .

X
ENVIRONMENTAL IMPACT

144

When I started painting, there wasn't a term "environmental artist." But, in painting and studying my subject, I became aware that more attention needed to be focused on our environment.

Being an artist since age three, an appreciation for the ocean and its magnificent creatures evolved naturally for me. I was fascinated by watching Jacques Cousteau on television and by seeing my first whale. I started diving into libraries wanting to learn more and, later, I started diving and researching life beneath the oceans.

The unparalleled beauty beneath the sea inspired many works of art and later the series of life-size murals dedicated to the great whales and their preservation. As I began to paint these magnificent creatures, I realized that if we were going to save the whales we had to save the oceans first.

I feel the best thing about the Whaling Walls is the impact they have on younger children. They're the ones they must reach. I believe the murals have helped them to understand and want to learn more about our oceans.

I believe, as an environmental artist, it is my responsibility to evoke emotions and paint images into the subconscious of people of all cultures. I realized after painting my first mural that if I was going to impact the masses, I had to paint whales in their true life size in public places throughout the world. The Whaling Walls are seen by millions of people each year, and I would hope that many will become more sensitive to our endangered oceans and move to protect them before it's too late.

ARTIST LECTURING FORMER HIGH SCHOOL IN MADISON HEIGHTS, MICHIGAN

This is the first step in conservation. If people see the beauty in nature, I believe they will want to protect it for our future generations. I think the reason that people seem to enjoy my art is that they relate to it so well. They have seen the images of the oceans being destroyed and the whales being decimated and the dolphins being killed in the driftnets. I think my art reflects the hope that we can now begin to see the whales as intelligent co-habitants of this great planet. People say again and again that my art captures the true spirit of these animals and goes far beyond the painting of a whale and a dolphin. I feel my work delves deep into the soul and spirit of these ocean animals. In the past few years, a new awareness has emerged throughout the world to now understand our ocean friends.

My art has supported many environmental groups over the years, and I continue to give time and energy to conservation issues. Conservation is going to be on the front burner for the next 100 years, and everyone on this planet has a responsibility to protect the environment. For me, it's with a paintbrush. As for other artists, I feel we all have an opportunity and a responsibility to make an important statement here. One person can indeed make a difference.

HELPING AN ENDANGERED ALBATROSS

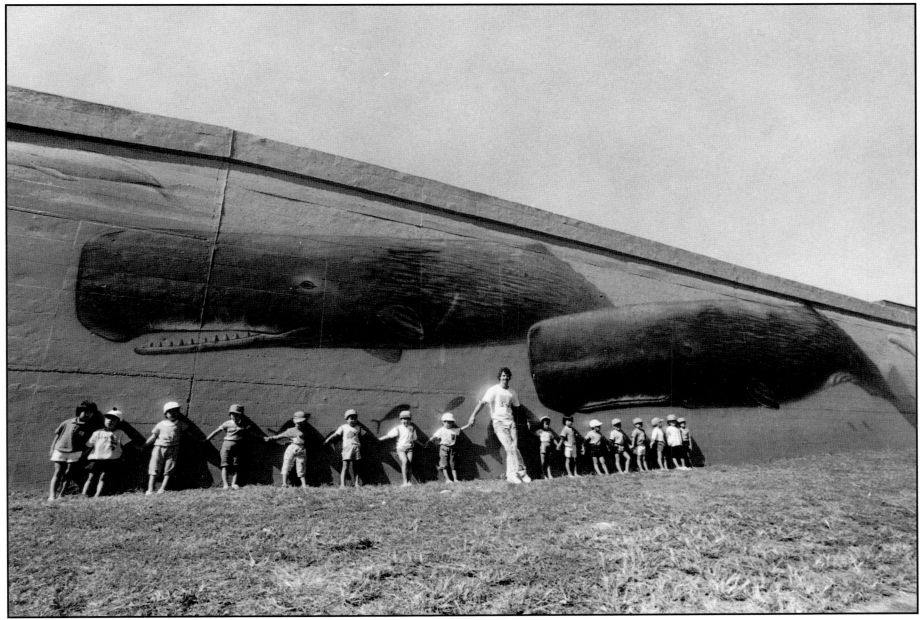

WYLAND WITH CHILDREN OF JAPAN

. . . The eye of the Whale is as deep as any ocean . . .

SCULPTURE
CLAY TO BRONZE

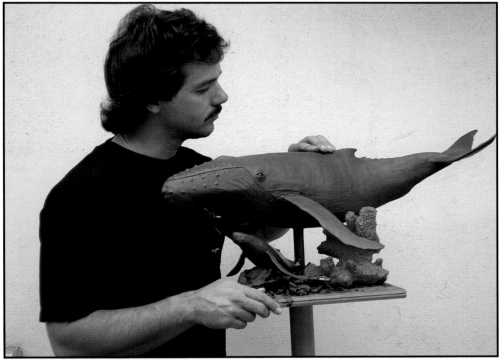

ARTIST WORKING ON HUMPBACK SCULPTURE, "THE INNOCENT AGE"

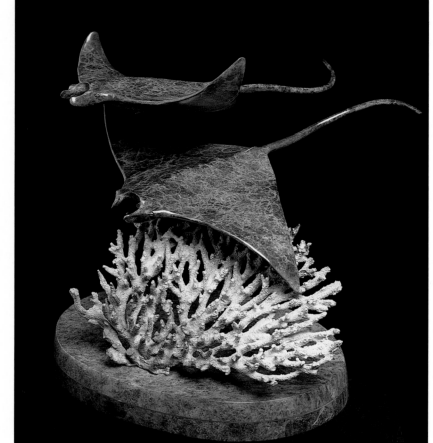
MANTA RAYS, BRONZE

SCULPTURE

I have always felt the urge to sculpt. Even in painting, I sculpt with a brush. My subjects scream for the third dimension. And while I majored in sculpture in college, it has only been in the last few years that I could afford the time to start sculpting again.

I am now in the process of going back and sculpting some of my earlier paintings. I believe the next step for me will be to sculpt my subjects in their true life size. I am planning a series of life-size bronzes to complement the Whaling Walls.

The desire for me to capture the spirit of whales, dolphins and other marine life in clay is as natural as fish in water. I started in junior high, using wax, and today I have found a way to use a combination of both wax and clay. This powerful medium allows me to create my favorite subjects in the infinite realism of bronze.

Each of my sculptures is individual, nurtured through the entire process of bronze casting. The final step is the patina — each sculpture has a different color and design, reflecting the creatures of the sea.

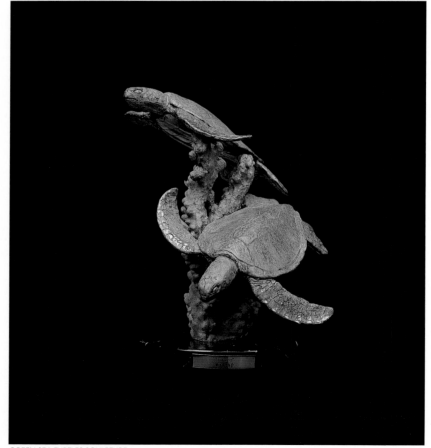
GREEN SEA TURTLES SCULPTURE

FOUNDRY POURING BRONZE

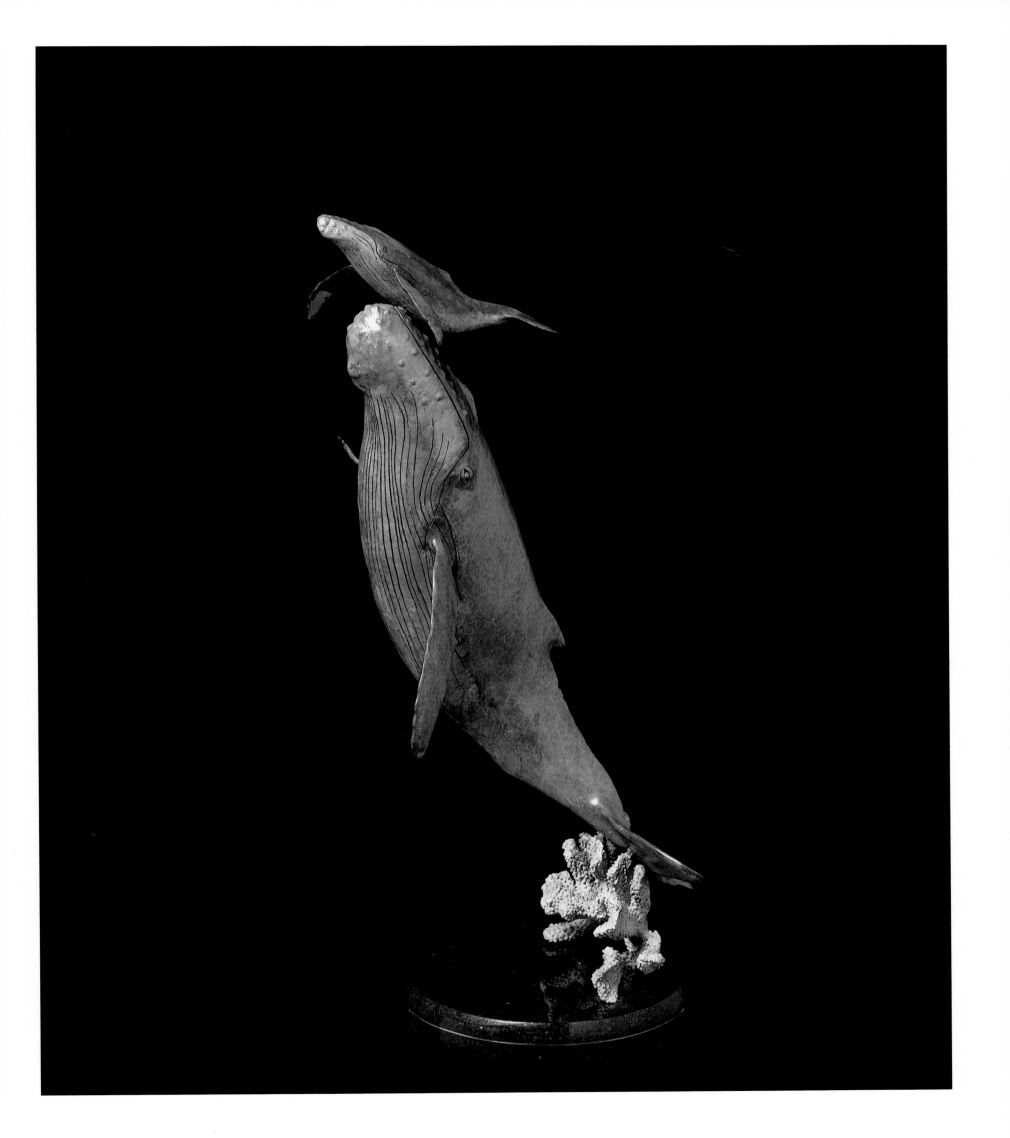

Breath, Limited Edition Bronze

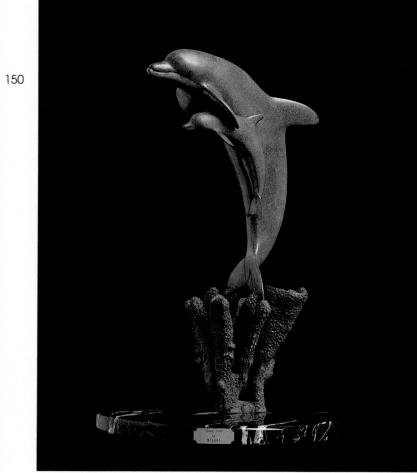

OCEAN CHILD SCULPTURE

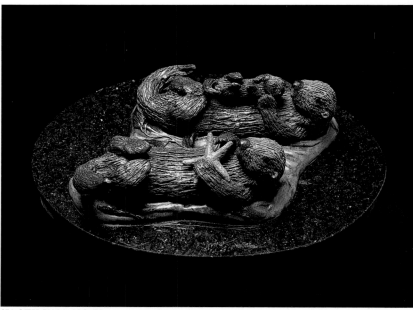

SEA OTTER FAMILY, BRONZE

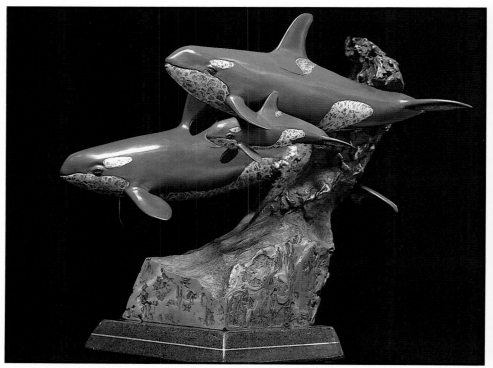

ORCA WATERS — BRONZE

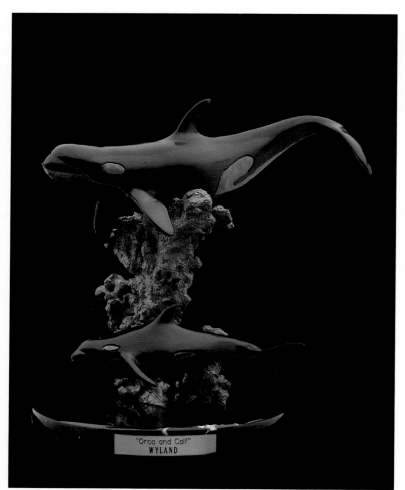

ORCA AND CALF, SCULPTURE

WELDING BRONZE

PATINA

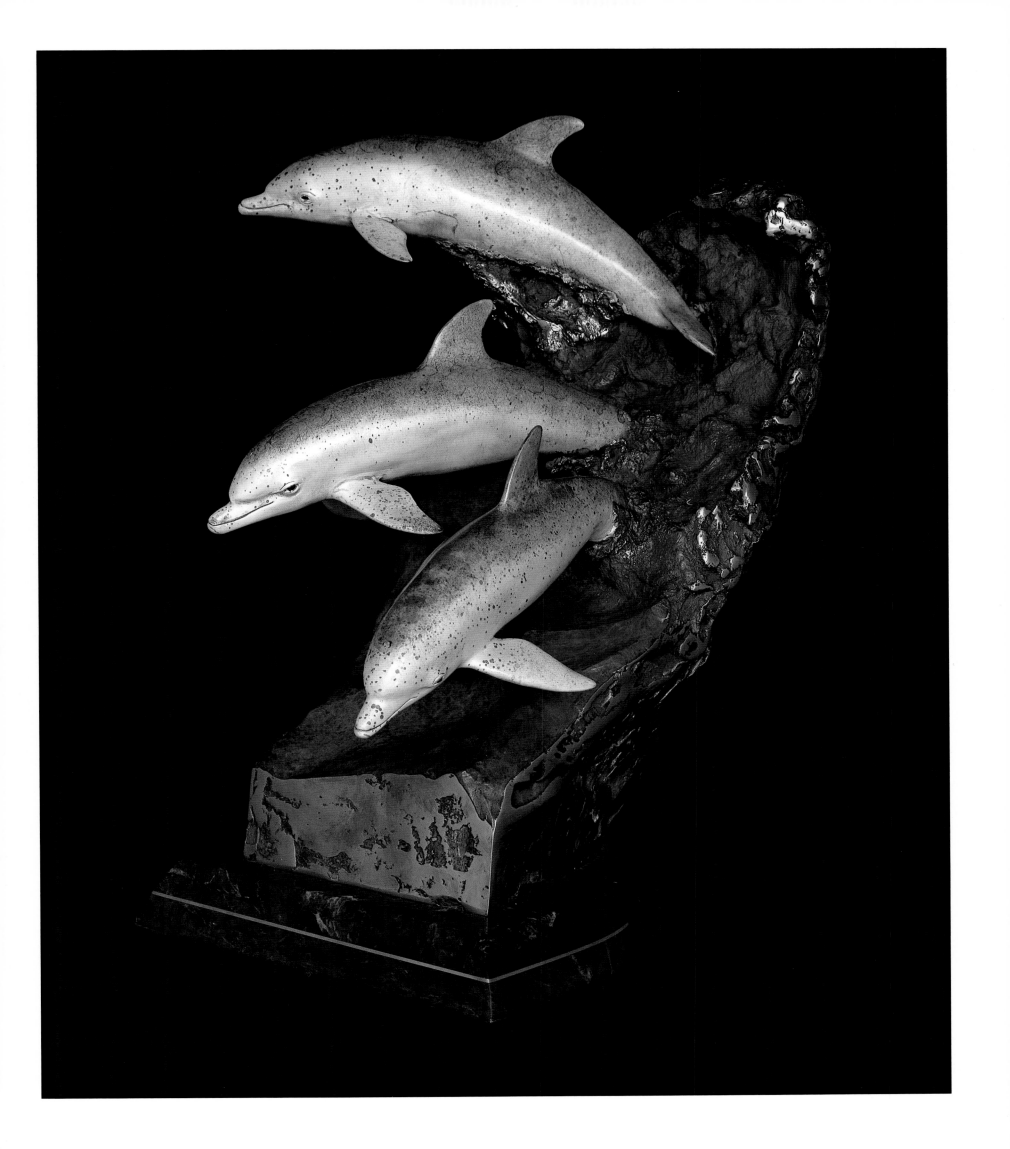

an Riders, Bronze

S C U L P T U R E

The first in a series of Environmental Furniture has been completed combining unique design with fine art sculpture. "I love the style and beauty these coffee tables reflect." "This was my first time creating functional art and has inspired me to continue to develop new concepts in fine art furniture."

These bronze coffee tables are a Wyland Collector's dream and an extension of his art for your living environment.

"Lamps, chairs, beds, anything is possible, I can't wait to get back to the foundry."

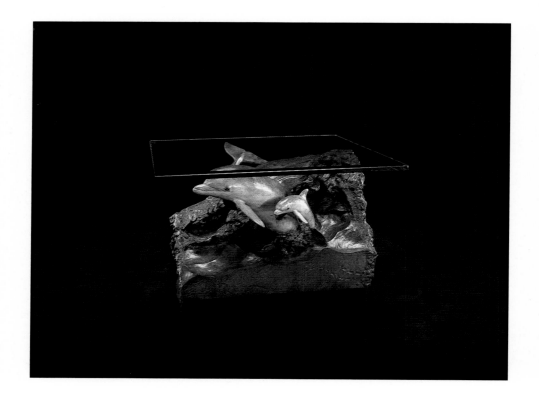

▲ **Dolphin Experience**— Bronze End Table 24" x 20" x 16½"

▲ **Wave Riders**— Bronze Coffee Table 40" x 24" x

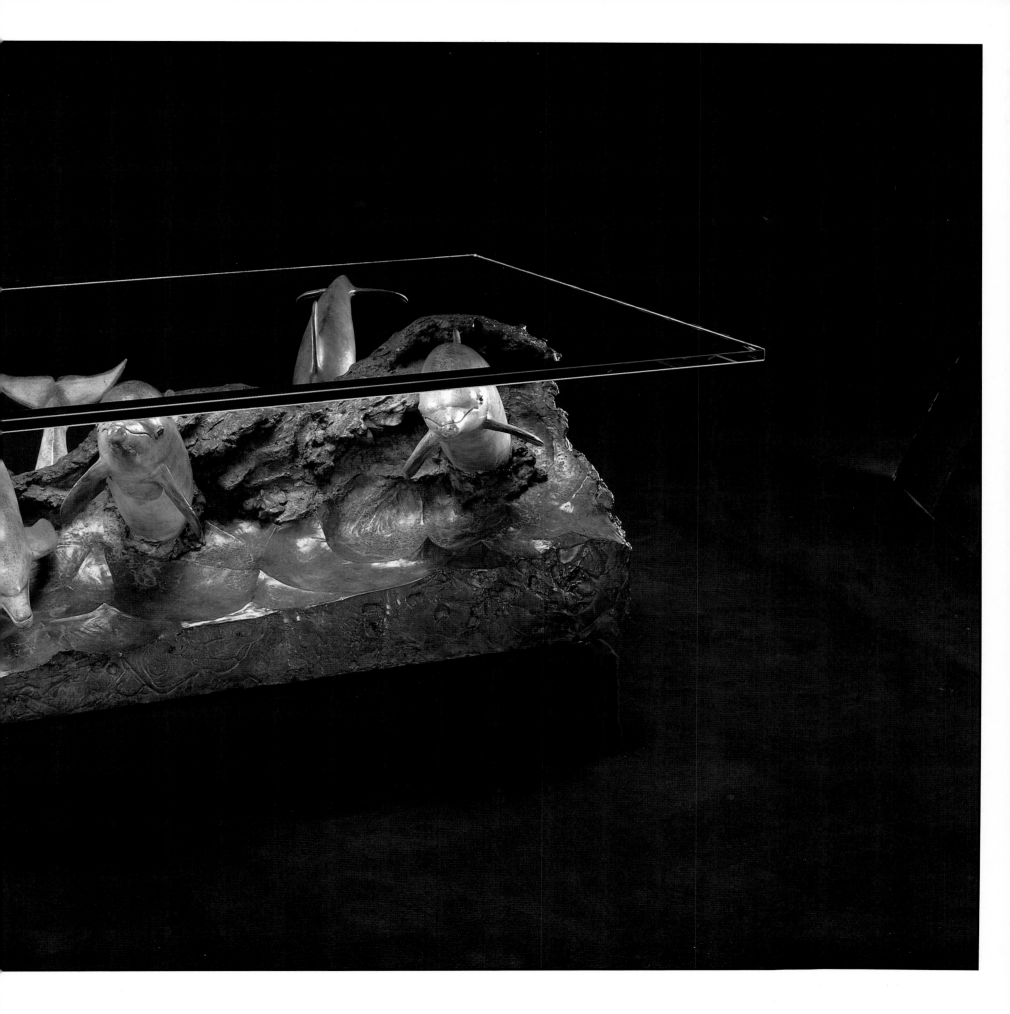

Sculpture captures the three dimensional world of whales and dolphins. . .

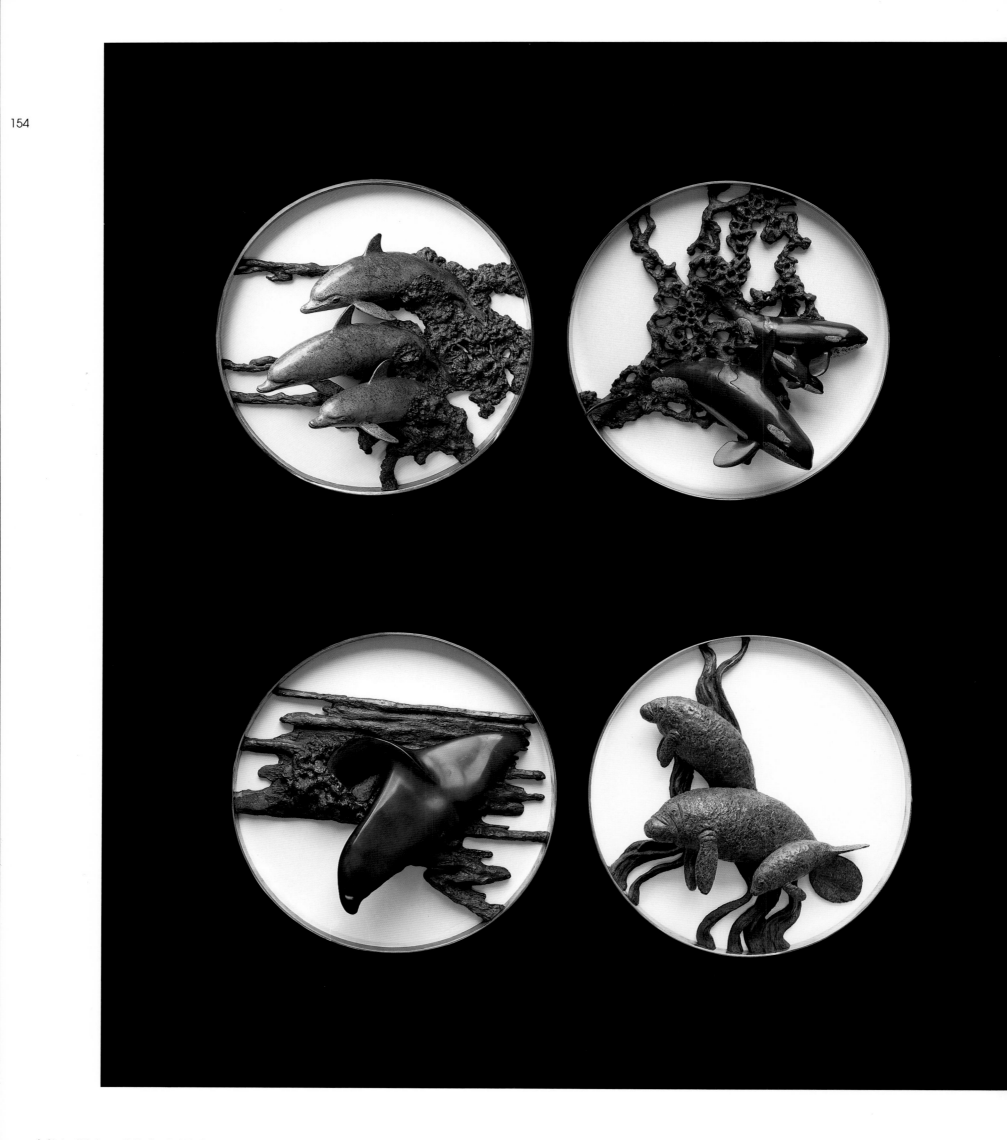

154

▲ **Circle of Life Bronze Collection,** Dolphin Circle of Life, Orca Circle of Life, Whale Tail Circle of Life, Manatee Circle of Life.

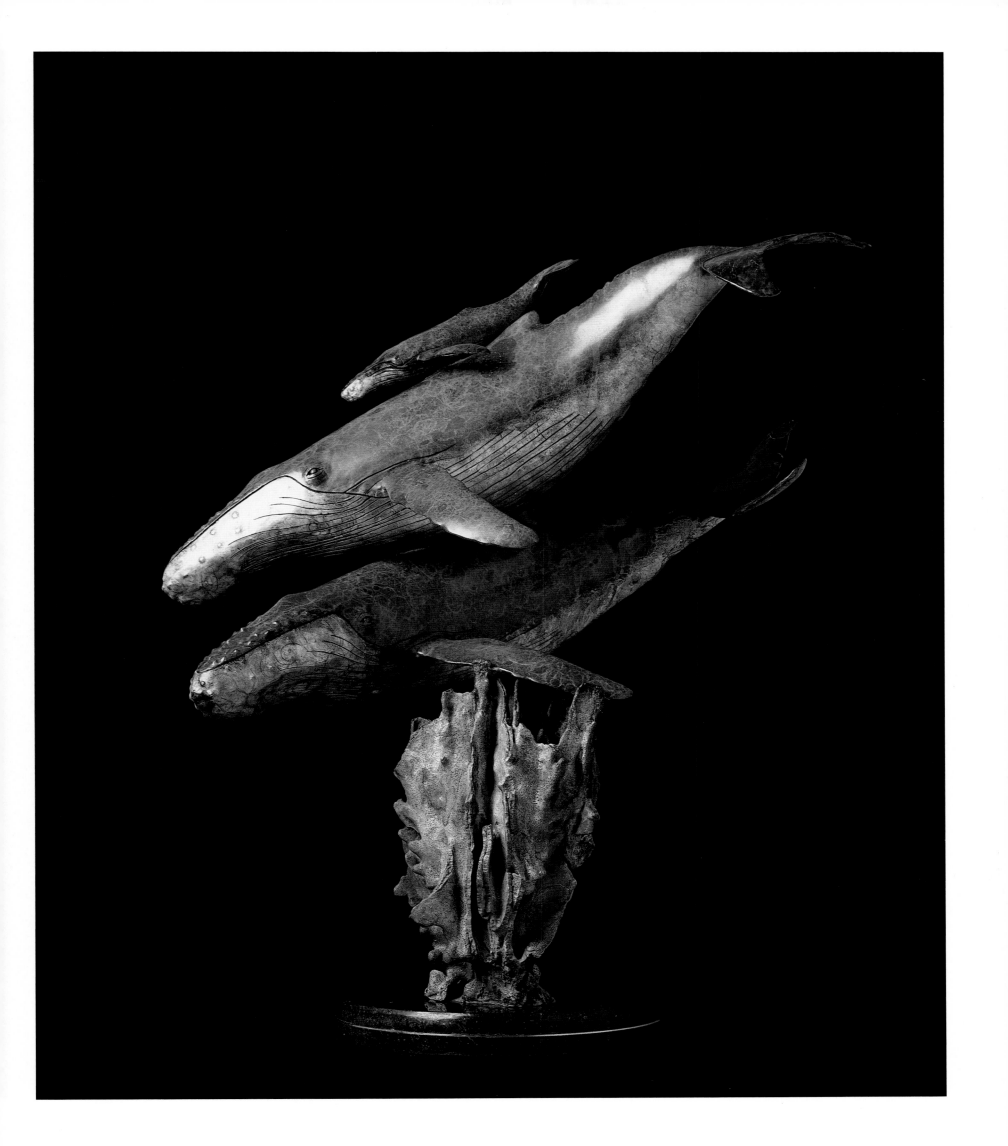

Encounter, Bronze

. . . The larger picture is not can we save the whales,
but can we save our oceans, our planet, us . . .

XII

FUTURE PROJECTS

158

"CHALLENGER" COMMISSIONED BY U.S.A. TODAY, GANNETT

"KEYS TO THE UNIVERSE" CORPORATE ART FOR USA. TODAY

...The oceans are the last frontiers on earth...

▲ 'Dedication' The Challenger — 5 feet x 7 feet — Collection Gannett, USA Today

DEDICATION OF PAINTINGS, COCO BEACH, FLORIDA

▲ "Keys to the Universe" — 8 feet x 17 feet — Collection Gannett, USA Today

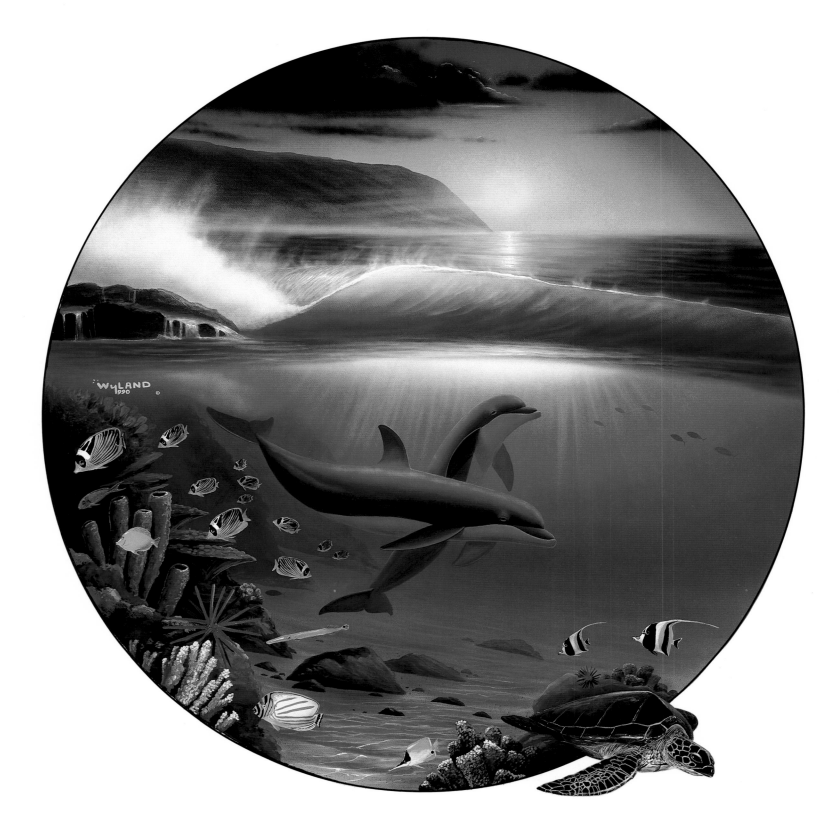

NORTH SHORE, OAHU

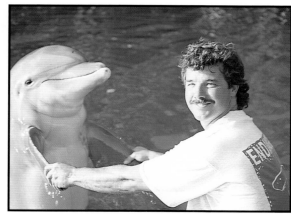

ARTIST WITH MODEL

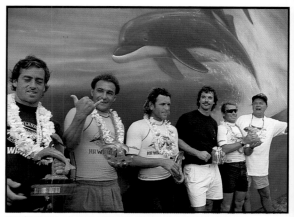

TOM CURREN, JOHNNY BOY GOMEZ, MARTIN POTTER, WYLAND,
TOM CARROL, DICK DALE

▲ Dolphin Days — Oil 48″ round ©1990

My dream since I was very young was to make my mark on society — I believe all artists want to leave their work for future generations to study and learn from.

"I feel my art reflects our environmentally conscious times, and I hope the whaling walls will help future generations to understand the importance of preserving our ecosystem."

"I have been planning for many years now to complete a series of lifesize canvasses and sculpture depicting all the great whales and dolphins of the world and other marine life as well. This life's work will be titled "Lifesize." It is my hope that this art will tour all of the great museums of the world and have an impact on generations to come — long after I am gone."

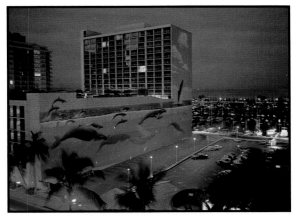
FULL MOON WHALING WALL, HONOLULU, HAWAII

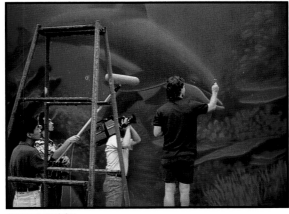
JAPAN TELEVISION

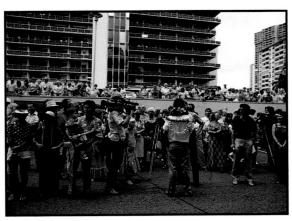
MASS MEDIA

PAINTING MURAL, WYLAND GALLERIES
HAWAIIAN PRO-TRIPLE CROWN OF SURFING

PART OF THE WYLAND GANG, LAGUNA BEACH

THE FUTURE

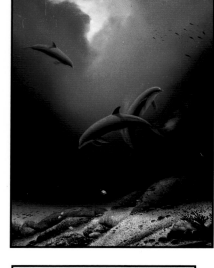

◄ **Children of the Sea**
25½" tall x 33½" wide
Edition 300
+ Proofs

SOLD OUT

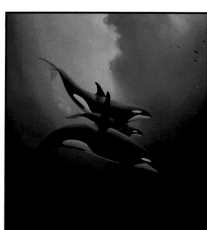

◄ **Orca Trio**
26" tall x 35" wide
Edition 450
+ Proofs

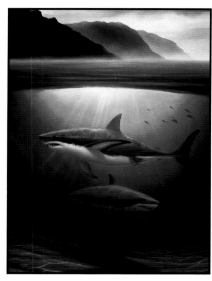

◄ **Great White S**
23" tall x 30" w
Edition 450
+ Proofs

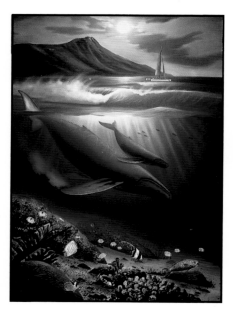

◄ **Maui Humpback
Breaching**
24" tall x 33" wide
Edition 300
+ Proofs

▼ **Maui Moon**
26" tall x 39" wide
Edition 450
+ Proofs

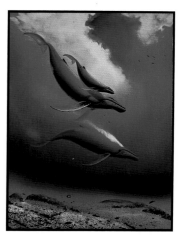

◄ **Humpback Whale
Family**
24" tall x 33" wide
Edition 300
+ Proofs

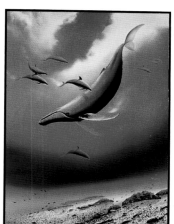

◄ **Sounding**
24" tall x 33" wide
Edition 300
+ Proofs

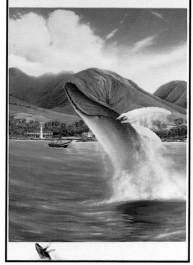

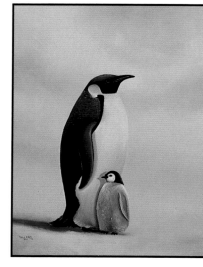

► **Baby Harp Seal**
20" tall x 24" wide
Edition 300
+ Proofs

◄ **Penguins**
20" tall x 24" wide
Edition 300
+ Proofs

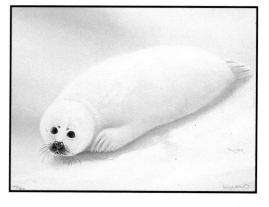

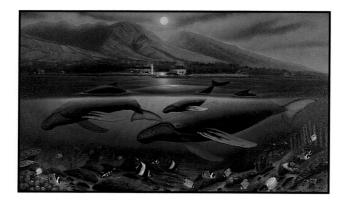

◄ **Full Moon
Diamond Head**
22" tall x 35" wide
Edition 450
+ Proofs

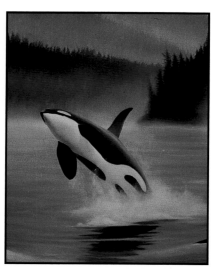

◄ **Orca Breaching**
30" tall x 40" wide
Edition 300
+ Proofs

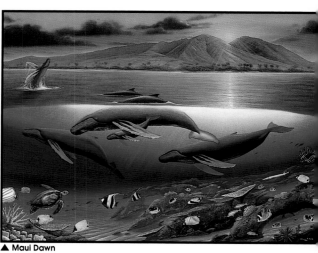

▲ **Maui Dawn**
26" tall x39" wide
Edition 750 + Proofs

LIMITED EDITIONS

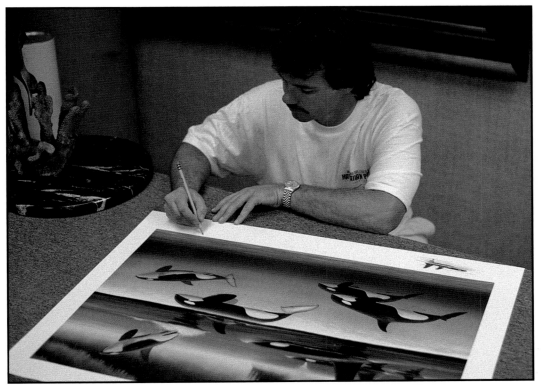

SIGNING NEW LIMITED EDITION

▶ **Northern Mist**
(Triptych)
25" tall x 74" wide
Edition 650
+ Proofs

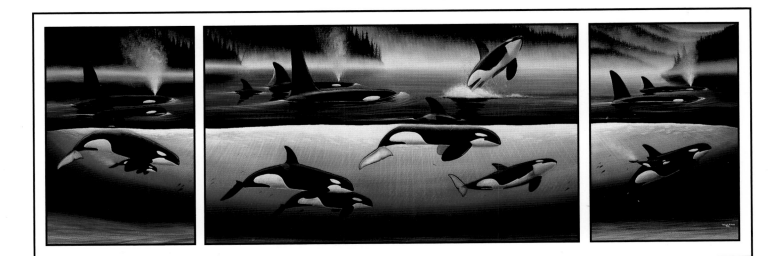

◄ **The Art of Saving Whales**
19½" tall x 25" wide
Edition 450
+ Proofs

◄ **Kissing Dolphins**
19½" tall x 25" wide
Edition 450
+ Proofs

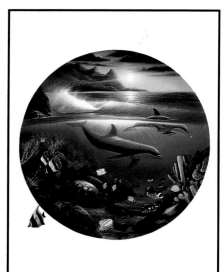

◄
Dolphin Parad
25½" tall x 30"
Edition 650
+ Proofs

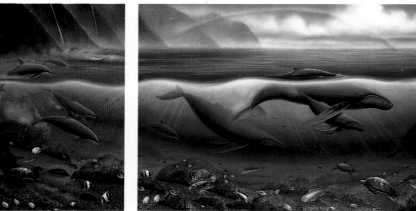

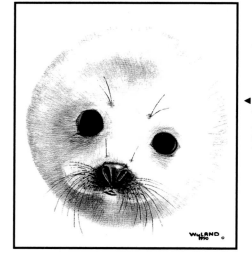

◄
Seal Pup
17" tall x 1
wide
Edition 65
+ Proofs

▲ **Hawaii (Triptych)**
74" tall x 25½" wide
Edition 450 + Proofs

▼ **Northern Passage**
29½" tall x 39½" wide
Edition 75 + Proofs

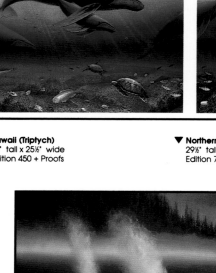

▲ **Tails of Great Whales**
18" tall x 25" wide
Edition 450 + Proofs

◄ **Above and Below**
25½" tall x 40" wide
Edition 650
+ Proofs

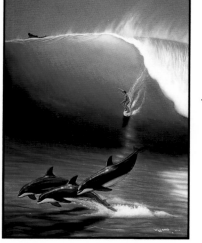

Triple Crown
19½" tall x 25" wide
Edition 650
+ Proofs

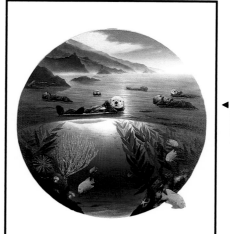

◄
Sea Otters
25½" tall x 28¾" wide
Edition 650
+ Proofs

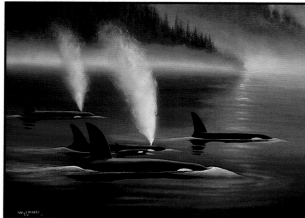

▲ **Celebration of the Sea**
21" tall x 25" wide
Edition 450 + Proofs

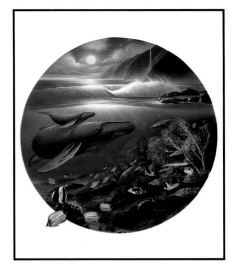

◄ **Islands**
25½" tall x 30" wide
Edition 650
+ Proofs

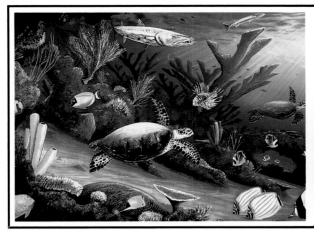

▲
Living Reef
35½" tall x 15" wide
Edition 650 + Proofs

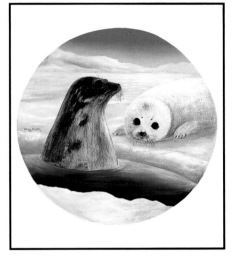

◄
Harp Seals
17" tall x 17" wide
Edition 650
+ Proofs

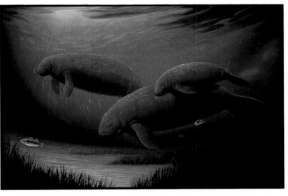

▲
Island Dolphins
26" tall x 32" wide
Edition 450 + Proofs

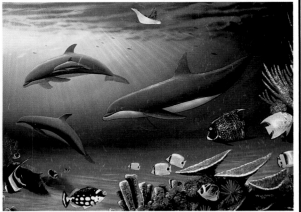

◄ **Hawaii—Born in Paradise**
18½" tall x 25½" wide
Edition 35,000
+ Proofs

Minds in the Water
▼ 19½" tall x 24" wide
Edition 450 + Proofs

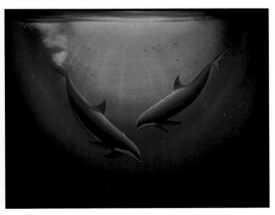

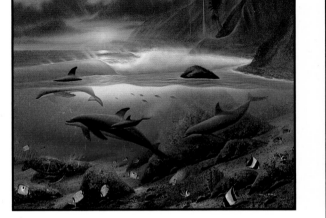

▲ **Endangered Manatees**
24" tall x 15" wide
Edition 650 + Proofs

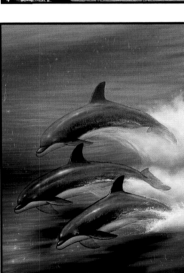
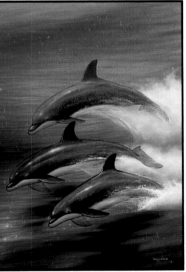

◄ **Dolphin Trio**
19½" tall x 25" wide
Edition 650
+ Proofs

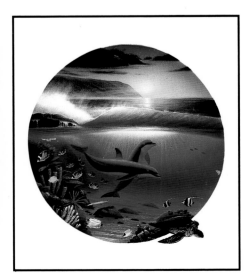

◄ **Dolphin Days**
24" tall x 28" wide
Edition 650
+ Proofs

◄
Surfing
25" tall x 30" wide
Edition 950
+ Proofs

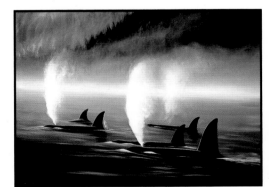

◄
Orca Mist
31" tall x 41" wide
Edition 75
+ Proofs

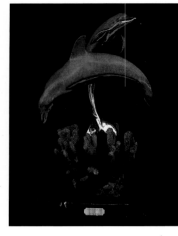

◀ **Children of the Sea**
Bronze
24" tall x 18" Wide
Edition 200
+ Proofs

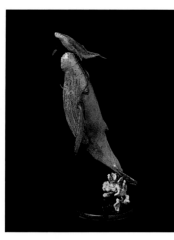

◀ **First Breath**
Bronze
31" tall x 21" Wide
Edition 200
+ Proofs

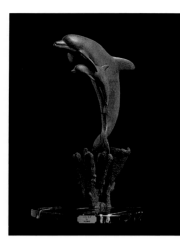

◀ **Ocean Child**
Bronze
22" tall x 16" Wide
Edition 200
+ Proofs

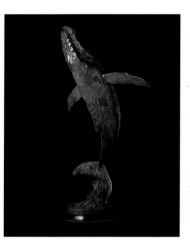

◀ **Ocean Celebration**
Bronze
32" tall x 21" Wide
Edition 200
+ Proofs

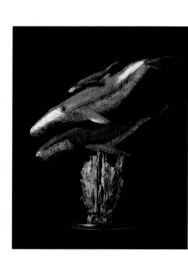

◀ **Ocean Encounter
(large)**
Bronze
31" tall x 29" Wide
Edition 200
+ Proofs

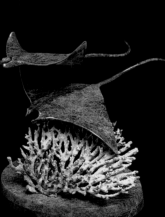

◀ **Manta Rays**
Bronze
15" tall x 14" Wide
Edition 300
+ Proofs

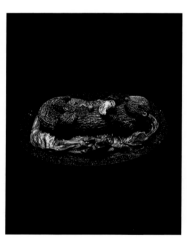

◀ **Sea Otter
with Abalone**
Bronze
4" tall x 12" Wide
Edition 300
+ Proofs

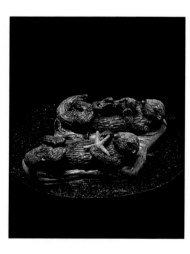

◀ **Sea Otter Family**
Bronze
4" tall x 11" Wide
Edition 300
+ Proofs

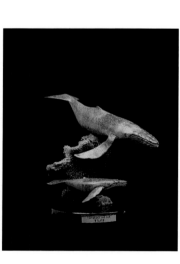

◀ **Humpback with Calf**
Bronze
8" tall x 7" Wide
Edition 300
+ Proofs

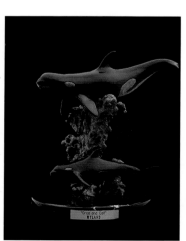

◀ **Orca with Calf**
Bronze
11" tall x 6½" Wide
Edition 300
+ Proofs

◀ **Whale Fluke**
Bronze
6½" tall x 9" Wide
Edition 300
+ Proofs

◀ **Green Sea Turtles**
Bronze
11" tall x 12" Wide
Edition 300
+ Proofs

SCULPTURE
BRONZES • STAINLESS STEEL

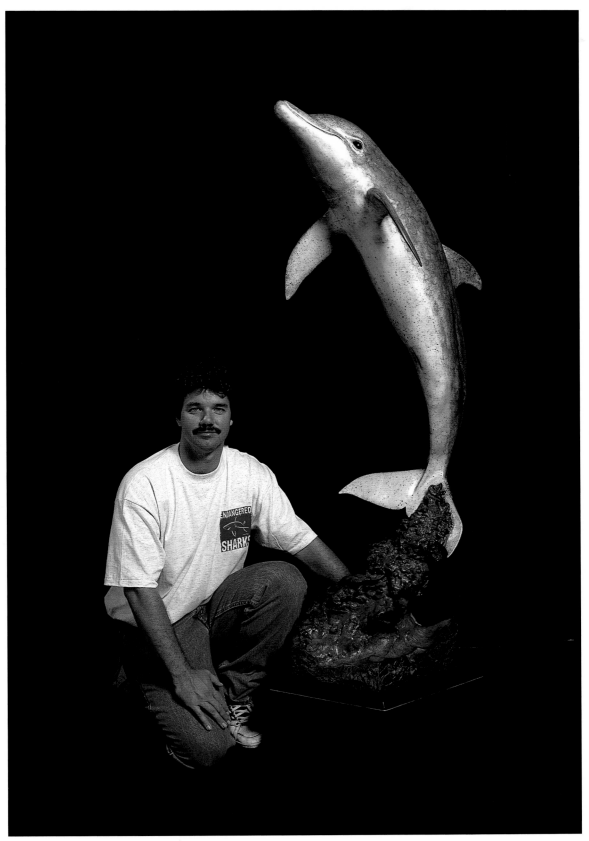

ARTIST WITH FRIENDLY DOLPHIN — FIRST LIFE SIZE BRONZE

▲ **Friendly Dolphin**
Bronze
5¹/₂ feet tall
Edition 200 + Proofs

◀ **Great White Sharks**
Bronze
8" tall x 14" wide
Edition 300
+ Proofs

◀ **Dolphins Up**
Bronze
9¼" tall x 14½" wide
Edition 300
+ Proofs

◀ **Manatees**
Bronze
16" tall x 8" wide
Edition 300
+ Proofs

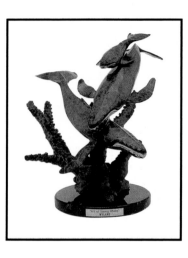

◀ **Art of Saving Whales**
Bronze
10" tall x 14" wide
Edition 300
+ Proofs

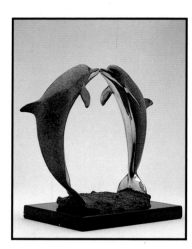

◀ **Kissing Dolphins**
Bronze
10⅛" tall x 11½" wide
Edition 300
+ Proofs

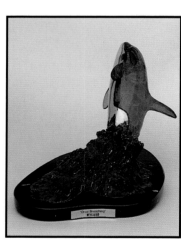

◀ **Great White**
Bronze
9¾" tall x 12" wide
Edition 300
+ Proofs

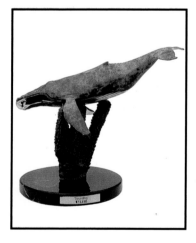

◀ **Sounding**
Bronze
9½" tall x 10½" wide
Edition 300
+ Proofs

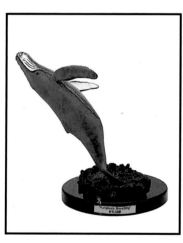

◀ **Humpback Breaching**
Bronze
8½" tall x 8¼" wide
Edition 300
+ Proofs

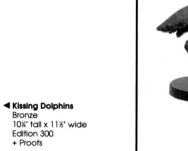

◀ **Orca Breaching**
Bronze
8" tall x 10" wide
Edition 300
+ Proofs

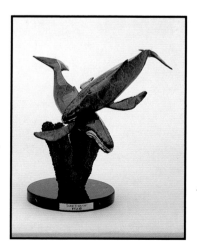

◀ **Ocean Encounter**
Bronze
10" tall x 13" wide
Edition 300
+ Proofs

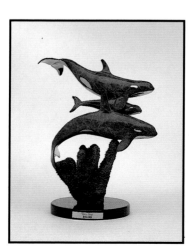

◀ **Orca Trio**
Bronze
17" tall x 11" wide
Edition 300
+ Proofs

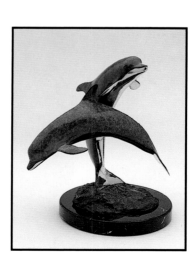

◀ **Children of the Sea**
Bronze
10¼" tall x 9" wide
Edition 300
+ Proofs

W Y L A N D

G A L L E R I E S

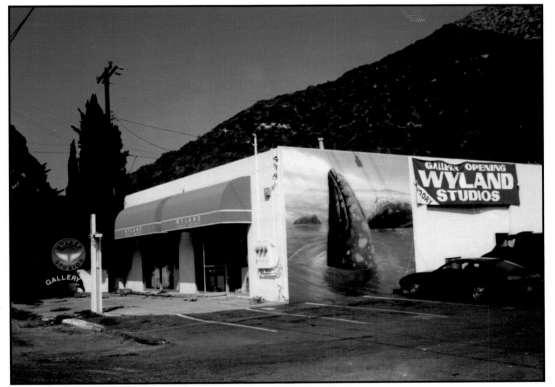

WYLAND STUDIOS, LAGUNA BEACH, CALIFORNIA 1979

W Y L A N D
G A L L E R I E S

LAGUNA BEACH

LAGUNA BEACH

HYATT REGENCY WAIKOLOA

Wyland Galleries was established in 1979 in Laguna Beach, California. Back then it was called Wyland Studio Gallery and was primarily used as the artist's studio. Later, Wyland and his younger brother, Bill, opened a gallery in Haleiwa, Hawaii on the North Shore of Oahu where they both live.

Today Wyland and his family have 15 fine art galleries on the islands of Oahu, Maui, Kauai, Hawaii and also in Laguna Beach, Long Beach, San Diego and Portland, Oregon.

The Galleries feature Wyland's original painting and sculpture with oil painting, watercolors and limited edition prints, hand-signed and numbered by the artist.

Wyland Galleries also feature a number of acclaimed artists such as John Pitre, Roy Tabora, James Coleman, Janet Stewart, Doug Wylie, Jim Warren and many more.

New are a series of Wyland Collection Stores showcasing his different products including T-shirts, towels, hats, bags, posters, note cards, 14k gold and silver jewelry, acrylic sculpture and other Wyland gifts.

LAHAINA, MAUI

LAHAINA, MAUI

KAPAA, KAUAI

Wyland Galleries, Main Office
2171 Laguna Canyon Road
Laguna Beach, CA 92651
Toll Free (800) 777-0039
Phone (714) 497-4081 • Fax (714) 497-7852

Wyland Galleries, Laguna Beach
218 Forest Ave.
Laguna Beach, CA 92651
Gallery (714) 497-9494 • Fax (714) 497-2298

Long Beach-Belmont Shore
4814 E. 2nd Street
Long Beach, CA 90803
Phone (310) 987-3830 • Fax (310) 987-3833

San Diego
Seaport Village
855 W. Harbor Drive, Suite A
San Diego, CA 92101
Phone (619) 544-9995 • Fax (619) 544-0945

Wyland Galleries, Oahu
66-150 Kamehameha Hwy.
Haleiwa, Hawaii 96712
Toll Free (800) 578-OAHU
Phone (808) 637-7498 • Fax (808) 637-5469

Hyatt Regency Waikiki
2424 Kalakaua Ave.
Honolulu, HI 96815
Phone (808) 924-3133 • Fax (808) 9

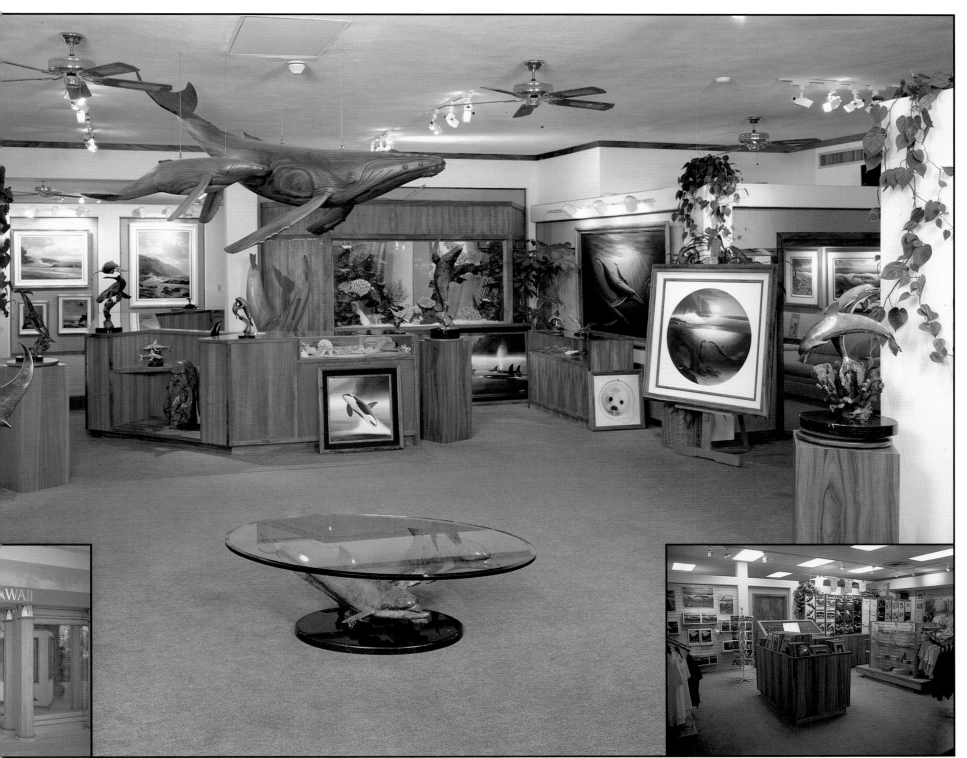

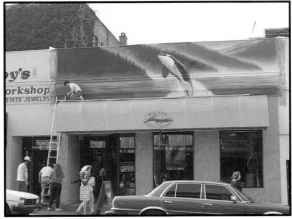

WYLAND COLLECTION STORE

KAPAA, KAUAI

HALEIWA, HAWAII

WYLAND GALLERIES, PORTLAND

Wyland Galleries, Maui
711 Front Street
Lahaina, HI 96761
(808) 667-2285 • Fax (808) 661-4511

Whaler's Village Maui
Building K1
2435 Kaanapali Parkway
Lahaina, HI 96761
Phone (808) 661-8255 • Fax (808) 661-3957

Wyland Galleries, Kauai
4-831 Kuhio Highway
Kapaa, Kauai, Hawaii 96746
Toll Free (800) 882-4558
Phone (808) 822-9855 • Fax (808) 822-7402

Wyland Galleries, Kauai, Anchor Cove
3416 Rice Streeet
Lihue, Kauai, Hawaii 96766
Phone (808) 246-0702
Fax (808) 622-4402

Wyland Galleries, Hawaii
Hyatt Regency Waikoloa
Waikoloa Beach Resort
HC02 Box 5500, Waikoloa, Hawaii 96743
Phone (808) 885-5258 • Fax (808) 885-5384

Wyland Galleries, Portland
711 S.W. 10th Avenue
Toll Free (800) 578-7316
Portland, Oregon 97205
Phone (503) 223-7692

172

. . . I believe if the Whales go, we are certainly next .

▲ **Tails of Great Whales** — Oil 72" x 48" ©1989

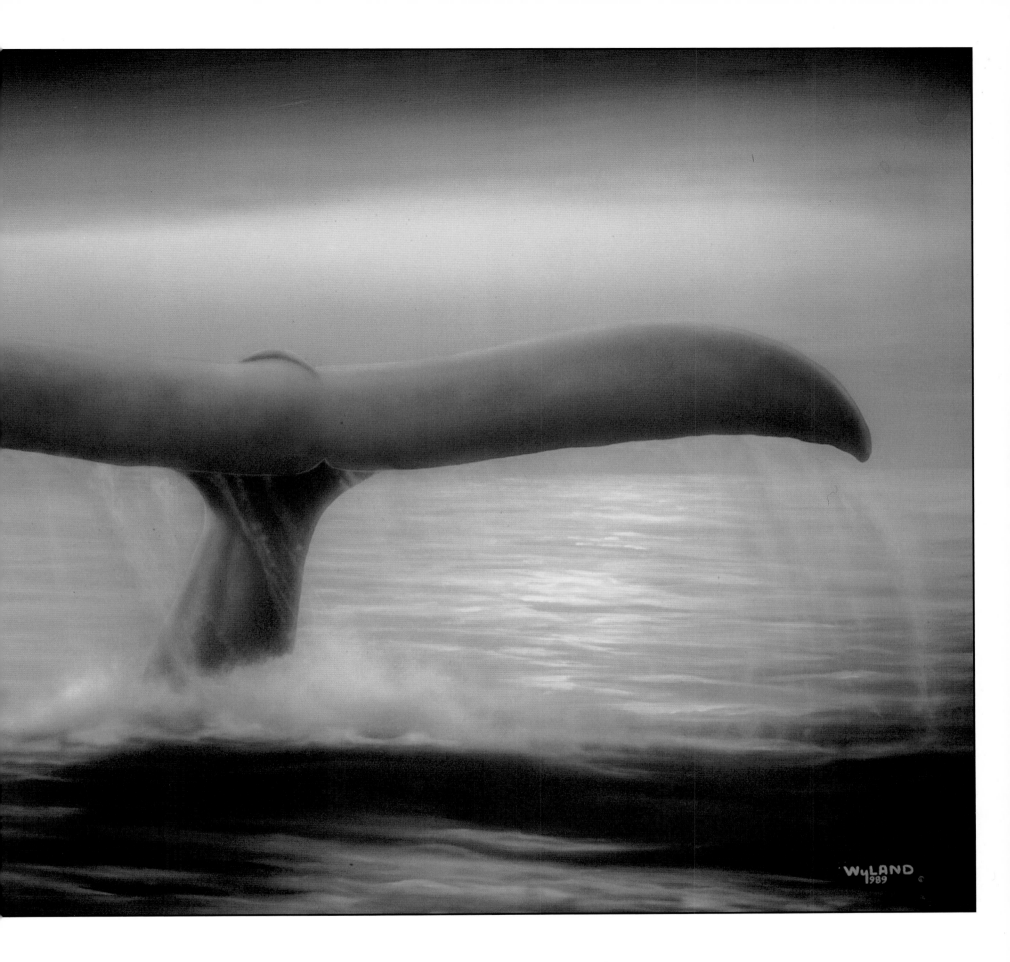

THE WHALING WALLS

L O C A T I O N S

1981 WHALING WALL I — "GREY WHALE AND CALF"
LAGUNA BEACH, CALIF.
140 FEET LONG X 26 FEET HIGH
DEDICATED JULY 9TH, 1981
BY MRS. JOHN WAYNE
REPAINTED 1986

1982 WHALING WALL II — "YOUNG GREY WHALE"
ORANGE COUNTY MARINE INSTITUTE,
DANA POINT, CALIF.
45 FEET LONG X 10 FEET HIGH
DEDICATED MARCH 20TH, 1982
BY BILL TOOMEY, OLYMPIC DECATHALON CHAMPION

1984 WHALING WALL III — "SPYHOPPING"
MARINELAND, RANCHO PALOS VERDES, CALIF.
20 FEET LONG X 30 FEET HIGH
DEDICATED JUNE 27TH, 1984
BY CLEVELAND AMORY, FUND FOR ANIMALS

1984 WHALING WALL IV — "THE GREY WHALE FAMILY"
WHITEROCK, BRITISH COLUMBIA, CANADA
70 FEET LONG X 30 FEET HIGH
DEDICATED SEPTEMBER 29TH, 1984
BY GORDON HOGG, MAYOR OF WHITE ROCK

1984 WHALING WALL V — "THE ORCAS OF PUGET SOUND"
SEATTLE, WASHINGTON
140 FEET LONG X 50 FEET HIGH
DEDICATED NOVEMBER 10TH, 1984
BY IVAR HAGLUND, SEATTLE PORT MANAGER

1985 WHALING WALL VI — "HAWAIIAN HUMPBACKS"
HONOLULU, HAWAII
300 FEET LONG X 20 STORIES HIGH (1/2 ACRE)
DEDICATED APRIL 21ST, 1985
BY RUSS FRANCIS, SAN FRANCISCO 49ERS

1985 WHALING WALL VII — "CALIFORNIA GREY WHALES"
DEL MAR, CALIF.
100 FEET LONG X 16 FEET HIGH
DEDICATED JULY 6TH, 1985
BY GLENN FREY, EAGLES SINGER/SONGWRITER

1985 WHALING WALL VIII — "ORCAS"
VANCOUVER, BRITISH COLUMBIA, CANADA
130 FEET LONG X 70 FEET HIGH
DEDICATED SEPTEMBER 10TH, 1985
BY MICHAEL HARCOURT, MAYOR OF VANCOUVER

1986 WHALING WALL IX — "FIRST VOYAGE"
POLYNESIAN CULTURAL CENTER, OAHU, HAWAII
130 FEET LONG X 14 FEET HIGH
DEDICATED FEBRUARY 4TH, 1986
BY JOHN HILLERMAN, ACTOR

1986 WHALING WALL X — "MANATEES"
ORLANDO, FLORIDA
14 FEET LONG X 8 FEET HIGH
DEDICATED 1986
BY JIMMY BUFFET,
SINGER/SONGWRITER

1986 WHALING WALL XI — "FIRST BORN"
SEA WORLD, ORLANDO, FLORIDA
30 FEET LONG X 12 FEET HIGH
DEDICATED SEPTEMBER 26TH, 1986
BY BILL EVANS, WASHINGTON D.C.

1987 WHALING WALL XII — "LAGUNA COAST"
LAGUNA BEACH, CALIF.
20 FEET LONG X 24 FEET HIGH
DEDICATED FEBRUARY 2ND, 1987
BY DARLENE WYLAND — ARTIST'S MOM

1987 WHALING WALL XIII — "A-5 POD"
VICTORIA, BRITISH COLUMBIA, CANADA
130 FEET LONG X 7 STORIES HIGH
DEDICATED JUNE 20TH, 1987
IN MEMORY OF ROBIN MORTON
DEDICATED BY ROBERT BATEMAN — ARTIST

1987 WHALING WALL XIV — "SPERM WHALES"
FUNABASHI, JAPAN
140 FEET LONG X 18 FEET HIGH
DEDICATED OCTOBER 14TH, 1987
BY DR. GORO TOMENAGA,
PROFESSOR EMERITUS OF TOKYO UNIVERSITY AND
MR. ONO, PRESIDENT OF THE TOKYO BAY FISHING COUNCIL

1988 WHALING WALL XV — "DOLPHINS OFF MAKAPUU POINT"
SEA LIFE PARK, OAHU, HAWAII
24 FEET LONG X 30 FEET HIGH
DEDICATED BY HENRY KAPONO,
SINGER/SONGWRITER

1989 WHALING WALL XVI — "ORCAS OFF POINT LOMA"
THE PLUNGE MISSION BEACH, SAN DIEGO, CALIF.
140 FEET LONG X 40 FEET HIGH
DEDICATED JUNE 29TH, 1989
BY BOB GAULT, PRESIDENT OF SEA WORLD

1989 WHALING WALL XVII — "BOTTLENOSE DOLPHINS"
OSAKA, JAPAN
20 FEET LONG X 30 FEET HIGH
DEDICATED AUGUST 27TH, 1989
BY MR. TOSHITA AND KENT FABULOUS
WALL WAS PAINTED FOR A 24 HOUR TELEVISED TELETHON
IN JAPAN.

1989 WHALING WALL XVIII — "SPERM WHALES OF THE MEDITERRANEAN"
NICE, FRANCE
42 FEET LONG X 120 FEET HIGH
DEDICATED OCTOBER, 1989 — FRANCE GOV. OFFICIAL

1990 WHALING WALL XIX — "FORBIDDEN REEF"
SEA WORLD, SAN DIEGO, CALIF.
90 FEET LONG X 14 FEET HIGH
DEDICATED JULY 9TH, 1990
BY MICHAEL PEAK — AUTHOR

1990 WHALING WALL XX — "GREY WHALE MIGRATION"
SEA WORLD, SAN DIEGO, CALIF.
80 FEET LONG X 15 FEET HIGH
DEDICATED JULY 9TH, 1990
BY BOB GAULT, PRESIDENT OF SEA WORLD

1990 WHALING WALL XXI — "WASHINGTON ORCAS"
TACOMA, WASHINGTON
120 FEET LONG X 45 FEET HIGH
DEDICATED JULY, 1990
BY TACOMA MAYOR, KAREN VIALLE

1990 WHALING WALL XXII (CEILING) — "ORCA HEAVEN"
YAMAGATA, JAPAN
145 FEET LONG X 45 FEET HIGH
DEDICATED 1990
BY MR. KAWADA, PRESIDENT SUN MARINA CORP.

1990 WHALING WALL XXIII — "BUNDABERG HUMPBACK FAMILY"
BUNDABERG, AUSTRALIA
125 FEET LONG X 95 FEET HIGH
DEDICATED SEPTEMBER 28TH, 1990
BY JOHN NIELSEN

1990 WHALING WALL XXIV — "HUMPBACK AND CALF"
SYDNEY AQUARIUM, SYDNEY, AUSTRALIA
90 FEET LONG X 35 FEET HIGH
DEDICATED SEPTEMBER 28TH, 1990
BY JIM LONGLEY, PARLIAMENT NEW SOUTH WHALES

1990 WHALING WALL XXV — "HUMPBACKS"
LAMPHERE HIGH SCHOOL, DETROIT, MI.
110 FEET LONG X 15 FEET HIGH
DEDICATED OCTOBER 8TH, 1990
BY JAMES McCANN, SUPERINTENDENT
LAMPHERE SCHOOL DISTRICT

1990 WHALING WALL XXVI — "SPERM WHALES AND FLORIDA KEYES REEF"
MARATHON KEYES, FLORIDA
150 FEET LONG X 20 FEET HIGH
DEDICATED OCTOBER 30TH, 1990
BY MARATHON KEYES FORMER MAYOR

1990 WHALING WALL XXVII — "MINKE WHALES"
MUSEUM OF NATURAL HISTORY, MARATHON KEYES, FL.
40 FEET LONG X 8 FEET HIGH
DEDICATED OCTOBER 30TH, 1990
BY MANDY RODRIQUEZ, DOLPHIN RESEARCH CENTER

1991 WHALING WALL XXVIII — "A TIME FOR CONSERVATION"
KAUAI VILLAGE, KAUAI, HAWAII
44 FEET HIGH WALLS, 360° MURAL
ON CLOCK TOWER
DEDICATED JANUARY 8TH, 1991
BY RON KOUCHI, COUNTY COUNCIL CHAIRMAN

1991 WHALING WALL XXIX — KAUAI HAWAII
150 FEET LONG X 24 FEET HIGH
DEDICATED JANUARY 8TH, 1991
BY PETER ALEVIZOS, KAUAI VILLAGE PRESIDENT

1991 WHALING WALL XXX — "MAUI HUMPBACK BREACHING"
LAHAINA, MAUI, HAWAII
26 FEET LONG X 30 FEET HIGH
DEDICATED JANUARY 21ST, 1991
BY JOHN PETRI AND JERRY LOPEZ

1991 WHALING WALL XXXI — GREY WHALE MIGRATION
REDONDO BEACH, CALIF.
586 FEET LONG 100 FEET HIGH (1-1/4 ACRE)
DEDICATED JUNE 24, 1991
BY JOHN BRYSON, CEO, SOUTHERN CALIFORNIA EDISON

1991 WHALING WALL XXXII — RIGHT WHALES
TAIJI WALL, JAPAN
35 FEET X 100 FEET
DEDICATED AUGUST, 1991
BY TAIJI TOWN MAYOR

1992 WHALING WALL XXXIII — PLANET OCEAN
LONG BEACH, CALIFORNIA
110 FEET HIGH X 1225 FEET LONG, 360° MURAL
(GUINNESS WORLD BOOK OF RECORDS MAY 4, 1992)
DEDICATED JULY 9, 1992 BY CHRIS ROBINSON, ACTOR

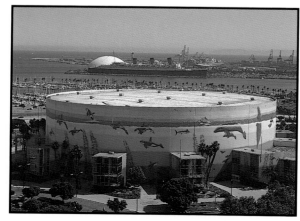

PLANET OCEAN, LONG BEACH, CALIFORNIA

W Y L A N D
B I O G R A P H Y

BIOGRAPHY — WYLAND 1991

BORN: 1956 — Detroit, Michigan

EDUCATION: Center for Creative Studies, Detroit

MAJOR EXHIBITIONS:
Vancouver Aquarium, British Columbia, Canada
Marineland, Palos Verdes, California U.S.A.
Ruth Mayor Gallery, Laguna Beach, California U.S.A.
Sea World, San Diego, California, U.S.A.
Sea Life Park, Honolulu, Hawaii
Dolphin Gallery, Maui , Hawaii
Front Street Gallery, Maui, Hawaii
Dotson Gallery, Maui, Hawaii
Waikiki Aquarium, Honolulu, Hawaii
Turtle Bay Hilton, Honolulu, Hawaii
Livingston Gallery, Honolulu, Hawaii
Polynesian Cultural Center, Laie, Hawaii
Collectors Choice Gallery, Laguna Beach, California, U.S.A.
Center for Creative Studies, Detroit, Michigan U.S.A.
Wild Wings Gallery, Fort Myers, Florida U.S.A.
Upstairs Gallery, Palos Verdes, California U.S.A.
Sawdust Festival, Laguna Beach, California U.S.A.
Art Expo, Los Angeles, California U.S.A.
Art Expo, New York, New York U.S.A.
Catalina Art Festival, Santa Catalina Island, California U.S.A.
Ellis Island Museum, Victoria, British Columbia, Canada
Provential Museum, Victoria, British Columbia, Canada
Smithsonian Institute, Washington, D.C. U.S.A.
Bunkamura, Tokyo, Japan

AWARDS:
The Senate of the State of Hawaii — Certificate of Appreciation
City and County of Hawaii
Arts Council — City of Laguna Beach, California
Greenpeace Award
Sawdust Festival Awards — 1983, 1984, 1985 and 1986, Best of Show
Conservation Council of Hawaii, Award
Key to the City of White Rock, British Columbia, Canada
"Wyland Building" Vancouver, Canada
Resolution, City of Laguna Beach, California
Chamber of Commerce, Award
Key to the City of Redondo Beach, California
Chamber of Commerce, Award
Key to the City of Redondo Beach, California
Beautification Award, Redondo Beach, California
Earth Day Grand Marshal, 1990 Hawaii
1991 Paloma Award — Los Angeles Society for the
Prevention of Cruelty to Animals
1992 Award — Volunteer of the Year
Guinness World Book of Records — May 4, 1992

PUBLICATIONS:
Aloha — Magazine, Sea Coast Magazine, Oceans Magazine, Cousteau Log, Greenpeace Examiner, Honolulu Advertiser, Vancouver Sun, The Province, Art Gallery International, Vegetarian Times, Now Magazine, McCleans Canada, Van Trucking Magazine, Los Angeles Times — Calendar, This Week — Oahu, Orlando Sentinel, Ocean Sports International, Sea Magazine, Los Angeles Times, Orange County Register, Daily Pilot Newspaper, Tides & Times Newspaper, Newsport, Orange County Magazine, Detroit Free Press, USA Today, Surfer Magazine, Cosmopolitan — Japan, Orange County Illustrated, Maui News, The Hawaii Hochi, Daily Tribune, The Reader, Southwest Art Magazine, Westways, Waterfront Magazine, UPI — Feature, Diving Magazine — Japan, Discover Magazine, Ranger Rick — Magazine, Island Directory of Oahu — Cover, The Japan Times, People Magazine — Australia, People Magazine — Japan, This Week — Maui, Fortune Magazine, Kauai Times, Playboy Magazine — Japan, L.A. Style Magazine.

TELEVISION FEATURES:
PM Magazine — National, NBC — National, ABC — National, KITV ABC — Word for Word, Eyewitness News — Detroit, CNN — New Network, Impact WOFL — Channel 35, Playboy Channel, Hawaiian Moving Company, Heartbeat of the Pacific, Vancouver Show, Animalia — French National TV Feature, 24 Hour TV — Japan National, Wyland — ESPN 1-hour special, Wyland Galleries Hawaiian Pro-Surfer, "Get Wet," National Television.

FILMS:
Wyland — "The Art of Saving Whales"
Wyland — "First Voyage" 21 minutes
Wyland — "Orca's A-5 Pod"
Wyland — PBS Sequel — "Wyland — The Power of One" — Narrated by
　　　　Leonard Nimoy
Wyland — The Art of Wyland — 1-hour television special
Wyland — "Get Wet" National Television

BOOKS:
The Art of Wyland — June 1st, 1992
Wyland — "The Art of Savings Whales," Vancouver "A Year In Motion,"
　　　　Honolulu, Vancouver Island

PRIVATE COLLECTIONS:
President Ronald Reagan, Pilar Wayne, James Irvine, Robert Redford, John Hillerman, Tom Selleck, Dick Dale, Glenn Frey, Bill Toomey, Cleveland Amory, Jean-Michael Cousteau, May Michael Harcourt of Vancouver B.C., Canada, Robert Bateman, Linda Blair — actress, Governor Bob Graham, Florida, Prince Charles & Princess Diana, Gannett Publishing — USA Today, Russ Francis, Dan Marino, LeRoy Neiman, Al Harrington, Bill Evans — US Fisheries, Governor Ariyoshi — Hawaii, Governor Waihee — Hawaii, Dan Fogelberg, Jimmy Buffett, Barbara Whitney — Whitney Gallery, Allain Bougrain-Dubourg, Lee Iacocca, Kareem Abdul Jabbar, Elayne Boosler, Roger Staubach, Paul Newman

ANNUAL SHOW

W Y L A N D
C H R O N O L O G Y

1956 Born in Detroit, Michigan

1960 First paintings of Dinosaurs

1970 Saw first whales — Grey whale migration off the coast of Calif.

1972 First paintings of whales and dolphins.

1974 Painted first Mural, Alps Mountain scene, Royal Oak, Michigan.

1974-75 Attended S.E.V.O.C. Art School

1975 Served as apprentice with Airbrush Master, Dennis Poosch, Shrunken Head Studies.

1976-77 Attended Center for Creative Studies, Detroit, Michigan — Painting/Sculpture.

1977 Moved to Laguna Beach, Calif.

Painted first Murals in Southern Calif.

1978 Taught Airbrush School, Costa Mesa, Calif.

Whaling Walls developed out of needing larger canvas for subject.

1979 First Gallery showing at Collectors Choice Gallery in Laguna Beach.

1980 Published first Whaling Wall poster

1980-91 Sawdust Festival, Laguna Beach, Calif.

1980 Opened first Wyland Studios Gallery, Laguna Beach, Calif.

1981 Completed first Whaling Wall Mural, 140' x 14' high, Laguna Beach, Calif.

1982 Whaling Wall II, Dana Point, Calif.

One Man Show, Sea World, Calif.

1983 Sawdust Festival Award, Best of Show, 1983, 1984, 1985, 1986.

1984 Whaling Wall III, Rancho Palos Verdes, Calif.

Whaling Wall IV, White Rock, B.C. Canada.

Key to the City, White Rock, British Columbia.

Whaling Wall V, Seattle, Washington.

Art Council — City of Laguna Beach, Calif.

1985 Whaling Wall VI, Honolulu, Hawaii.

The Senate of the State of Hawaii — Certificate of Appreciation.

Whaling Wall VII, Del Mar, Calif.

Whaling Wall VIII, Vancouver, B.C., Canada.

"Wyland Building" Vancouver, British Columbia.

PM Magazine National Television.

City and County of Hawaii — Resolution for Whaling Walls.

Green Peace Award.

1986 Original Painting "Aloha Liberty" for Ellis Island Museum, New York, New York.

Whaling Wall IX, Oahu, Hawaii.

Whaling Wall X, Orlando, Florida.

Whaling Wall XI, Orlando, Florida.

1987 City of Laguna Beach — Resolution for Whaling Walls.

Whaling Wall XII, Laguna Beach, Calif.

Whaling Wall XIII, "Orca's A-5 Pod," dedicated by Artist Robert Bateman, Victoria, Canada.

Original Painting "Orca's A-5 Pod" Provincial Museum, British Columbia, Canada.

Whaling Wall XIV, Funabashi, Japan.

PAINTING BALD EAGLE

W Y L A N D
C H R O N O L O G Y

1988
Easter Egg Painting at the White House, Washington, D.C.

Whaling Wall XV, Oahu, Hawaii.

Easter Egg Painting — Collection of Smithsonian Institute, Washington, D.C..

Opened first Wyland Gallery, Haleiwa, Hawaii.

1989
Whaling Wall XVI, San Diego, Calif.

Whaling Wall XVII, Osaka, Japan.

Whaling Wall XVIII, Nice, France.

1990
Whaling Wall XIX, San Diego, Calif.

Earth Day Grand Marshall, Hawaii.

Los Angeles Art Expo, Feature Artist.

CNN Headline News feature.

First cast bronze sculpture — "Children of the Sea."

Whaling Wall XX, San Diego, Calif.

Whaling Wall XXI, Tacoma, Washington.

Whaling Wall XXII, Yamagata, Japan.

Whaling Wall XXIII, Bundaburg, Australia.

Whaling Wall XXIV, Sydney, Australia.

Whaling Wall XXV, Detroit, Michigan.

Whaling Wall XXVI, Marathon Keys, Florida.

Whaling Wall XXVII, Marathon Keys, Florida.

People, Magazine, Australia.

1991
Completed Whaling Wall XXVIII, and XXIX in Hawaii.

New York Art Expo.

Series of original bronze sculptures.

Whaling Wall XXX, Maui, Hawaii.

1991
Completed largest mural in America, 622 feet by 10 stories high, in 11 days, 3,000 gallons of paint, Redondo Beach, Calif.

Key to the City of Redondo Beach, Calif., given by Mayor Brad Parton.

Featured on National French Television — Animalia.

One Man Show — Japan Art Exhibition, Tokyo.

Whaling Wall XXXII, Taiji, Japan.

Editing PBS serial feature "Wyland's Whaling Walls."

Designing series of "lifesize" sculptures and canvases for international museum tour featuring whales, dolphins and other marine life — "lifesize."

Japan Television — 1/2 hour special national television.

Writing The "The Art of Wyland" — a large coffee table art book.

Wyland — "The Power of One" — on PBS narrated by Leonard Nimoy.

Sponsor of Wyland Galleries Hawaiian pro triple crown event.

1992
First book release "The Art of Wyland" — May 1992.

ESPN 1-hour special — Wyland Galleries Hawaiian Pro-Surfer.

The Art of Wyland 1-hour television special.

Painting largest mural in the world — on the Long Beach Convention Center — 2 acres — 110 feet in diameter x 1,225 long (7,000 gallons of paint).
Guinness Book of World Records

2011
Completion of 100th Whaling Wall.

WYLAND WITH SURREALIST ARTIST, JOHN PITRE

SPECIAL THANKS

Darlene Wyland
Steve Wyland
Bill & Kelly Wyland
Tom & Valerie Wyland
Angela Eaton
George Payne
Sky Climber Scaffolding
Gary H. Mayberry
Sandra George
George Elliot Safire
LeRoy Neiman
Robert Bateman
Tom Selleck
Robert Redford
Jimmy Buffet
Glenn Frey
Mark & Debbie Ferrari
Dan Fogelberg
Lorne Green
Dennis Poosch
Image Art Works
Stan Reich
Debbie Osborne
Ian McTavish
Chris Robinson
John Pitre
David Talisman
Roger & Shelly Silagi
Judy Burke
Neil Fitzpatrick
Leah Vasques
Leonard Nimoy
Robert K. Gault, Jr.
Ted Danson
Dale Evers
Judy Rispaud
Ron Wiley
Chuck & Helene Allen
Doug & Lori Wylie
Frazer Smith
Peter Ehrlich
Roy Tabora
Mike Latronic
George & Theresa Parsons
John Lara
Ron & Linda Martin
Robin Clark
Blake Haverberg
Ronn Ronck
Linn Larson
Lynn Horner
Chris Opp & Family
Linda Jaume
Reg Swenkie
John Burgess
John Perry
Rachel Simmons
Andrea & Gary Smith
Rick Scutter
Brian Davies
Mr. Seager
Jerry Sell & Family
Jim Sell & Family
Linda Gustafson & Family
Rick & Terri Ondrasek
Aunt Debbie & Family
Pam Stacy
John Cyphor
Robert Sulnick
Bob Meyers
Maiden Foundry, Oregon
Richard Haber
Walter Flood
Dick & Jill Dale
David Baker
Pilar Wayne
John Hillerman
Mr. & Mrs. Bill Moore
James Irvine
Ken Frank
State of Hawaii Dept. of Educ.
Lamphere High School
Laguna Beach High School
Laguna Beach Unified School
 District
East Elem., Michigan
Hoover Elem., Michigan
Page Jr. High School, Michigan
Center for Creative Studies
Rubina Forrester
Laguna Beach Police Dept.
Madison Heights Police Dept.
Waikikian Hotel
Laguna Hotel
Claes Anderson
Turtle Bay Hilton
Orange Coast College
Four Seasons Hotel
Bank of Hawaii

Michael Wix
Diegos
Haleiwa Cafe
Huevos Restaurant
Saks Fifth Avenue
Harley Davidson
Southern California Edison
The B.C. Provincial Museum
Le Jardin Academy
Stephen Switzer
White House Restaurant
Roger Lock
Jim McCann
Bob Sheridan
George Jessco
Kay Schwarzberg
Bill Gerard
Jay Hair
Russel Keeter
Jay Holland
Bill Nivens
Bob Moore
Bruce D. Praet
Ed Sultan
David Schutter
Steve Ness
John Carder
Taiji Town
Bunkamura Japan
Linda Trembly
Donna Yap
Aggie Schenk
Susan Thoma
Ron & Lynn Cruger
Ken Keef
Carol Rosin
Gary Fogner
Chuck Wyrick
Dr. Fred & April Eckfeld
Rod Coronado
Angus & Sally Graham
Robert Wyland
Therese Eberhard
Jim Wilson
Bill Toomey
Bill Evans
Dan Marino
Gov. Ariyoshi of Hawaii
Gov. John Waihee of Hawaii
Gov. Bob Graham of Florida
Mayor Gordon Hogg
Dr. Bill Otten
Dr. Steve Montgomery
Dr. Ed Hickum
Dr. Taub
Mayor Brad Parton
Senator Mary Jane McMurdal
Rep. James Shon
Senator Neil Abercombie
Senator Rick Reed
State of Hawaii
Peter & Fay Paul — Cliff Type
Dave Thomas
Justine Slane — Cliff Type
Harlequin Nature Graphics
Western Pacific Gifts
JEL Studios
Dick Lyday
Xenex Publishing
Light Inc.
Catapult Productions
Ed Capelle
Gunthers Printing
Sinclair Paint
Bob Eggert
Ron Garland
Denise Brown
Hamilton Collection
Bob Torez
Crown Printers
Tom Shorett
Maiden Sunshine
Sawdust Festival
Nina & Piere Aurmides
Honolulu Star Bulletin
Honolulu Advertiser
Hawaii Hochi
Lahaina News'
Daily Tribune
USA Today
Detroit Free Press
Detroit News
L.A. Times
Daily Pilot
KONG Radio
KIKI Radio
KPOI Radio
Tim Slahatgar
Shelly Perysian

Jackie Hill
Don Eddings
Triple Crown
Kawela Bay Neighbors
Alan Newheart
Michel Ward
Andrew Annenberg
Suzanne & John Hills
Dan Dredson
Banyon Arts Serigraphs
Hillery Palmer
Bill Shutt
Pacific Rim Restaurant
Jack & Barbara Dwyer
Rick Lipoff
Amy L. Price
Phil Herbert
Tom Klingenmeier
Bennett S. Cohn
Steve Schrock
Mel Kebang
Kim Knechtl
Linda Blair
Mr. Ono
Al Harrington
Barbara Whitney
Ivar Hagland
Michael Harcourt
John Cunningham
Tom & Sandy Smelser
Toni Costa
Tamaki Sarabaugh
Sunshine Smith
Heather Evers
Ron Robertson
Kevin Short
Reed Nakamura
Russ Francis
Ken Rowley
Walter Jones
Harry Wilkins
Barry Bowman
Marge McDowelle
Henry & Pam Kapono
Jim Lyon
Kim Taylor Reece
Judith Delaney
Dan Kenney
Mr. Kawada
Marty Kahn
Ron Whiley
Scott A. Hartvigsen
Bill Hawley
Larkin Lawson
David Lee
Kent Ullberg
Brian Evenson
Robert Lewin
Rick Clay

Lynn Cook
Ron Robertson
Lisa Lang
Rickie Donny
Bill & Jean O'Connor
Jerry Rochford
Ron Brown
Randy Rarick
Hal Johnson
Jeff Smith
David Solomon
Jay Brooks
William Davis
Al Giddings
Wyland Art Wear
Peter Allvso
Sue Bauer
Carol Belar
Cindy Silva
Cheri Baker
Sallie Graham
Susan Shawman
Shelley Schwenke
Joan Irvine
Charles Peck
Morgan Craft
Ralph Rodgers
Don Logay
Nicholas Wilson
Cleveland Amory
Jack Davidson
Chris Newbert
Budget Rent A Car
Wiki Wild Print
Gannett Pub — USA Today
Four Runner Productions
Pioneer Video
Sea World of Florida
Sea World of San Diego
San Diego Zoo
Honolulu Zoo
National Wildlife Federation
The Marine Mammal Commission
Dr. William Evans
Sydney Aquarium
Greenpeace
Save the Manatees
Dolphin Research Center
Sea Life Park
Vancouver Aquarium
Earth Trust
The Cousteau Society
American Oceans Campaign
Donald Locke, Ed. D
Conservation Council Hawaii
Heal the Bay
Richard & Marlu Oliphant
Bobie Minkin
Jay Anderson

Steven K. Katona
Perry & Price
Big Al Koulter
Randy Brant
Mark Fu
Kelly Block
Lissa Ballard
Jim Sharp
Gary Kobota
Steven Mattony
Murry & Melissa Langston
Gale & Kathy Notestone
George Lee
Michael Peak
Lynne Russell
Chris Von Imhof
Janet & Don Stewart
Steven Songstead
Al Spraig
Don Stephens
Steve Hughes
Bob Talbot
Geroge Becker
Pheoby Gedge
Steve Whitaker
Ann Taylor
Bill Paul
Chick Bragg
Steve Bloom
Candas White
Jerry Lopez
Jerry Hopkins
Carol Cox
Gillan Abercrombie
Big Jim Nabors
Judge Herman Lum,
 Supreme Court Justice
Bob Yehling,
Tom & Jan Davidson
Fred Livingston
Paul Newman
Trisha Dennis
Pam Lager Bauer
Tracy Taylor
Roy Gonzalez Tabora
Jim Warren
James Coleman

Corporate Office, Waipahu
Rene Agsalda
Cheyenne Arneson
Jeff Allen
Jessica Bell
David Blas
Yvonne Coleman
Judy Castle
Jeff Castle
Jason Castle
Karen Ertell
Hope Haygne
Peace Hokoana
Annette Jaime
Barri Johnson
Aaron Kibota
Carol Machida
Vanessa Nacino
Keith Nolan
Michael Osborn
Perry Pascual
Rain Risher
Tina Rollins
Teresa Ruiz
Joyce Sumile
Allen Suan
Eugenie Taboada
Tara Vaughn
Linda Wiley
Julia Winfield
Fina Yokatake
Marites Yadao
Big Island Gallery
Stacey Anthony
Kristeen Bakewell
David Gonzales
Priscilla Winn
Harold Zeh
Marilyn Zeh
Richard Ortega
Maui Galleries
Saundra Be-Taylor
Janey Cinzori
Thomas Dilliner
Jason Derner
Barb Dixon
Don Dixon
Lori Lee Elmer
David Glickman
Brian Henderson
Randy Hunter
Randall Kniesley

Christopher Kniesley
Peter Kaltenekker
Stephen Kemper
Sharon Kayser
Andrea Labore
Tanja Miller
Kaatee Miller
Richard Oxman
Thomas Peters
Susie Perk
Timothy Peraza
Richard Ryckoff
Patrick Sweeney
Christine Slesser
Kristin Urlick
Diane Williams
John Chase
Nancy Fillebrown
Jane Farrer
Mark Jackson
Oahu Galleries
Cynthia Anderson
Christine Brett
Mary Bayus
Kara Craver -Jones
Marilyn Carr
Daiva Friedrich
Joanne Gorey
Joan Gallette
Sylvia Hughes
Karen Hedemann
Linda-Lee Koerte
Fred Mongeon
Jon McKay
Lisa Mongeon
Troy Nelson
Shigeko Ricci
Gregory Shaffer
Ann Sterwart
Patrick Secuya
Tina Sterling
Tamara Timoshik
Amy Vartanian
Therese Gandre
Ohio Okada
Kauai Galleries
Ray Charron
Susan Ocha-Belmonte
Wyland Studios, Laguna
Jim Augenstein
Sondra Augenstein
Sylvia Bass
Daemon Clark
Angela Eaton
Bette Griffin
Linda Gustafson
Brian Keith
Joanie Kessler
Jenna Lewis
Safron Logan
Adam Lyons
Lisa Magness
Sheldon McCance
Karen McDuff
Hilary Merritt
Jennifer Mueller
David Sebreros
Jill Thomas
William Weber
Darlene Wyland
Wyland Galleries, San Diego
Sandy Anderson
Sadi Applebaum
Richard Little
Michael Murray
Debbie Taylor
Susan Peters
Rowena Wellman
Wyland Galleries 218
Jolene Armstrong
Gary Daverso
Sheila Joseph
Kris Martinelli
Kerry McKee
Wyland Collection Store, Laguna
Doug Black
Gary Leaf
LeeAnn Smelser
**Wyland Collection Store,
 Long Beach**
Shannon Schweigert
Karlye Klomsky
Eric Hansen
Hope Ramey
Wyland Galleries, Long Beach
Sherrill Beard
Ed and Sharyn Kennedy
Michael Mercadante
Tim Moran

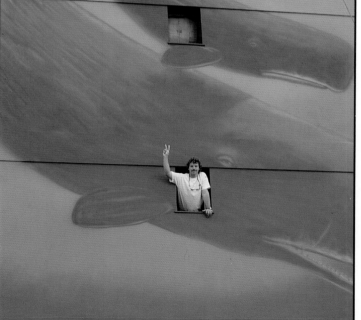

INSIDE WHALING WALL

CONSERVATION
ORGANIZATIONS

American Oceans Campaign
725 Arizona Ave., Suite 102
Santa Monica, CA 90401

American Cetacean Society
Box 2639
San Pedro, Ca 90731

California Marine Mammal
 Center
Marin Headlanes — GGNRA
Ft. Cronkhite, CA 94965

Conservation International
1015 18th St. N.W. Suite 1000
Washington, D.C. 20036

Defenders of Wildlife
1244 19th St. N.W.
Washington, D.C. 20036

Friends of the Sea Otter
Box 221220
Carmel, CA 93922

The Humane Society
 of the United States
2100 L Street N.W.
Washington, D.C. 20036

Marine Mammal Fund
Bldg. E., Fort Mason
San Francisco, CA 94123

Maui Whalewatchers
Box 457
Lahaina, HI 96761

National Geographic
P.O. Box 2895
Washington, D.C. 20077-9960

American Society for
 the Prevention of Cruelty
 to Animals
441-E 92nd St.
New York, NY 10128

Animal Protection Institute
Box 22506
Sacramento, CA 95822

Center for Whale Studies
39 Woodvine Court
Covington, LA 70433-724

Cousteau Society
930 W. 21st Street
Norfolk, VA 23517

Earth Trust
2500 Pali Highway
Honolulu, HI 96817

Friends of the Earth
218 D Street S.E.
Washington, D.C. 20003

Greenpeace International
Keizersgracht 176
1016 DW Amsterdam
The Netherlands

International Fund for
 Animal Welfare
Box 193
Yarmouth Port, MA 02675

National Audubon Society
950 Third Avenue
New York, NY 10022

Natural Resources
 Defense Council
40 W. 20th Street
New York, NY 10011

Animal Welfare Institute
Box 3650
Washington, D.C. 20007

Center for Environmental
 Education
624 9th Street
Washington, D.C. 20001

Cultural Survival, Inc.
11 Divinity Avenue
Cambridge, MA 02338

Environmental Defense Fund, Inc.
257 Park Avenue South
New York, NY 10010

Friends of the Sea Lion
20612 Laguna Canyon Road
Laguna Beach, CA 92651

Fund for Animals
200 W. 57th Street
New York, NY 10019

Greenpeace
Bldg. E, Fort Mason
San Francisco, CA 94723

Marine Mammal Stranding Center
P.O. Box 773
Brigantine, NJ 08203

National Wildlife Federation
1412 16th Street N.W.
Washington, D.C. 20036

Oceanic Society
Bldg. E, Fort Mason
San Francisco, CA 94123
Save the Manatees
1191 Audubon Way
Maitland, FL, 32751

W. Quoddy Marine
 Research Center
Box 9
Lubec, ME 04652

Whale Protection Fund
624 9th Street NW
Washington, D.C. 20001

Worldwatch Institute
1776 Massachusetts Ave. N.W.
Washington, D.C. 20036

Sierra Club
730 Polk Street
San Francisco, CA 94109

The Wilderness Society
900 Seventeenth St. N.W.
Washington, D.C. 20006

Society for Marine Mammology
Oregon State University
Newport, OR 97365

Whale Museum
Box 945
Friday Harbor, WA 98250

World Wildlife Fund
1601 Connecticut Ave. N.W.
Washington, D.C. 20009

Save the Whales, Inc.
1426 Main St., Unit E
P.O. Box 2397
Venice, CA
USA 90291

Dolphin Research Centre
P.O. Box 2875
Marathon Shores, FL
USA 33052

Mote Marine Laboratory
1600 Thompson Parkway
Sarasota, FL 34236

The Dolphin Network
3220 Sacramento St.
San Francisco, CA
USA 94115

Human/Dolphin Foundation
33307 Decker School Road
Malibu, CA
USA 90625-96088

Lifeforce
P.O. Box 210354
San Francisco, CA
USA 94121

*International Wildlife Coalition
(Whale Adoption Project)
Holly Park
634 North Falmouth Highway
North Falmuth, MA)USA 02556

The Sea Turtle Center
P.O. Box 634
Nevada City, CA
USA 95959

University of the Sea
A Volunteer Research
 Organization
Old College, 401 West Second
Reno, Nevada 89503

Clean Water Action
1320 18th St. NW
Washington, DC
USA 20036

Orcalab
P.O. Box 258
Alert Bay, British Columbia
Canada V0N 1A0

Surf Rider Foundation
122 S. El Camino Real #67
San Clemente, CA 92672

To order the Directory of Environmental Organizations, contact: Educational Communications, c/o Nancy Sue Pearlman
P.O. Box 35473, Los Angeles, California 90035

Best Fishes

WyLAND